The Planter's Prospect

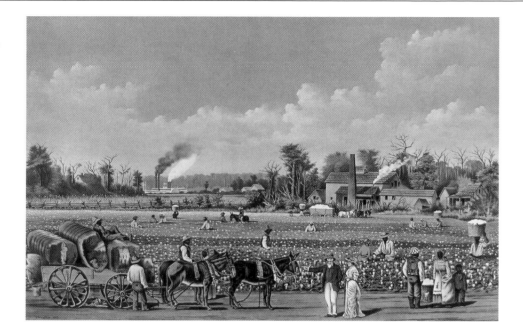

The RICHARD HAMPTON JENRETTE *Series in Architecture and the Decorative Arts*

The Planter's Prospect

Privilege and Slavery in Plantation Paintings

JOHN MICHAEL VLACH

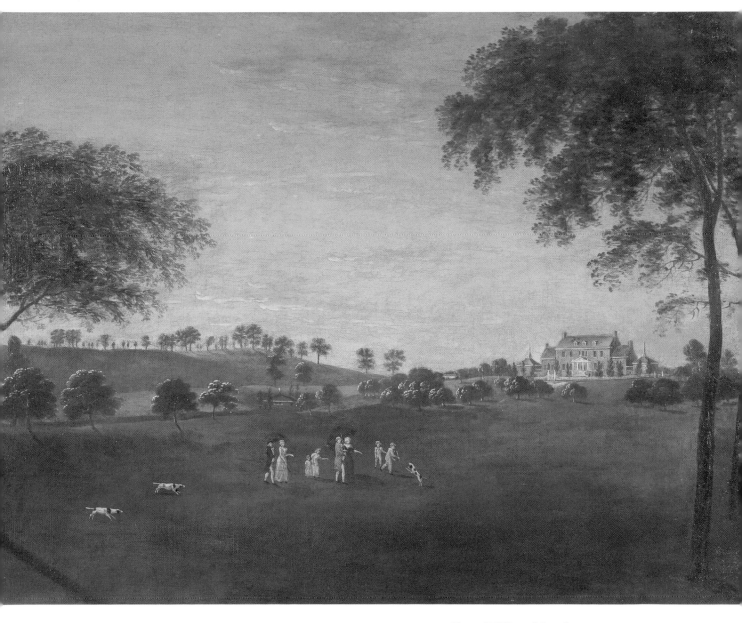

THE UNIVERSITY OF NORTH CAROLINA PRESS *Chapel Hill and London*

© 2002 The University of North Carolina Press

Manufactured in the United Kingdom

by Butler and Tanner Ltd.

This book was set in Charter types

by Eric M. Brooks

Book design by Richard Hendel

The paper in this book meets the guidelines for
permanence and durability of the Committee on
Production Guidelines for Book Longevity of the
Council on Library Resources.

Library of Congress Cataloging-in-Publication Data

Vlach, John Michael, 1948–

The planter's prospect: privilege and slavery in
plantation paintings / John Michael Vlach.

 p. cm.

Includes bibliographical references and index.

ISBN 0-8078-2686-3 (cloth: alk. paper) —

ISBN 0-8078-5352-6 (pbk.: alk. paper)

1. Landscape painting, American—Southern
States—19th century. 2. Landscape painting,
American—Southern States—20th century.

3. Plantation life in art. I. Title.

ND1351.5 .V58 2002

758'.997503—dc21 2001041458

cloth 06 05 04 03 02 5 4 3 2 1

paper 06 05 04 03 02 5 4 3 2 1

For Kate and Molly

CONTENTS

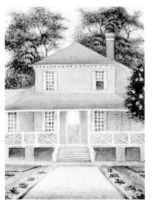
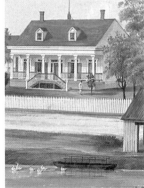

 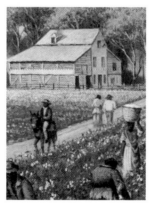

A gallery of color plates follows page 108.

ACKNOWLEDGMENTS

The seeds for this book were present in my previous study, *Back of the Big House*. Offering a visual tour of numerous plantation settings as well as a cultural analysis of the physical landscape of slavery, that book gave rise, on several occasions, to questions about the 200 photographs and scaled drawings that accompanied my text. Since the illustrations in *Back of the Big House* were all generated by a New Deal–era survey project, I was sometimes asked about photographs from earlier periods and what they might have revealed. After one public lecture when I was challenged for not using images made during the antebellum period, I argued back that during those years there was little outdoor photography. It was, I said, an era principally of drawings and paintings. The follow-up question was, "Well, what do those pictures show?" Not knowing how to respond with any confidence, I began to consider a course of study that eventually turned into *The Planter's Prospect*. My first debt, then, is to the anonymous questioner who pushed me to consider the documentary qualities of regional art.

In this study of southern landscape images I was guided initially by two outstanding art historians, Jessie Poesch and Estill Curtis (aka "Buck") Pennington. Their energetic regional surveys provided me with a broad map for my own journey. When a manuscript finally appeared, Buck Pennington served further as one of its readers, and he sternly warned me off of my more imprudent assertions. Richard Gruber, director of the Ogden Museum of Southern Art in New Orleans, also reviewed my draft, offering an enthusiastic assessment for which I am most grateful. Other experts in the area of southern art will find that they appear regularly throughout my notes. For Stiles Tuttle Colwill, Martha Severens, Barbara SoRelle Bacot, and Cynthia Siebels, these notes are my way of offering homage to your admirable diligence.

This book also tilts toward social history; I "read" the works of art discussed here against the backdrop of southern social narrative. The scholarship of a cadre of savvy historians—including James C. Cobb, Edward L. Ayers, Pete Daniel, Charles Joyner, and Vernon Burton—has helped me to clarify and refine my interpretation. At the head of this group stands Peter Wood. As tough-minded and demanding as they come, he has also developed a deep interest in the influence that art has on the shaping of social values. He offered me his wide-ranging insights in

a lengthy written evaluation that was matched with a great sheaf of photocopied images. He even suggested an alternative title for one of my chapters. Because of his clever wordsmithing, Chapter 5 is now called "Mrs. Palmer's Cabin."

Throughout the writing process I was offered opportunities to try out my ideas in several public presentations. I would like to express my thanks to the Art Department and to the Visual Studies Group at George Washington University as well as to the English Department at Indiana State University for opportunities to speak about my research on southern art. Similarly, I have benefited from responses to papers on plantation paintings that I offered at the meetings of the American Folklore Society and the Collegium for African American Research. Such presentations energize one's writing; the discovery that the findings over which one mulls for so long in private actually *do* make sense to others is both reassuring and inspiring.

The 122 images that appear in this book were graciously provided by more than thirty different museums, libraries, archives, galleries, historic sites, and private collections. During the protracted process of gathering these illustrations, I have gotten to know a sizable group of directors, curators, conservators, rights managers, photographers, and registrars. Their various enthusiasms and expressions of interest were wonderful to hear. But to me, foremost among these figures who labor behind the scenes is Angela Mack of the Gibbes Museum of Art in Charleston, South Carolina. She shouldered the largest burden as she helped me procure the lion's share of the images that appear in this book.

At the University of North Carolina Press I have once more found myself in the company of competent and friendly handlers. My old editor David Perry encouraged the first inklings of a manuscript, and when he found himself loaded down with too many responsibilities, he did me the great favor of passing this book project on to Elaine Maisner. A strong advocate for *The Planter's Prospect*, she skillfully moved the manuscript through its revisions on to its final acceptance. Kathy Malin has clipped and shaped my prose, and designer Rich Hendel has created a handsome layout. Those who actually give form to books and save their authors from embarrassing grammatical errors are not appreciated enough.

Finally, this book is dedicated to my daughters Kate and Molly. For many years they remained generally indifferent as they watched their drudge of a father turn out his books. But now, as they move closer to the edge of adulthood, books seem to have more appeal. They will enjoy seeing their names at the start of this book and hopefully will be happy to show their friends what their father thinks of them.

The Planter's Prospect

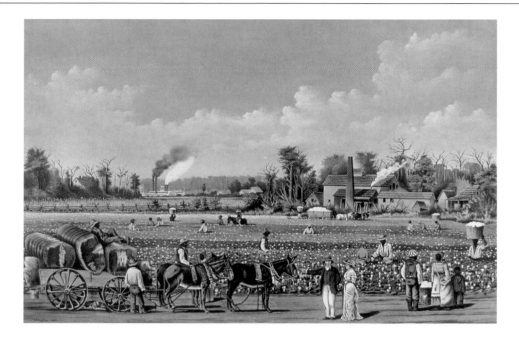

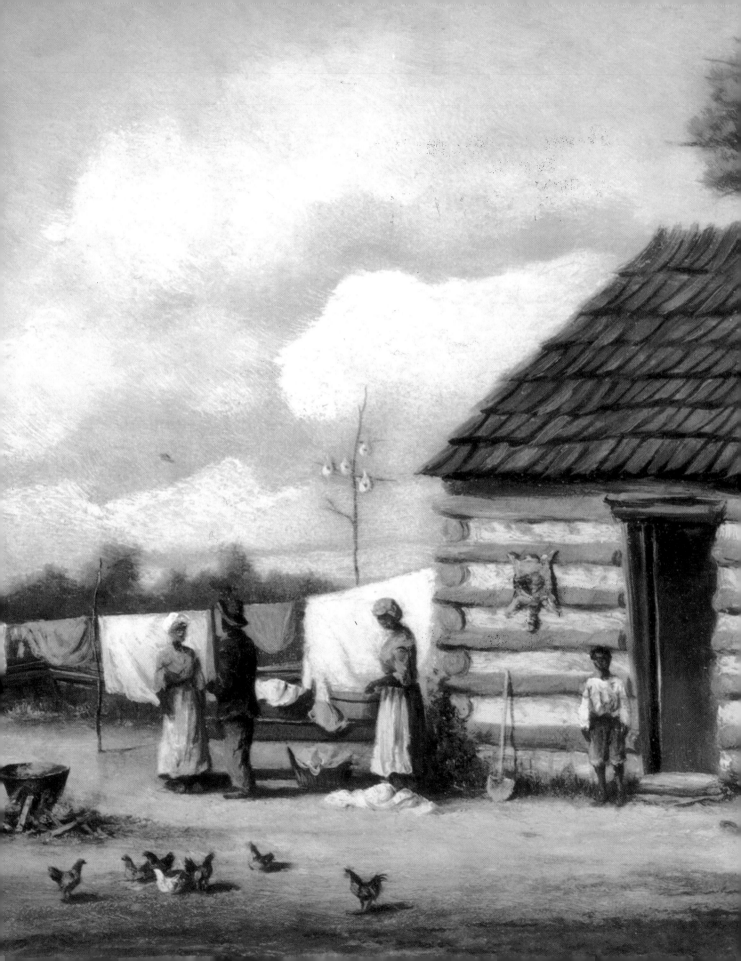

INTRODUCTION

When nineteenth-century artists painted plantation scenes, they usually began with preparatory sketches made while standing in front of a planter's house or somewhere slightly below it. From either position, their gaze—and that of anyone who looked at their paintings—was necessarily directed upwards. Viewing a plantation house from that perspective, one experienced a sense of the presumed authority of its owner. Since members of the planter class were certainly among the wealthiest Americans, they naturally assumed that they would be accorded a certain amount of deference. Or, to put it another way, they expected to be looked up to as superior individuals. When creating plantation vistas, painters tended not to observe the most common compositional rule for landscape painting: instead of painting the usual view, of a setting as seen from above, artists painting plantations rendered images as seen by an upturned face, one that implicitly signaled submission and respect.

In his book *The Magisterial Gaze*, Albert Boime explains that during the middle decades of the nineteenth century the central feature of American landscape painting was its consistent use of the view from a high place.[1] When painters rendered a scene from a lofty perch, they effectively took charge of all that their eyes might see. According to Boime, around 1830 the sight lines of most American landscapes fostered a feeling of mastery, a sensory goal that was fully consistent with the national policy of conquest and acquisition known as "Manifest Destiny." While preparing the essays that constitute this volume, I too became keenly aware of the statements of power encoded in plantation landscapes, of the superior position of the planter. But Boime's suggestions about the impact of a painter's stance are not enough to explain fully how artists conveyed the sense of authority when rendering the planter's prospect.

As important as position and gaze were the features of content that artists decided to highlight. Especially revealing of planters' concerns was the way in which slavery was depicted. Any successful plantation needed a reliable source of manpower, and southern planters secured the workers they needed by purchasing Africans, and later African Americans, who as the victims of chattel slavery would become laborers for life. Over the course of two and a half centuries, the enslaved population of the United States grew at a steady rate. The approximately 500,000

persons brought from Africa would increase eightfold; by 1860, almost 4 million captive blacks were counted in the federal census.[2] This sizable slave presence was not only an indicative feature of the American South but the definitive characteristic of a plantation.

Yet, prior to the Civil War, surprisingly few black figures appeared in plantation paintings. Art historian Hugh Honour reports that during the first half of the nineteenth century "the whole black presence was understated in paintings of the American scene."[3] Further, plantation vistas tended to omit most indications of agricultural labor. The exclusion of slaves from paintings of plantations was, like the choice of the view from below, a powerful tactic that artists used to suggest a planter's undisputed command over his estate. If there were no blacks to be seen in a plantation landscape, then white people, by default, would have to be recognized as the primary occupants. Images of rural estates that presented no black figures, or only a few, were intended to flatter planters and their families by offering them visual confirmation of their claims to power and authority. Given that the fortunes of slaveholders were in fact dependent on the efforts of a black majority—a population that on several noteworthy occasions opposed their captivity with acts of full-scale rebellion—members of the planter class were perpetually plagued with feelings of anxiety. It is thus understandable that they would commission images that focused solely on themselves, their families, and their buildings and spaces. The pervasive whiteness of an idealized planter's prospect offered, at least in symbolic terms, a reduction of the ominous black threat. By rendering slaveholding estates in a manner that either hid or diminished the presence of African Americans, those paintings functioned as documents of denial. Such paintings offered a soothing propaganda that both confirmed and justified the social dominance of the planter class.

The abolition of slavery in 1865 signaled the end of many plantations. On those estates that were able to remain in operation, owners found themselves forced to negotiate contracts with the very people over whom they had once exercised absolute dominion. Confronted with the new boldness of the black workforce, what these planters wished for most was a return to the old days, when their orders were followed without question or complaint. To a degree, these desires were realized, in images of plantation estates that inverted the older formula for plantation landscapes. When a plantation was viewed from its fields rather than from its front yard (as had been typical in antebellum depictions), the work performed by black field hands was necessarily highlighted. Viewed from the fields, the planter's house, if it appeared at all, was reduced to a diminutive presence in the distance. These images of toil, which focused on the labor of black tenants or sharecroppers, recalled an earlier time, when enslaved blacks had performed

these tasks. Postbellum paintings that presented large gangs completing their assigned tasks with only minimal supervision were functionally expressions of planters' longing. They supported a nostalgic vision in which black subservience, a key element of the old social order, was ostensibly restored. Intended more as symbolic evocations than as records of individual estates, these post-Emancipation paintings assumed all white southerners as their primary audience.

In the chapters that follow I focus expressly on paintings of plantation vistas, works best described as topographical images. More than renderings of scenery, these paintings were, for the most part, attempts at the faithful depiction of a specific, identifiable locality.[4] As such, they were visual records of a particular planter's house, along with its surrounding grounds, buildings, fields, and pastures. Although they were appreciated for their decorative qualities, up until the Civil War these paintings functioned chiefly as documentary celebrations of what was owned. Even in the postbellum period, when plantation paintings had a stronger nostalgic or symbolic function, most images still presented specific locations. While there are a number of paintings and drawings that focus on aspects of the daily life of the enslaved—works that could reasonably be considered in tandem with depictions of plantation landscapes—these images of daily routines are more accurately categorized as genre paintings.[5] As such, they fall outside the focus of my study.

Paintings by six relatively obscure artists stand at the center of this book. Generally unknown outside of the South, they are granted, at best, only a brief comment or two in the standard histories of American art. These six are, nevertheless, the only painters who produced enough plantation landscapes to constitute what might be called "bodies of work." Consequently, it is to their careers that one must turn when attempting an in-depth study of the aesthetic motives and social uses of plantation imagery. Collectively, they worked over a rather long period, from 1800 to 1935. Their importance lies in the fact that they documented plantations across the whole of the South, from Maryland to Louisiana, and did so over a period of time that witnessed a crucial social transition.

The six case studies of plantation imagery that form the core of this book are bracketed by two chapters that examine, first, the formal features of plantation paintings and, second, the social attitudes that influenced the way that southern audiences viewed those paintings. Chapter 1, "Plantation Images: The Contours of Practice," surveys the wide range of plantation images, including paintings, sketches, moving panoramas, newspaper and magazine illustrations, map decorations, ink drawings, watercolors, oil paintings, lithographs, and block prints. This sample reveals the broad outlines of general practice within which painters of topographical landscapes were operating. Some forty-one artists are examined,

a group that includes well-known figures such as Charles Willson Peale and Winslow Homer, considerably more obscure painters like Jane Peticolas and Henrietta Drayton, and some who still can be identified only as "Anonymous." Their images not only served as potential sources of inspiration for landscape painters but also stimulated an interest in the topic among diverse audiences.

In the concluding chapter, "Controlled with a Paintbrush: Black Figures in Plantation Paintings," I examine the social reception of plantation landscapes, by tracing parallel trajectories in both artistic and literary images. The descriptions of plantations found in novels and other commentaries appear to rouse sentiments similar to the feelings that artists were attempting to express with their brushes. The close links between written and visual expressions suggest that artistic production was shaped by a shared climate of opinion. Southern history has long been marked by profound tensions associated with the matters of race, privilege, and authority. These subjects were deeply embedded in plantation landscapes both before and after the Civil War, and they were guaranteed to provoke strong reactions in art patrons and other viewers.

In an insightful address on the formation of southern identity, offered in 1928, historian U. B. Phillips focused expressly on the question of race relations. Southern whites, he alleged, were so worried by the large black population with whom they shared their beloved region that their need to control them became the central theme of southern culture. He suggested that feelings of anxiety had impelled southerners of the antebellum period to defend the practice of slavery with "vigor and vehemence as a guarantee of white supremacy and civilization." Moreover, he added, although advocates of the southern way of life "did not always take pains to say that this is what they chiefly meant . . . it may nearly always be read between the lines, and their hearers and readers understood it without overt expression."[6] Had Phillips thought for a moment about the various illustrations that he must have encountered during his reading of old newspapers and journals, he certainly would have amended his statement to include visual as well as verbal expression. By providing reassuring visual propaganda regarding southern refinement and achievement, plantation images were an *overt* visual expression of presumed white virtue. Before the Civil War, flattering plantation landscapes reinforced the chief tenets of the proslavery argument. The paintings created after the war sanctioned ingrained racial hierarchies with reassuring portrayals that depicted the former era as one of certifiable white superiority. The aesthetic qualities of these paintings should not mask the social functions that they performed.

Historians have generally identified any agricultural holding operated with the labor of at least twenty slaves as a plantation. Although other significant criteria are also used to determine plantation status—the amount of acreage, type of commodity, and that a single crop was cultivated for export—the number of slaves held is considered as the most indicative trait. By this measure, in 1860, when the practice of chattel slavery had reached its highest level, there were some 46,274 plantations located all across the southern states.[1] Granting that a good many of these places would have looked, and more importantly would have been managed, like farms, the number of plantations conforming to the usual expectations either of great size or architectural splendor was closer to 5,000. But even if we count only those estates where the enslaved workforce numbered at least 100, we are still left with almost 2,300 plantations. These totals reveal that, whether we count all slaveholding properties or consider only those sites marked by certain signs of eminence, plantations were significant emblems of the region. Not only did visitors comment repeatedly upon them, but planter status became the social goal that many southerners longed to attain.[2] It is something of a surprise, then, to find that we have relatively few paintings of plantations. After surveying a wide range of media and formats—paintings, sketches, watercolors, map decorations, newspaper illustrations, prints—we find the total number of images is far less than the number of estates. In spite of the fact that plantations were representative of the South, it is clear they were not considered to be the most suitable subject matter for a painting.[3]

The dearth of plantation paintings can be explained in part by the general contours of the history of art in the United States. Landscape remained a secondary genre until the second quarter of the nineteenth century, when Thomas Cole's efforts to render the scenic beauty of the Catskills initiated the formation of the so-called Hudson River School.[4] One consequence of the relatively late development of landscape painting was that there was no ready American convention that might encourage the rendering of the earliest plantation estates. Further, the first efforts at landscape paintings were confined largely to the northeastern portions of the country, and thus the potential appeal of southern scenery was neglected.

Some of the earliest renderings of plantation estates are found in the backgrounds of portraits. Charles Willson Peale's paintings of Maryland's landed gentry offer several examples.[5] His group portrait of the Edward Lloyd family, done in 1771 and regarded as among the best of his early works, conveys the "striking impression of the self-confidence of the planters of Maryland's Eastern Shore."[6] This feeling is conveyed in part by the view of a country house, which appears just beyond Mr. Lloyd's right elbow. However, this building, meant to represent Lloyd's imposing residence in Talbot County, was actually a mansion that Peale had copied from Isaac Ware's book *Complete Body of Architecture* (1756). In subsequent planter portraits, however, Peale did include actual elements of the Maryland environment. In his 1788 portrait *William Smith and Grandson* (Figure 1.1), he softened the formality of the painting's classical trappings by including a depiction of Eutaw, Smith's estate in northern Baltimore County. Shown in the upper left corner are Smith's residence, a representative Chesapeake house outfitted with a wide front porch and flanked by two smaller outbuildings, along with views of his orchard and water-powered mill. Just three years later Peale included a scene of a wheat field as a background for his group portrait *Mr. and Mrs. James Gittings and Granddaughter*. That Gittings gained his wealth chiefly from the wheat raised at his Long Green plantation is conveyed not only by the sheaf of wheat that he holds in his hand but also by the presence of a slave gang busily engaged in the tasks of harvest. These glimpses of local landscape recall one of Peale's earlier efforts at rendering a panoramic vista of an estate. In 1775 he completed a painting for Charles Carroll of Mount Clare, his residence on the outskirts of Baltimore (Figure 1.2). Peale rendered Carroll's mansion in the distance, standing atop a low ridge, while Carroll himself and two associates are shown mounted on horses in the foreground.[7] Even though much of the scene is filled with fenced pastures, grazing livestock, a vineyard, and a set of greenhouses, the painting does not suggest that arduous work was performed at this estate. What one senses most are the leisurely pleasures that were regarded as the perquisites of a country squire. Mount Clare was, however, a very active work site. In addition to 800 acres of wheat fields and orchards, the plantation also featured a flour mill, a brick kiln, and a shipyard.

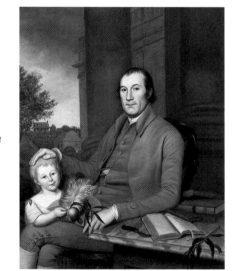

FIGURE 1.1.
Charles Willson Peale, William Smith and His Grandson *(1788). Oil on canvas. Collection of the Virginia Museum of Fine Arts, Richmond. Museum purchase with funds provided by The Robert G. Cabell III and Maude Morgan Campbell Foundation and The Arthur and Margaret Glasgow Fund. © Virginia Museum of Fine Arts.*

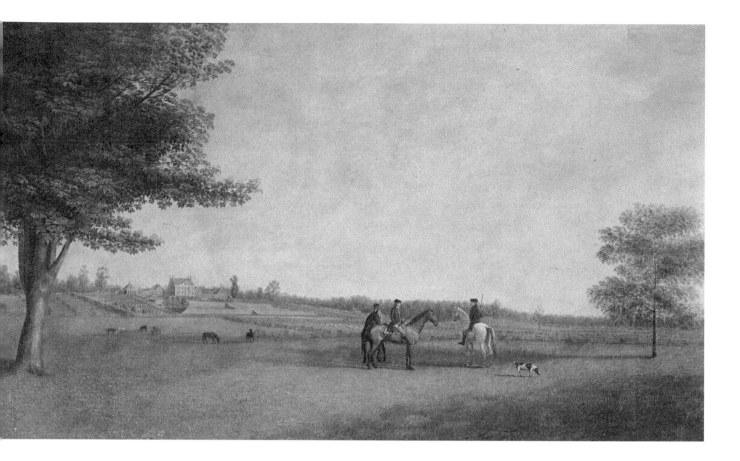

The connections that planters sensed between their personal identities and their homes effectively transformed a painting of one's house into something like a surrogate portrait. Planters' desires for personal likenesses easily expanded into requests for images of their plantations. Elias Ball II, master of several estates along the Cooper River in South Carolina, ardently wanted scenes of his properties, and he sought the help of his brother-in-law Henry Laurens, who was both a planter and a merchant with good connections for obtaining luxury items like paintings. In 1756 Laurens wrote to ship's captain Richard Shubrick in the hope of obtaining the requested canvases:

> Our brother Elias Ball who has lately finished & got into his new house is desirous of compleating the decorations within by adding two handsome Landscapes of Kensington & Hyde Park [two of Ball's five plantations] which will just fill up two vacancys over the Chimney pieces in the Hall and a large Parlour, & we must now beg the favour of you to procure such for him & and send them out by the first good opportunity. He would have handsome Views

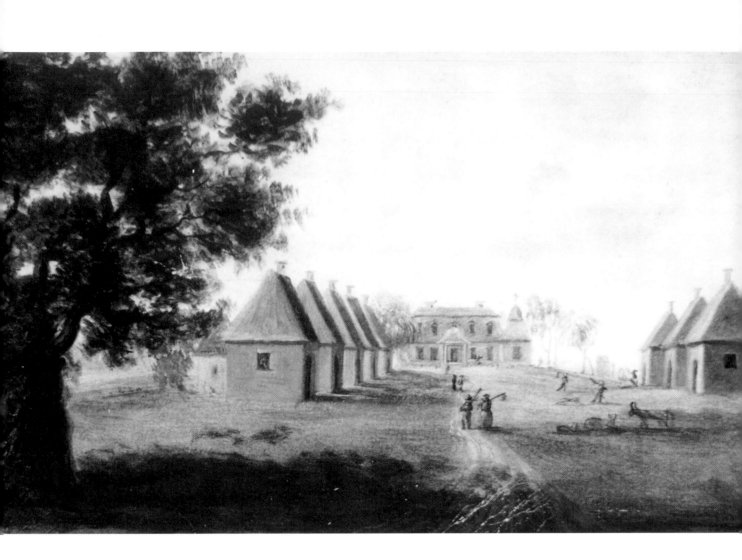

FIGURE I.3.
Thomas Coram,
View of Mulberry,
House and Street
*(ca. 1800). Oil on
paper. Gibbes Museum
of Art/Carolina Art
Association, Charles-
ton, South Carolina.
Museum purchase.*

of those two places with the adjacent Woods, Fields, & Buildings & some little addition of Herds, Huntsman, & ca., but not too expensive in the Painting.[8]

Even though there is no indication that Ball ever received these paintings, it is clear that he and Laurens fully understood that would-be gentlemen could confirm their social position by displaying images of their estates. Laurens's letter reveals that the British taste for topographical landscapes would soon arrive in America.[9]

Thomas Coram, a Charleston engraver, sensed a growing interest among Carolina planters for estate images. Learning of the popularity in England of books consisting of engraved views of the country estates, he hoped to produce the local equivalent of a book like William Watts's *The Seats of the Nobility and Gentry* (1782). He traveled to various plantations, producing a series of small, rough sketches, done in oil on paper. Intended only as preparatory works, these images

were the first stage in the creation of a book of engraved views. While no such book of plantation views was ever produced, Coram's paintings of Mulberry (Figure 1.3), Cockfield, and various estates along Goose Creek, all done circa 1795–1800, do have a distinctive charm.[10] The most important consequence of Coram's efforts was that they inspired his student Charles Fraser to paint a number of plantation vistas. However, when Fraser finally decided to make painting his full-time profession, he specialized chiefly in portrait miniatures (see Chapter 3).

Probably the most compelling view of a South Carolina plantation is a painting of Rose Hill, a rice estate located on the Combahee River (Figure 1.4 [Plate 1]). Although the artist remains unidentified and the year of execution is uncertain, it is safe to date this work to about 1820.[11] Since John Gibbes sold this property to Nathaniel Heyward sometime around 1810, it seems likely that it was Heyward who commissioned this image, as a way both to confirm and to celebrate his acquisition.[12] The painting presents a peaceful scene suggestive of success at every turn. The imposing house, located on the highest point above the river, stands, as a planter might, "surveying" the property. A broad lawn reaches down to the edge of a rice field where a few sheep and horses graze contentedly. That it is autumn might be sensed from the pink tinge in the sky, but more telling of the season to a planter are the large stacks of rice gathered next to the lawn where they wait to be threshed. The winnowing house raised up on stilts and the barn where the threshed rice will be stored stand at the ready. There is a sense of anticipation here as the last stage of production is about to commence. While a few slaves are shown walking across the yard, their movements do not compete with the view of the house and the harvested rice. The image thus focuses on the planter's achievement rather than the slaves' work and confirms Heyward's mastery over the land. This painting offers the sort of celebratory imagery that Elias Ball had sought some fifty years earlier. After more than half a century, laudatory estate views in the British tradition had finally reached South Carolina.

In Maryland it was British expatriate Francis Guy who provided plantation paintings, mainly for a number of Baltimore merchants who were eagerly transforming themselves into members of the planter class (see Chapter 2). Closely following models that seem to derive from William Birch's engravings of manor houses in suburban Philadelphia, Guy provided panoramic vistas that allowed him to include more of the agricultural components of his clients' holdings.[13] Beginning in 1798, for the next nineteen years Guy created many views of Baltimore and its surrounding countryside. But finding the market for estate paintings uneven, he moved on to New York in 1818, and he remains best known for his rendering of a Brooklyn street scene.

In 1851, during the last decade of slave-owning plantations, French architect-

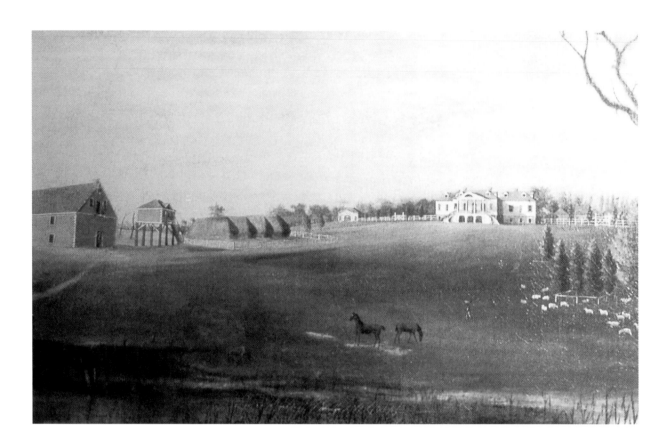

engineer Marie Adrien Persac arrived in Louisiana (see Chapter 4). A highly skilled draftsman, he eventually found work in New Orleans, first as a map illustrator and later as a painter of posters used to advertise the sale of houses. He also discovered that Louisiana planters wanted images of their houses. Precisely rendered with the exacting rigor one might expect of an architect, Persac's sensitively colored paintings were also works of considerable appeal. An intriguing fusion of the art of painting and the precision of engineering, his works suggest a sustained interest in topographical landscapes, at least among Louisiana planters.

Hunting scenes were a special subset of the British estate paintings; in these, the owner of a manor and his guests were shown on horseback, riding across the vast expanse of his property while in pursuit of game, usually a fox or a stag. This genre, like the topographical view, was also exported to America, although relatively few examples are known. One pair of hunting views by an unknown artist was commissioned by Bartholomew Truehart of Powhattan County, Virginia, circa 1800.[14] Entitled *The Start of the Hunt* and *The End of the Hunt*, they were the sort of images appropriate to hang on either side of a fireplace. One indication of a plantation context in these paintings is a slave dressed in livery, who was appar-

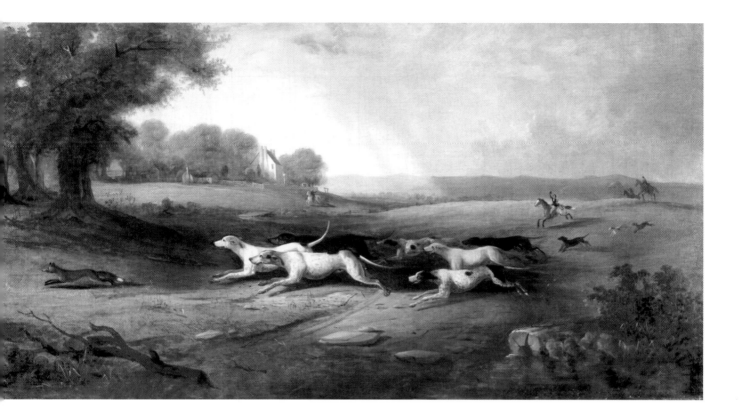

ently charged with keeping the hounds in order. In *End of the Hunt*, the artist also included the zigzag rail fences typical of the Virginia countryside and two small cabins, perhaps depictions of slave quarters. The continued popularity of depictions of the chase among Virginians is signaled by John J. Porter's *The Culpeper Hunt* (ca. 1858) (Figure 1.5). Rendered in a style very much in the tradition of British painter George Stubbs, the painting focuses primarily on a pack of hounds shown running down their prey.[15] The hunters, seen coming over the ridge in the background, barely manage to keep pace. Also included in this scene is a full ensemble of plantation buildings, including a large "big house," kitchen, stable, and a string of slave quarters.

By far the great majority of nineteenth-century plantation paintings were not landscapes but house portraits, images in which the more mundane elements such as fields, crops, livestock, and farming work were pushed beyond the margins of the picture. Jane Braddick Peticolas provides a representative example in her 1825 painting of Thomas Jefferson's Monticello (Figure 1.6). One of the few paintings ever made of this distinguished house, Peticolas's work rendered the building as seen from its garden, which enabled her to focus on the more private,

FIGURE 1.5.
John J. Porter,
The Culpeper Hunt
*(ca. 1858). Oil on
canvas. Courtesy
of The Charleston
Renaissance Gallery,
Robert M. Hicklin Jr.,
Inc., Charleston, South
Carolina.*

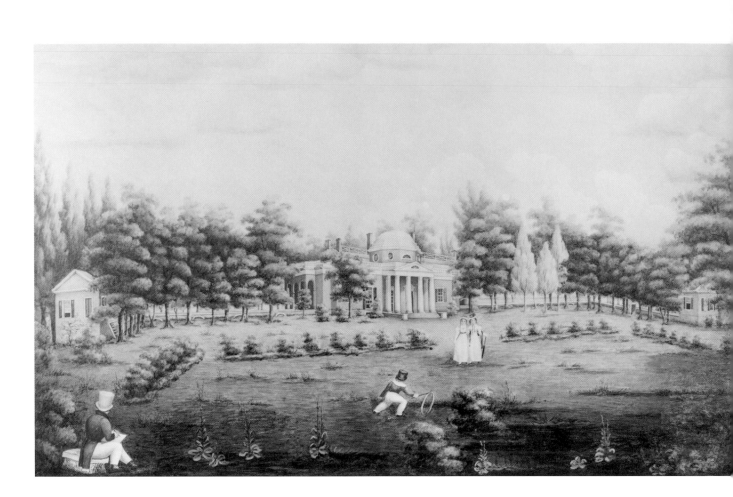

FIGURE 1.6.
Jane B. Peticolas,
View of the West
Front of Monticello
and Garden *(1825).*
Watercolor on paper.
Collection of Monti-
cello/Thomas Jefferson
Memorial Foundation,
Inc.

domestic face of the house. The long "arms" of the building's semi-subterranean wings reach out from the house to embrace the lawn and its beds of flowers. Presenting the building within a thicket of trees, Peticolas showed the house emerging from the tangle of branches. Thus she links Monticello not to history or to agricultural production but to nature, a perspective confirmed by a companion painting that offered a view looking down from the "little mountain" out across the pleasant Piedmont countryside toward the village of Charlottesville.[16]

A standard portrait format was used repeatedly in images of planters' mansions. A watercolor by Anthony St. John Baker presented Charles B. Calvert's Riversdale plantation in the formulaic manner of a portrait, that is, from the front but slightly to one side (Figure 1.7). Here in place of the conventional props and drapery that might surround a sitter, the house is framed by other equally conventional elements: trees and a lawn.[17] John G. Chapman's image of James Madison's Montpelier, which appeared just nine years later, employed the same conventions, except that the viewing point is far enough back from the mansion so

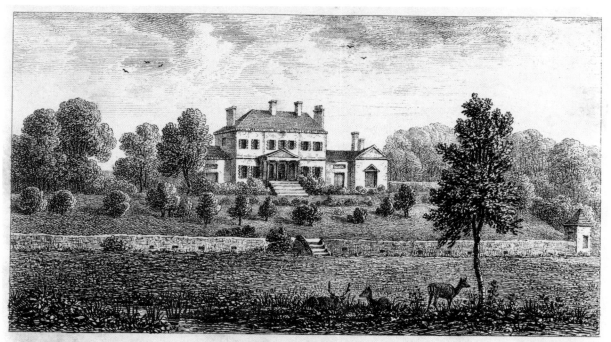

A. St. John Baker. del.t 1827.

RIVERSDALE near BLADENSBURG,
MARYLAND;
The Seat of George Calvert Esquire.

B. King ex. Transfer Lithograph.
11 Charlotte St. Rathbone Place.

FIGURE I.7.
Anthony St. John Baker, Riversdale near Bladensburg, Maryland *(1827). Lithograph from* Memoires d'un Voyageur *of a watercolor original. Reproduced by permission of The Huntington Library, San Marino, California.*

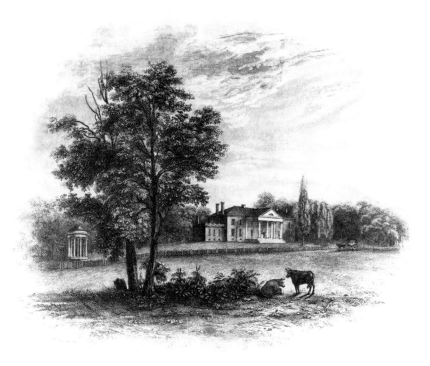

FIGURE I.8.
John G. Chapman, Montpelier, Va., the Seat of the Late James Madison *(ca. 1836). Lithograph. Library of Congress, Prints and Photographs Division.*

that more of the agricultural context can be indicated by the inclusion of two cows in the foreground (Figure 1.8). An 1844 lithograph of the Tayloe family's Mount Airy estate in Richmond County, Virginia, offers yet another frontal image of a mansion, but here the scale figures are a woman, young girl, and their pet dog, who are seen walking on the lawn (Figure 1.9). This mode of presentation became so entrenched that even an adventurous and gifted landscape artist like Frederic Edwin Church would not stray beyond the conventional limits of this format. In 1851, after a brief stay at Shirley plantation in Virginia, he created what he called a "slight sketch" of this prominent James River plantation as a gift to the family in thanks for their hospitality (Figure 1.10). His crisp drawing effectively captures many details of the house, but, like all the other images of plantations during this period, it presents nothing more than a large, pretentious house as seen three-quarters from the front.[18]

Images of George Washington's Mount Vernon provide a high-profile example of the common plantation formula. One of the first paintings of this presidential estate was completed in 1792 by an unknown artist (although sometimes it is attributed to Edward Savage). A charming but highly conventional picture, it showed Washington's house and many of its service buildings standing high above the Potomac River (Figure 1.11). Since Mount Vernon was a vast 5,000-acre hold-

FIGURE 1.9. *Anonymous,* Mount Airy, Richmond County, Va., Before the Fire of 1844, *(ca. 1850). Lithograph by Pendleton. Historic American Buildings Survey Collection, Library of Congress, Prints and Photographs Division.*

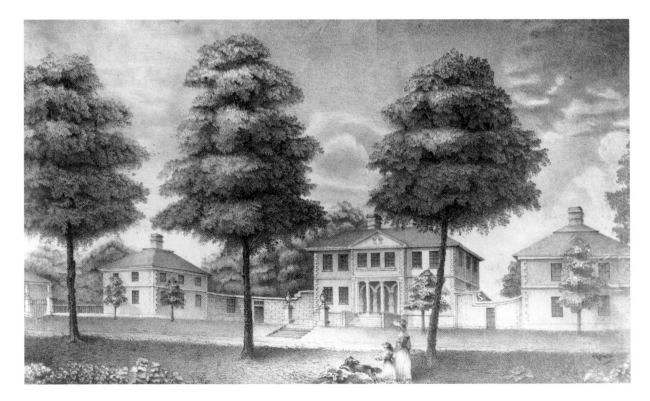

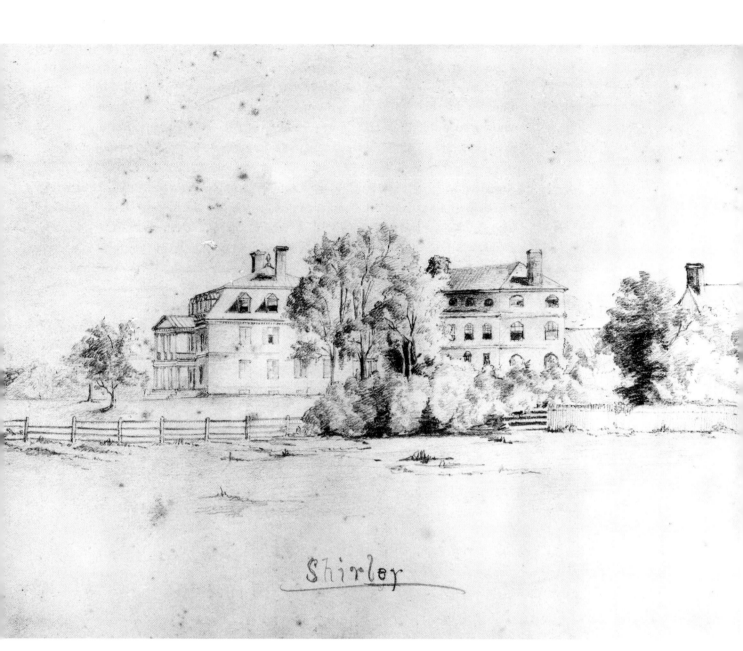

Shirley

ing comprised of five separate tracts, it was prudent for Savage to focus on the so-called "Mansion House Farm," where the famous hero's mansion was located. That the painter opted for the river vista rather than a view from across the front lawn is understandable. The river side, the so-called "East Front," was graced by a two-story piazza, a unique feature that set Washington's home apart from those of his contemporaries.[19] The East Front would become the preferred "face" of Mount Vernon; it was the view chosen in quick succession by William Strickland (1795),

FIGURE 1.10. *Frederic E. Church, Shirley (1851). Pencil on paper. Courtesy of the Carter Collection at the Colonial Williamsburg Foundation Library.*

Alexander Robinson (1799), and William Birch (1801).[20] In 1800, British engraver Francis Jukes transformed Robinson's watercolor painting into a widely circulated aquatint (Figure 1.12). Jukes's print would inspire various works, including a very large oil painting by George Ropes of Salem, Massachusetts, and numerous copies by amateurs eager to try their hands at landscape.[21] The wide public interest in images of Mount Vernon stems, of course, from the deep reserves of patriotic feeling inspired by Washington himself. Paintings of his home were not only tokens of respect but akin to acts of worship. Yet, even though paintings of Mount Vernon should be understood as elements of public-spirited ritual, it should not be overlooked that even though Washington was lionized as the "father of his country," he was also recognized as a wealthy planter. Treating Mount Vernon finally as a manor house, artists clearly sensed that it was best to render it three-quarters from the front. This conventional perspective allowed them to capture both the depth and breadth of this impressive building as well as a glimpse of the river that bends away in the background. Historians Robert and Lee Dalzell suggest that such a view is marked by a "commanding spaciousness commensurate with the character of the man whose house this was."[22]

That one conventional formula for an estate painting could be seen as an act of

FIGURE 1.11.
Anonymous (possibly Edward Savage), East Front of Mount Vernon *(ca. 1792). Oil on canvas. Courtesy of the Mount Vernon Ladies' Association.*

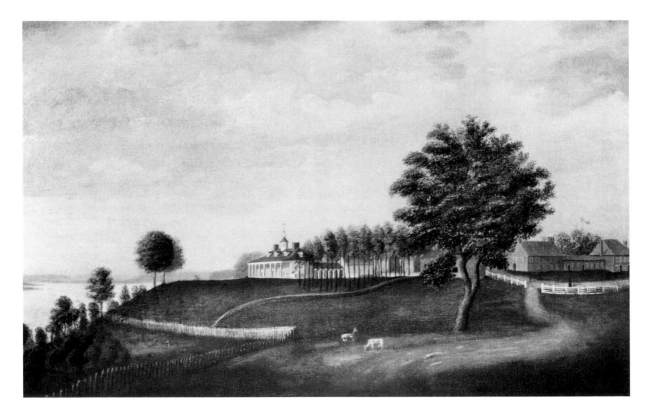

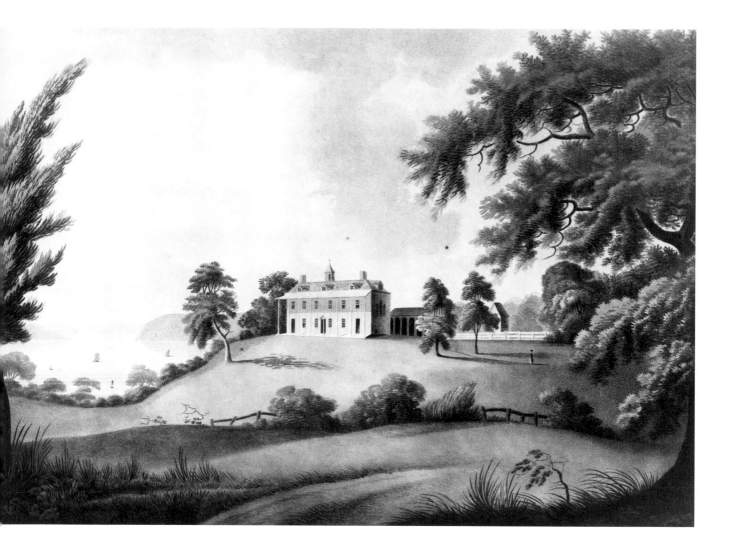

homage is clearly demonstrated when the usual image of Mount Vernon is contrasted with Eastman Johnson's painting *The Old Mount Vernon*, done in 1857 (Figure 1.13). Standing at the north end of the mansion, Johnson focused intently on the servant's hall, which from this perspective appears almost as large as Washington's house. His close-in view eliminates both the sense of being atop a high bluff and the majestic view of the river below. While the mansion is a prominent element in this painting, because Johnson has placed it both to the back and to the side, it is no longer the primary focus of attention. At the center of Johnson's image is an open doorway; a dark void that outlines the figure of a black person. Johnson chose to paint Mount Vernon in this unusual manner because he was most interested in the plantation's enslaved occupants. Eschewing the common conventions for rendering a plantation house, he chose to express his growing

FIGURE 1.12.
Francis Jukes,
Mount Vernon *(1800).*
Aquatint engraving
of a painting by
Alexander Robertson.
Library of Congress,
Prints and Photo-
graphs Division.

sympathy for the plight of African Americans held in bondage. These emerging sentiments would soon be expressed more forcefully in his most celebrated work, *Negro Life at the South* (1859).[23] Readying himself to undertake such a serious act of social revision, Johnson realized that he had to rethink the conventions of painterly practice. When he painted Mount Vernon, he dared to ignore the eminence of the estate's revered founder and moved deliberately toward the margins of the property.

Many nineteenth-century plantation views were painted by amateurs—some clearly gifted, most less so. Falling in the latter category was Christophe Colomb, a Haitian emigré who settled in Louisiana in 1785. Around 1800 he painted *White Hall Plantation*, a watercolor showing the estate of Marius Pon Bringier as seen from across the Mississippi River. Colomb, while dutiful in his efforts to record the key elements of the property, including the main house and four of its dependencies, nevertheless hid the mansion behind the trees along the levee. Further, because Colomb was intrigued most by the traffic on the river, the plantation serves mainly as a scenic backdrop, rather than as the subject of the painting.[24] Often it was the children of planters who attempted to paint a likeness of their family's estate. The results were generally recognizable, though awkward, images like those produced by William M. Hutson of Beaufort County, South Carolina. In 1860 he did paintings of Jericho plantation, where he lived, and of another nearby estate called Cedar Grove, both works that were seemingly devoted as much to the depiction of trees as they were to the houses.[25]

Watercolors attributed to Henrietta Augusta Drayton, on the other hand, reveal a considerable talent for landscape. Her romantically tinged paintings of Ashley Hall, the home of former South Carolina governor William Bull, were probably executed circa 1820, during a prolonged visit, for which the plantation elites of Carolina were famous. One of her views captured the house standing in a grove of trees as seen across an artificial lake and a large expanse of lawn. A second painting showed the house standing above the Ashley River. Since the estate was well known for its gardens, both images understandably highlight trees, flowers, and shrubbery. But even though her scenes were thickly forested, she still managed to make sure that the mansion and its two dependencies were clearly visible. In her riverside image (Figure 1.14) she centers on a monument raised in memory of the estate's founder, William Bull. This tall obelisk was deemed so important that in 1825 Robert Mills indicated this monument rather than the plantation house in his celebrated *Atlas of the State of South Carolina*. Clearly, Drayton thought carefully about both what elements to include in her paintings and how to insure that those features would have a strong visual impact. While not an artist by profession, she was certainly a capable painter of landscape.

FIGURE I.13.
Eastman Johnson,
The Old Mount
Vernon *(1857).*
Oil on canvas.
Courtesy of Fraunces
Tavern Museum,
New York City.

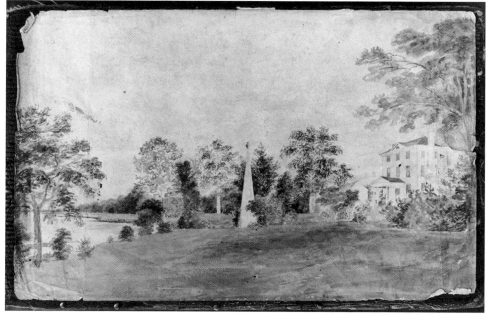

FIGURE I.14.
Henrietta Augusta Drayton, Ashley Hall *(ca. 1820). Watercolor on paper.*
Collection of the South Caroliniana Library, University of South Carolina, Columbia.

Generally the consequence of pride or admiration, most plantation paintings were not intended to serve as authoritative visual records. Because most artists tended to concentrate exclusively on an owner's house, almost all the elements vital to agricultural production were ignored. For a more creditable visual record, one must turn to the images left by surveyors, mapmakers, and architects. As the marsh lands lying along the rivers of South Carolina and Georgia were transformed into plantations, there was a crucial need for accurate maps.[26] No property owner would undertake the financial burden of installing levees, canals, and flood gates without first being sure that his "improvements" were fully within his own property. Joseph Purcell was a South Carolina surveyor who produced numerous plat maps that documented the size, extent, and location of many lowcountry plantations. One of them done about 1770 was decorated with a cartouche containing a detailed plantation scene (Figure 1.15). This view from a river shows the planter's house standing in its fenced yard and eight slave houses lined up in a row off to one side.[27] In 1773, when Henry Mouzon drew up a map of St. Stephen's Parish (in what was then Craven County), he included a detailed sketch of the steps involved in the production of indigo. In a single idealized scene, he included all the required steps, beginning with the harvesting of indigo plants and ending with the small cakes of blue dye ready for export.[28] Surveyor John McKinnon produced an intriguing watercolor panorama of Francis Levett's Julianton Plantation near Darien, Georgia, sometime before 1803. Because he was attempting to create a visual inventory of the property, he made sure to include every building. In addition to the "big house," McKinnon rendered six outbuildings, a stable, and a row of twenty-three slave cabins. The painting was, in effect, a spectacular bird's-eye-view map.

Benjamin Henry Latrobe, who for a time served as architect of the United State's Capitol, was a fine draftsman who regularly prepared presentation drawings to illustrate potential projects for prospective clients. He also had the habit of making detailed sketches in his daily journal. Included among his papers are ink and watercolor images of plantations that he encountered as he traveled through Virginia in 1796.[29] The properties he documented include Francis Eppes's plantation in Chesterfield County, known as Eppington; Green Spring near Jamestown; and George Washington's Mount Vernon. The following year Latrobe traveled to Airy Plain in New Kent County, Virginia. Falling ill during the visit, he convalesced at the plantation for about a month and thus had the opportunity to explore the estate in considerable detail. As a result he produced a detailed site map, indicating the location of the house, the slave quarters, and the mill, as well as a triptych of the house and its river vista. But his most engaging picture was a scene showing

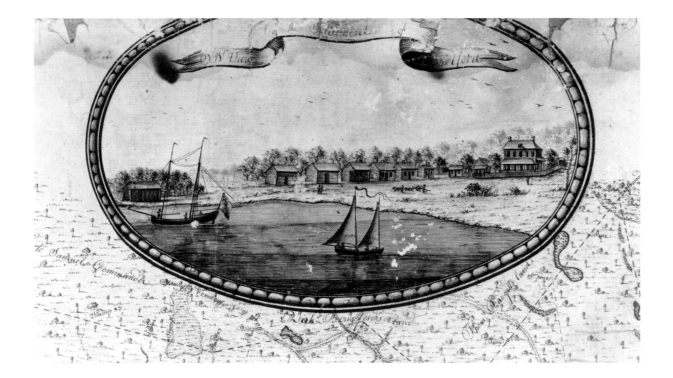

a group of slaves who have returned from fishing (Figure 1.16 [Plate 2]). Four black men standing at the water's edge are shown with their boat and seine net; the river's high bank looms over them and the plantation house can be glimpsed in the background. Unlike his other views, which focused exclusively on the planter's home, here Latrobe has captured the position of the enslaved—literally and politically, he rendered a view from below.[30]

Joseph Michel Paret served as the local priest to St. Charles Parish in Louisiana from 1848 to 1869. Like Latrobe, he too kept a diary that he supplemented with a number of watercolor sketches. What sets Paret's work apart from other would-be painters of local scenery was his ability to render convincing bird's-eye views of his surroundings. Assigned to a country church located just twenty miles upstream from New Orleans, he painted detailed views of many of the sugar estates owned by his parishioners. Particularly skilled at rendering buildings and grounds, he captured various estates with the precision that one would more readily expect of a mapmaker. Comparisons of his paintings with surviving plantations reveal the high degree of fidelity in his documentary efforts (Figure 1.17). Yet occasionally the human figures that he included were too large for their settings. Further, his perspective was at times awkwardly warped; passing steamboats look as if they are about to capsize, and trains appear to lie on their sides. An intriguing combination of accuracy and amateurism, Paret's images have recently been

FIGURE 1.15. *Joseph Purcell, SW View of the Settlement of Richard Berisford (ca. 1770). Pen-and-ink map decoration. Private collection. Photograph courtesy of The Charleston Museum, Charleston, South Carolina.*

hailed as "invaluable records of America's Creole heritage in the lower Mississippi River Valley."[31]

Basil Hall (1788–1844) became a professional traveler after serving for many years as a captain in the British navy. Having received the standard training in draftsmanship required of all military officers, he illustrated published accounts of his voyages to Asia and South America with numerous sketches.[32] In 1829, Hall authored *Travels in North America in the Years 1827 and 1828*, which was accompanied by a folio of forty drawings made with the aid of a camera lucida, a prismatic viewer attached by a fixed rod to a drawing board. One of these sketches, *Rice Fields in South Carolina*, presented the view from Nathaniel Heyward's rice plantation (Figure 1.18). Intrigued by the seemingly endless acres of rice as well as by the fact that the river appeared to run "backwards" during the periods of high tide, Hall sketched a scene of flooded paddies stretching off to a distant horizon. His *Swamp Plantation on the Banks of the Alatamaha* was a similar depiction of the

FIGURE 1.16. *Benjamin H. Latrobe,* View of the Fishing Shore on York River at Airy Plains, looking to the East *(1797). Pen-and-ink and watercolor on paper. Maryland Historical Society, Baltimore, Maryland. (Reproduced in color as Plate 2.)*

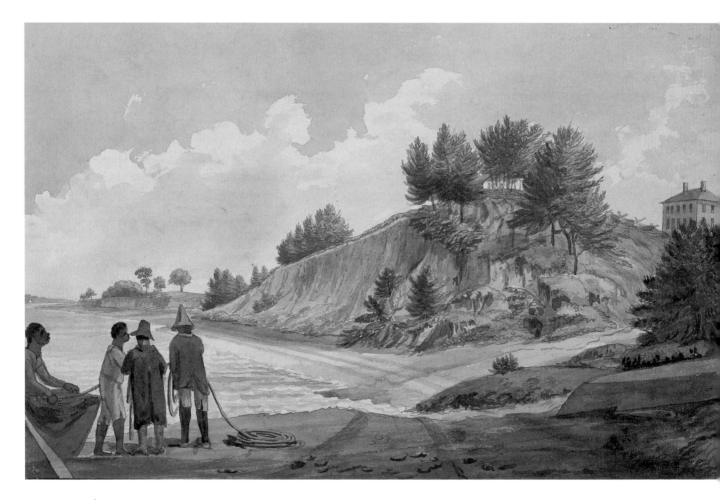

fields at Hopeton, an estate in Glynn County, Georgia, that belonged to James Hamilton Couper. Since the land at Hopeton was so flat, Hall apparently got himself, along with his drawing apparatus, onto the roof of the house in order to capture a comprehensive view of the fields, canals, levees, and slave houses.[33]

Plantation images that were done for documentary purposes focused most on farming. They stressed the fields and yards where work was performed rather than the planter's home. While the descriptive, pragmatic purposes of these images made them less celebratory than the paintings that planters commissioned to confirm their status as property owners, they are no less intriguing. The scenes that appear on maps, deeds, plats, and in journals and diaries reveal numerous useful facts about plantation life. Published views, like those by Hall, apparently satisfied the interested outsider's need to understand what went on at plantations, places that had an air of mystery because they were generally distant, self-contained communities. Hall's detailed glimpses served to pull back the curtain of secrecy. Margaret Hall, who had accompanied her husband on his North American trip, was terribly disappointed with coastal Georgia, observing in a letter to a

FIGURE 1.17.
Father Joseph Michel Paret, St. Charles, Louisiana *(1859). Watercolor on paper. Private collection. Photograph courtesy of The F. B. Kniffen Cultural Resources Lab, Louisiana State University, Baton Rouge, Louisiana.*

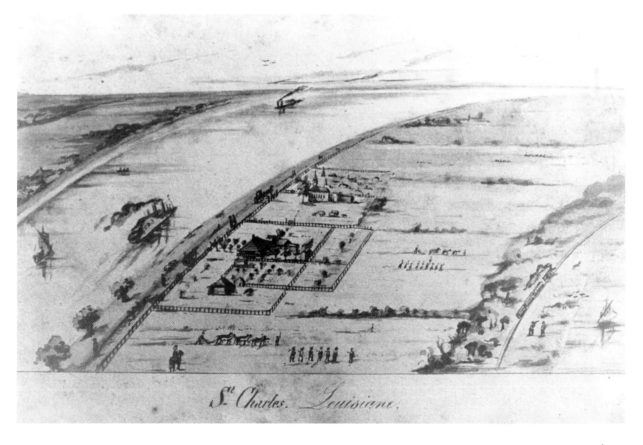

FIGURE I.18.

Basil Hall, Rice Fields
in South Carolina
*(1828). Illustration
for* Travels in North
America in the Year
1827 and 1828, 2 vols.
*(London: Simpkin
and Marshall, 1829).
Library of Congress,
Prints and Photo-
graphs Division.*

friend that the region possessed "no beauty whatever" and was merely a flat place filled with bothersome swamps.[34] Minus the negative feelings, that was exactly what Captain Hall rendered—flat marsh land. But he believed that whatever opinions he might hold, there was still a curious public eager to see what he had seen.

During the first decades of the nineteenth century, public demand for views of the United States was stimulated by a spate of illustrated travel books; notable among these were Isaac Weld's *Travels through the States of North America, and the Provinces of Upper and Lower Canada* (1798), John Melish's *Traveller's Directory* (1815), and Joshua Shaw's *U.S. Directory* (1822). Shaw also compiled *Picturesque Views of American Scenery* (1820–21), a folio of landscape images painted by British artists. The majority of Shaw's illustrations were romantically rendered depictions of southern sites; places like the Natural Bridge of Virginia, Spirit Creek near Augusta, and the Great Falls of the Potomac. He included no scenes of plantations. After decades of wasteful farming practices, the region's agricultural vistas apparently held little appeal for landscape artists. As early as 1813, Virginian John Taylor fumed publicly that plantation-style cultivation had exhausted the soil. "Let us boldly face the fact," he wrote, "that our country is nearly ruined."[35] Two decades later circumstances were not much improved; a correspondent for a Richmond newspaper traveling through the middle counties of Virginia in 1833 observed that the "whole face of the country presented a scene of desolation that baffles description—farm after farm had been worn out, and washed and gullied, so that scarcely an acre could be found in a place fit for cultivation."[36] It is not too hard to understand why painters who were searching for beautiful scenery would

not stop to paint plantations. Yet, given that slave-owning estates had become so emblematic of the South, there was still considerable interest in them.

This interest was demonstrated during the 1840s and 1850s by plantation images that were featured in several "moving panoramas" of the Mississippi River. These colossal works were painted on huge rolls of canvas claimed to measure 12 feet high and more than 3,000 feet long. One artist claimed that his panorama was four miles long.[37] Mounted on large spools, these paintings were slowly scrolled before an audience; the gradual horizontal motion was intended to re-create the sense of traveling downriver on a steamboat.[38] Audiences were asked to imagine themselves sitting on deck as they watched scenes on an imaginary shore glide by. Beginning at the Falls of Saint Anthony in Minnesota and ending up in the Gulf of Mexico, John Banvard's "trip" took place over three consecutive nights.

Banvard completed his panorama in 1846, and it was seen by huge audiences all over the United States and in Europe. His much-touted success inspired John Rowson Smith to complete his own Mississippi panorama in 1849. Henry Lewis would likewise attempt to capitalize on the popularity of this form of painting in 1857, when he completed both a panorama and a book containing a selection of eighty views that appeared on his enormous canvas.[39] Panoramas were actually composed of individual scenes measuring between 30 and 36 feet in length (roughly the width of a theatrical stage). The segment of Banvard's famous panorama that covered the portion of the river south of St. Louis included thirty-nine images. One of those pictures still exists as a small oil painting entitled *Mississippi River Plantation Scene*, which shows a modest planter's house and a bit of a wood pile at the river's edge (Figure 1.19). The Spanish moss drooping from the trees and two slaves dancing to the strains of a banjo tune serve as the key signs that the image depicts the southern end of the river. That Smith was more rigorous in his representations of southern scenery is indicated in his program notes, where he offers detailed comments on aspects of plantation agriculture. Nevertheless, his view of Zachary Taylor's Cypress Grove plantation, which was published in *Graham's Magazine* in 1849, shows a rather nondescript group of buildings gathered on the distant shore. Henry Lewis included three plantations in his panorama; he repeated Taylor's plantation and provided generic versions of two others. His view of Taylor's estate is appealing mainly because of the fisherman who stands next to his boat in the foreground. Lewis's cotton plantation was a highly improvised composition, containing features that suggest the scene was based more on his imagination than on his actual travel experiences (Figure 1.20). As works of art, the plantation scenes contained in these various panoramas were innocuous, even forgettable, works. Moving panoramas were, in form and function, more stage entertainments than paintings. The narrated movie travelogues

FIGURE 1.19.
John Banvard,
Mississippi River
Plantation Scene
(ca. 1850). Oil on
canvas. Minnesota
Historical Society,
St. Paul.

of their day, they were theatrical devices used to create the illusion of effortless travel. While the creators of panoramas were not championing the aesthetic virtues of plantations, common sense required that such sites be included. Displayed in all the major American cities (Banvard's painting was shown for sixteen consecutive months in New York alone), panoramas helped to insure that plantations would occupy a special niche in the popular imagination as an important symbol of the South. During the period when academically trained artists largely turned their backs on the South, popular forms of entertainment like panoramas and minstrel shows kept elements of plantation life before a large and receptive national audience.[40]

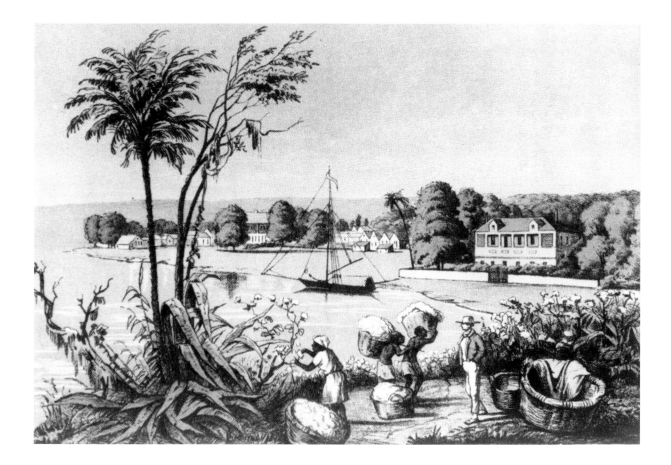

FIGURE 1.20.
Henry Lewis, Cotton
Plantation *(1856).*
Colored lithograph.
Illustration for Das
Illustrite Mississip-
pithal. *Library of
Congress, Rare Books.*

ROMANTIC INCLINATIONS

The singular voice among nineteenth-century artists raised on behalf of the scenic virtues of the South belonged to T. Addison Richards. Born in England in 1820 and raised in Hudson, New York, he moved with his family to Penfield, Georgia, sometime before 1838. An "adopted son" of the South, he quickly became the region's chief artistic advocate.[41] In 1841 he and his brother William published *Georgia Illustrated in a Series of Views*, a collection of engravings of Addison's sketches paired with brief commentaries. The book was intended to supplement and extend the images found in Shaw's earlier folio, *Picturesque America*. In the book's introduction, William Richards claimed that southern vistas offered exciting inspiration that would rival the charms of the Hudson Valley: "The scenery of Georgia is not less beautiful and attractive than that of other sections of the union; nor indeed, are there wanting natural objects, which may vie in interest, with any that our vast country presents to the eye of the tourist."[42] Even though T. Addison Richards moved back to New York in 1844 and lived in Manhattan for the rest of his life, he never abandoned his passion for the South. In an article published in

Harper's New Monthly Magazine in 1853, entitled "The Landscape of the South," he repeated his earlier challenge to the New York establishment, which had become so thoroughly enraptured with the Catskills. Contrasting the North and South mountain for mountain, waterfall for waterfall, and river for river, he claimed that there were experiences to be encountered in the South that could not be found elsewhere. Invoking the same tone employed earlier by his brother, he wrote of the South: "she has the loveliest of valleys, composed and framed like the dream of the painter. . . . Above her are skies soft and glowing in the genial warmth of summer suns, and beneath lie mysterious caverns, whose secrets are still unread." As if these attractions were not enough, Richards added that plantations provided yet another source of inspiration. In order to foreclose any argument that scenes of rice cultivation such as those published by Hall might have little aesthetic appeal, he wrote that flat fields threw "the whole burden of interest upon the dreamy atmosphere and the luxuriant vegetation, and well, too, do they sustain it."[43]

Richards's romanticism is evident in both his landscapes and his prose. He read the scenic virtues of the natural landscape as indications of the potential for a "higher and nobler civilization" and considered nature as a morally redemptive force. This position was well expressed in his essay "The Rice Lands of the South," published in 1859.[44] An encyclopedic account of rice cultivation that examined in great detail all the stages of production, the article was accompanied by eighteen illustrations, divided equally between views of scenery and depictions of various plantation tasks and settings (Figure 1.21). That Richards so thoroughly fused images of slave labor with portrayals of "arboreous beauty" indicates that he was looking for a way to distance himself from the ongoing debates over slavery. In a painting that is now called *River Plantation* (1859), Richards effectively uses the beauty of the setting to deflect attention from the brutality of the slavery system (Figure 1.22 [Plate 3]). A magnificent oak tree shown overhanging a river bank dominates the painting. A black man guides three horses into the foreground as four other small black figures trail off into the distance. Deep in the shadows one can just make out the suggestion of the columned facade of a planter's house, an indication that the unsupervised black figures in the painting are, in fact, slaves. Here nature acts as a curtain that shields the plantation from all but the most prying eyes. That Richards may have initially entitled this painting *A Water Oak in South Carolina*, when it was first shown along with six other renderings of southern scenery at the National Academy of Design in 1859, is telling.[45] Reluctant to paint subjects that might open his adopted homeland to harsh judgments, Richards chose instead to create appealing images that would further his advocacy on behalf of the virtues of the South. To do this, he found it prudent to wrap his depiction of a plantation setting in the verdant cloak of nature.

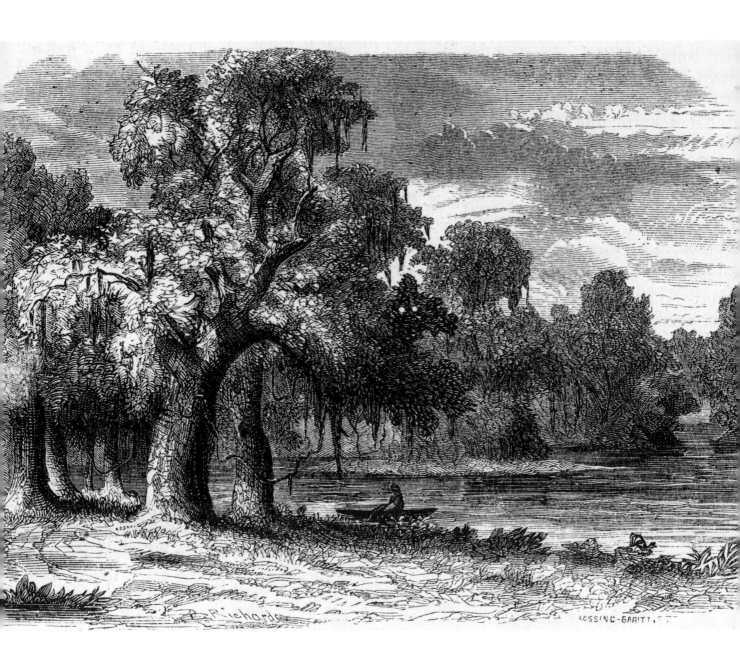

Other mid-nineteenth-century painters who were similarly drawn to romantic or idealized imagery also rendered plantation scenes that emphasized natural beauty over human enterprise. Cannon's Point plantation, located at the northern end of St. Simon's Island, Georgia, was painted circa 1850 by John Lord Couper, grandson of the estate's founder (Figure 1.23). An example of the commonest sort of plantation portrait, showing just the house and its immediate grounds, Couper lavished extraordinary attention on the trees and shrubs that surrounded the house. This was altogether appropriate, given that the Coupers were well-known

FIGURE I.21.
T. Addison Richards,
Lowland River Scene
*(1853). Illustration
for "Landscape of the
South" in* Harper's
New Monthly
Magazine 6 *(1853).*
Library of Congress.

for their experiments with exotic plants, including olive trees, mulberry trees for silk, and grape vines. Aaron Burr, who visited the estate in 1804, wrote approvingly about the presence of oranges, figs, pomegranates, melons, and peaches.[46] It is not surprising, then, to see so many different species of plants depicted in the yard, even date palms that were imported from Persia.[47] But because Couper focused so much on flora, the painting suggests not a plantation but a garden occupied by a rather unassuming house.

After a visit to Washington, D.C., in 1838, W. T. Russell Smith, a Philadelphia artist best known for his painted theater curtains, produced several drawings of Mount Vernon. The following year he transformed one of them into a painting of this venerable plantation house (Figure 1.24).[48] Concentrating on the natural features of the setting, Smith emphasized most the shifting sky and the long shadows that the surrounding trees cast upon the house. In the foreground, not only do tenacious vines overtake a low brick wall, but they threaten as well to dislodge one of the gate posts. These first signs of ruination were not, however, meant as tokens of decay; rather they were commonplace romantic devices used to indicate a

FIGURE 1.22.
T. Addison Richards,
River Plantation
(ca. 1855–60).
Oil on canvas.
Morris Museum of Art,
Augusta, Georgia.
(Reproduced in color
as Plate 3.)

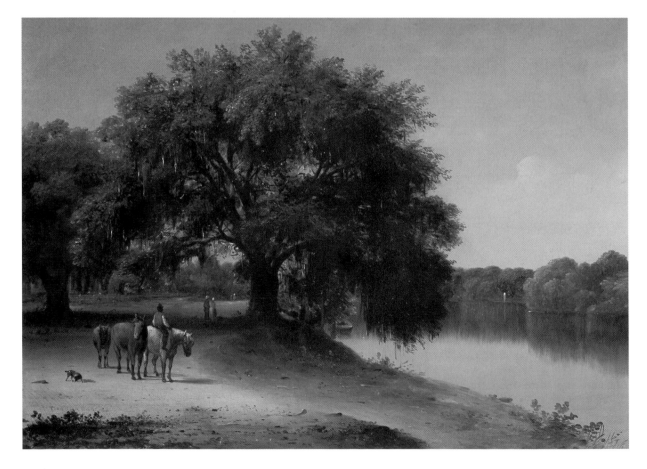

union of Washington's ideals with the higher laws of nature. Of course, by this time Washington's quasi-divine status was already well established in the public mind by numerous monuments as well as by works of literature and art.

Other images sought to make Washington a more approachable figure. A painting by Junius Brutus Stearns, *Washington as a Farmer, at Mount Vernon*, shows the famous general and former president out inspecting his fields (Figure 1.25). Presented in a relatively casual moment, Washington converses with an overseer, while several slaves are shown diligently gathering in the wheat harvest. Washington displays his authority by dispensing advice that we assume will be followed. Yet, his slaves seem not to pay him even the slightest bit of attention; the two who are closest to him even stop for a drink of water. Washington seems a fair and generous master, and slavery appears to be a benign practice, a position that the artist emphasizes by including in the foreground two children at play. Stearns's vision of bondage was one that many southerners defended.[49] Romantic

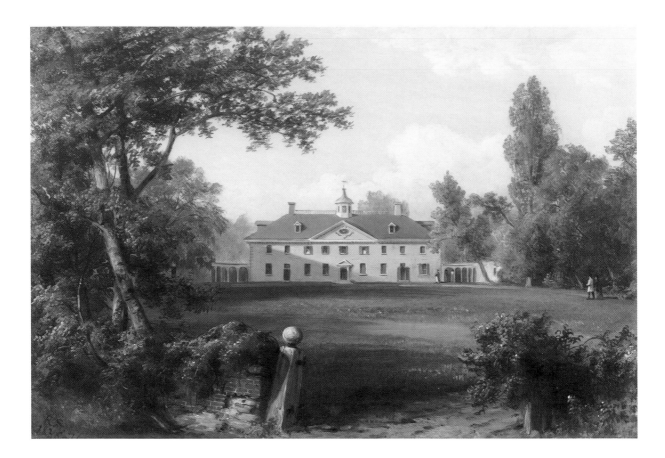

FIGURE 1.24.
*William Thompson
Russell Smith,* Mount
Vernon *(ca. 1839).*
Oil on canvas.
*Morris Museum of Art,
Augusta, Georgia.*

idealization provided artists like Richards, Couper, and Stearns with the means to lift plantations above the storms of divisive public debate that swirled persistently around the issue of slavery.

POSTWAR EFFORTS

In the aftermath of the Civil War, plantation images were largely documentary works, as artists rendered images either of ruin or remembrance.[50] In 1869 Edward Lamson Henry returned to a pencil drawing that he had made while serving as a Union army clerk during Grant's 1864 campaign against Richmond. Working from this rough sketch, he created a meticulous painting that he called *Old Westover Mansion,* a scene presenting not the glory of the plantation but its conquest (Figure 1.26 [Plate 4]). In Henry's image, invading Yankees have taken over: they muster into formation in the yard, send semaphore signals from the roof, and pitch their tents on the lawn. One wing of the house is nothing more than a burned-out shell, the fence has been knocked down, and a gatepost blasted into splinters. While Henry shows that the old regime has certainly passed, one also senses that a certain strength remains in the core of the house; perhaps a signal by

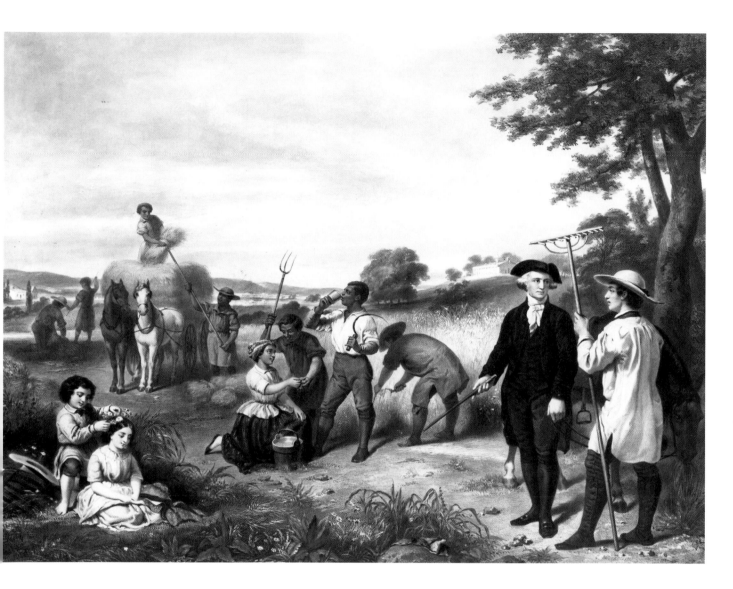

this Charleston-born artist that the South might rise again to its former glory. In George David Coulon's *Ruins of a Louisiana Plantation* (ca. 1885) the sense of loss is more acute. In Coulon's painting a wreckage of house stands alone in a field, shorn of roof, windows, doors, and veranda. There are no signs of life; there would be no recovery here. By far the most readily accessible scenes of postwar southern life were those produced by the New York lithography firm of Currier & Ives, which followed its numerous editions of Civil War battle prints with two dramatic scenes by Frances Palmer (see Chapter 5). She rendered two sets of plantation landscapes that showed old estates both before and after their destruction in the war.

These widely distributed images of defeat and loss were balanced by reassuring

FIGURE 1.25.
Junius Brutus Stearns, Washington as a Farmer, at Mt. Vernon *(1851). Hand-colored lithograph by Regnier (ca. 1853). Library of Congress, Prints and Photographs Division.*

paintings that suggested a more tranquil mood. In 1879 New Orleans artist Charles Giroux rendered a peaceful view of a bayou scene entitled *Golden Twilight in Louisiana*, an image of an isolated agricultural settlement occupied by black figures (Figure 1.27). In another of Giroux's paintings, *Cotton Plantation*, he uses the same arrangement as the bayou painting and presents similar buildings and fences while showing black families on their way to a long day of work (Figure 1.28). The main difference between the two pictures is that the right half of the second painting is occupied by a cotton field instead of a placid bayou. Giroux, who between 1872 and 1881 was listed in the New Orleans city directory as a cotton broker, certainly knew the plantation landscape quite well. He apparently focused on what for him was a familiar and appealing subject as he prepared to make painting his eventual full-time career.[51]

During the second half of the nineteenth century the great majority of planta-

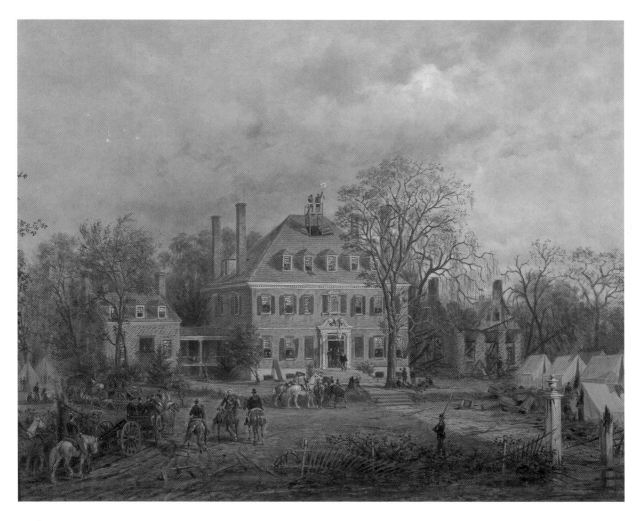

FIGURE 1.26. *Edward Lamson Henry,* Old Westover Mansion *(1869). Oil on panel. Collection of the Corcoran Gallery of Art, Washington, D.C. Gift of the American Art Association. (Reproduced in color as Plate 4.)*

tion images appeared in newspapers and magazines. Some of the earliest of these pictures were, without a doubt, the products of overheated imaginations. For example, the view of an alleged Louisiana sugar plantation offered to the readers of *Gleason's Pictorial Drawing-Room Companion* in 1852 showed a fanciful house, one more likely to be found in the Italian countryside than along the shores of the Mississippi (Figure 1.29). That the artist had never seen a Louisiana plantation was indicated further by the fact that the house was positioned right at the edge of the river. Since seasonal floods could raise the Mississippi River as much as forty feet, no planter would have dared to site his house in such a precarious position. Subsequent issues of this Boston-based journal (later renamed *Ballou's Pictorial*) provided images that were far more credible. The edition published on June 5, 1858, led with a report of "The Crevasse at Mr. Bell's Plantation," a tale of catastrophe caused by a major levee break just four miles north of New Orleans. The accom-

FIGURE 1.29. *Anonymous,* A Planter's House and Sugar Plantation, On The Mississippi River *(1852). Wood engraving in* Gleason's Pictorial Drawing-Room Companion. *Library of Congress, Prints and Photographs Division.*

panying image showed not only a representative plantation house in water up to its window sills but a flotilla of pile drivers gathered at the site of the break as they try to turn back the massive torrent.

Most Americans living outside of the South knew very little of the region, but with the coming of the Civil War they found their interests whetted by descriptions of various locales that sometimes accompanied reports from the battlefront. C. E. H. Bonwill, while following the Union forces in 1864 on their campaign through the Teche region of Louisiana for *Frank Leslie's Illustrated Newspaper*, provided a juicy bit of travelogue when he stumbled upon Oak Lawn plantation.[52] Intrigued that the owner, a Mrs. Porter, was a northern woman who spent her summers in Rhode Island, he wrote up a description and provided nine very detailed sketches of the property. These were printed broadside-fashion across a full page with two panoramic vistas of the property surrounded by smaller images that showed the gate and porter's lodge, hospital, church, sugar mill, saw mill, overseer's house, and finally the Greek Revival mansion (Figure 1.30).[53]

Stories detailing various aspects of southern life, particularly accounts of agricultural practices, were published in northern newspapers well after the war was over. *Frank Leslie's* ran a full page of illustrations of a rice plantation on the Cape Fear River of North Carolina in 1866; a similar set of images of a Georgia rice plantation appeared in *Harper's Weekly* the following year. *Harper's* employed Alfred R. Waud as its "special artist" commissioned to record the South.[54] Sent to Kentucky, Tennessee, Louisiana, and elsewhere to record postwar conditions, Waud found that he was drawn repeatedly to plantations. He rendered several authoritative views of the cotton lands of Alabama, but his most compelling image was *The Sugar Harvest in Louisiana*, which appeared in *Harper's* in 1875 (Figure 1.31). Here Waud presented a plantation at the peak of its operations. The sugar refinery, running full blast, sends thick black columns of smoke into a cloud-filled sky as a gang of cutters armed with machetes works its way across the fields, fields filled with cane twice as tall as any man. In the center of the picture, the owner on horseback with his back to the viewer surveys the action. What Waud captured here is the sense of urgency reported by sugar workers and managers alike. Since the period between the full maturation of the cane and the first killing frost could be relatively brief, the harvest was a particularly arduous period when workers had to be in the fields as many as sixteen to twenty hours a day.[55]

Not to be outdone by its competitors, *Scribner's Monthly* also ran several series of illustrated articles on the South. One of them, an account of rice cultivation in South Carolina, featured images by J. Wells Champney. Repeating elements covered in earlier stories, Champney presented views of rice fields, slave quarters (now transformed into "Negro Cabins"), a rice barge being unloaded, and a win-

FIGURE I.30.
C. E. H. Bonwill,
Oak Lawn, Plantation
of Mrs. Porter, On
the Teche, La. *(1864).*
Wood engraving for
Frank Leslie's Illus-
trated Newspaper.
Library of Congress,
Micro-forms Division.

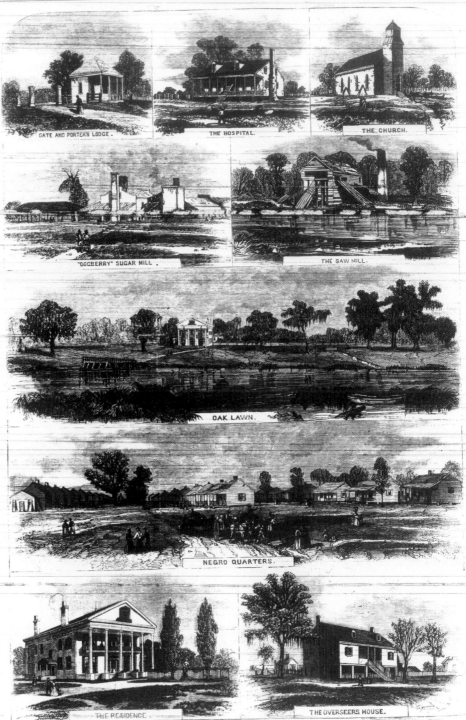

GATE AND PORTER'S LODGE. THE HOSPITAL. THE CHURCH.

"DOGBERRY" SUGAR MILL. THE SAW MILL.

OAK LAWN.

NEGRO QUARTERS.

THE RESIDENCE. THE OVERSEERS HOUSE.

OAK LAWN, PLANTATION OF MRS. PORTER, ON THE TECHE, LA.—FROM SKETCHES BY OUR SPECIAL ARTIST, C. E. H. BONWILL.

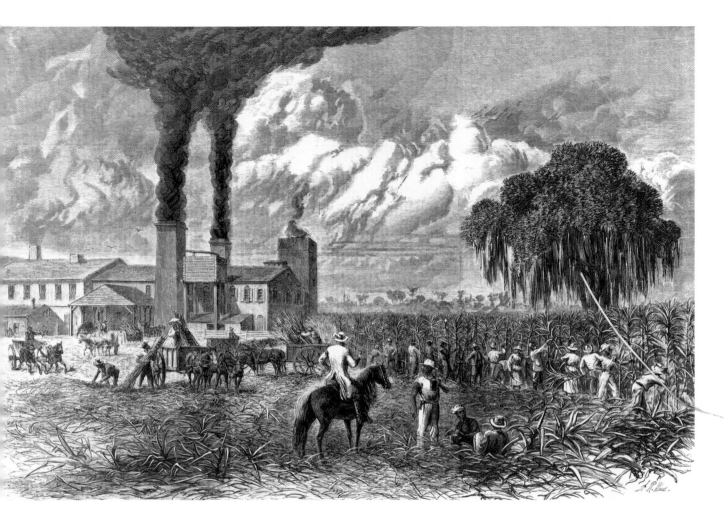

FIGURE I.3I.
A. R. Waud, The
Sugar Harvest in
Louisiana (1875).
Wood engraving for
Harper's Weekly
Magazine. Library of
Congress, Prints and
Photographs Division.

nowing platform. Collectively, all these images, but especially those by Waud, provided the reading public with a detailed understanding of key aspects of plantation experience. Certainly they were shown that plantations were places dependent on the labor of black people. They also might have realized that, despite owner's claims to the contrary, plantations were places that had been created and maintained by blacks.

Magazine images brought field hands forward and into view, a trend that was pursued even more forcefully by Winslow Homer. Assigned by *Harper's* to follow the Army of the Potomac during the Civil War, Homer produced a number of memorable camp scenes that included sensitive portrayals of black subjects. At the war's end, he painted *Near Andersonville* (1866), which showed a young black woman standing in front of her cabin. She looks pensively into the distance, perhaps trying to imagine her future, as a corps of captured Union soldiers is marched past her house on the way to their internment in the notorious Andersonville

prison camp. Homer, always somewhat circumspect about voicing his opinions, does not signal here what the black woman's fate might be, but by arranging the view from her side of the fence, from within her space looking out, he makes it clear where his allegiances lie. Two other scenes set inside former slave cabins, *A Visit from the Old Mistress* (1876) and *Sunday Morning in Virginia* (1877), reveal that his connection with and commitment to black concerns had intensified. The first of these paintings revisited the moment when liberation was first announced, and the second presents early efforts by African Americans at self-empowerment through literacy and education. To show what had become of the plantation system during the period of Reconstruction, Homer painted two black women working in a cotton field (Figure 1.32 [Plate 5]). Of this painting, *The Cotton Pickers* (1876), Peter H. Wood and Karen C. C. Dalton write:

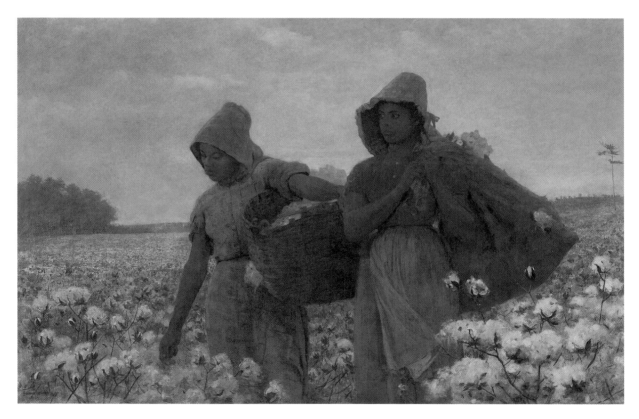

FIGURE 1.32.
Winslow Homer, The Cotton Pickers *(1876). Oil on canvas. Los Angeles County Museum of Art, Acquisition made possible through museum trustees: Robert O. Anderson, R. Stanton Avery, B. Gerald Cantor, Edward W. Carter, Justin Dart, Charles E. Ducommon, Camilla Chandler Frost, Julian Ganz Jr., Dr. Armand Hammer, Harry Lenart, Dr. Franklin D. Murphy, Mrs. Joan Palevsky, Richard E. Sherwood, Maynard J. Toll, and Hal B. Wallis. Photograph © 2001 Museum Associates/LACMA. (Reproduced in color as Plate 5.)*

Two statuesque young women stand isolated in a vast cotton field, silhouetted against an expanse of white-topped plants and silvery sky. Cropped below the knees and grouped with their loads of cotton as a sculptural mass in the center of the painting, they loom large in the foreground of the picture. Far from being diminished by the acres stretching to the low horizon, they seem to rise out of the land and, through their monumental presence, claim it as their own.[56]

Here the old conventions of plantation landscape are completely overturned. Homer makes no reference to a great house, a fine garden, or to the owner in any way. He draws to the center of his canvas representatives of the people who for more than century of artistic practice had been shunted beyond the limits of the picture frame.

Homer's compassionate treatment of African American workers stands out as one of the few exceptions to the numerous grotesque renderings of black people that were commonplace during the late nineteenth century.[57] Caricatures, ranging from the merely silly to images that were outrageously monstrous, became the norm. The *Dark Town Series* published by Currier & Ives, a collection of eighty popular prints that lampooned black behavior in all manner of contexts, was indicative of the slanderous manner in which black subjects were most often rendered.[58] In the context of such images the Currier & Ives print *A Cotton Plantation on the Mississippi* (1884) would have seemed rather benign (see Figure 6.6). Based on a painting by William Aiken Walker, that image presented an up-tempo cotton harvest, an idealized portrayal of tasks that were always arduous and demanding.[59] Equally pleasant in its prospect was the print issued by the Calvert Lithography and Engraving Company in 1883 (Figure 1.33). In this bird's-eye view of a cotton plantation located on a high bluff above the Mississippi River, pickers are shown moving down the rows as they gather the bits of white fiber. Some of them carry their loaded baskets on to the cotton gin and cotton press seen in the middle distance. After processing there, bales are moved to a long inclined ramp, where they will slide down to an awaiting steamboat. The narrative of production told here, and presented as well in Walker's painting, shows not merely the first stage of how cloth is made. Implied here is suggestion of a full recovery from the dark night of Reconstruction as well as a claim that the New South stands ready to be a dependable trading partner. These rehabilitated plantations suggest the reliability and the future economic virtue of the New South.

FIGURE 1.33.
Anonymous,
Sunny South *(1883).*
Chromolithograph by
Calvert Lithography
and Engraving
Company. Library of
Congress, Prints and
Photographs Division.

NOSTALGIC ICONS

At the turn of the twentieth century, painters working in the South were, according to art historian Estill Curtis Pennington, "preoccupied with images of a lush landscape, beautiful happy children, dreamy women standing in the moonlight by a gardened gate or columned mansion."[60] Artists' experiments with impressionism resulted in numerous sentimental images. Examples of plantation houses rendered in this manner are found in the works of New Orleans artist Clarence Millet. After visiting Natchitoches, the site of Louisiana's first colonial capital, he rendered two moonlit views of the Prudhomme-Rouquier house circa

1935 (Figure 1.34). The cool tones of Millet's mauve and gray palette captured a romantic feeling strongly akin to the sentiments also expressed in the novels and movies of the period. Responding to one of Millet's paintings, one critic remarked that it presented "a composite of every abandoned old plantation house I've ever seen."[61]

Charleston, South Carolina, was one place where interest in plantation imagery remained particularly strong. A prime tourist destination during the first decades of the twentieth century, the city was visited regularly by northerners eager for encounters with vestiges of the Old South. Local artists Elizabeth O'Neill

FIGURE 1.34.
Clarence Millet,
View of the
Prudhomme-Roquier
House, Natchitoches
(1941). Oil on canvas.
Morris Museum of Art,
Augusta, Georgia.

Verner, Anna Heyward Taylor, Alfred Hutty, and Alice Ravenel Huger Smith responded to this interest with numerous paintings, prints, and etchings that depicted either plantation settings or scenes of blacks, now as tenants rather than as slaves, carrying out domestic or agricultural tasks.[62] As one might expect, the chosen styles and media of this group of artists varied considerably. Hutty's drypoint engraving *Yeamans Hall Oak* (ca. 1940) offered a realistic rendering of one of the oldest "sentinel" trees that stood on a plantation on the outskirts of Charleston, a venerable, silent witness to centuries of history (Figure 1.35).[63] Verner was best known for her precisionist drawings, but in *Avenue of Oaks at Litchfield Plantation* (ca. 1940) she chose to work in oils and use an impressionist technique (Figure 1.36). Concentrating on the entrance of the estate, she reduced the house to a minuscule presence in the distance as she gave her full attention to the play of light and shadow along the arcade formed by the two parallel rows of trees.[64] Taylor

FIGURE 1.35.
Alfred Hutty,
Yeamans Hall Oak
(ca. 1940). Drypoint
on paper. Gibbes
Museum of Art/Caro-
lina Art Association,
Charleston, South
Carolina. Gift of Mrs.
Alfred Hutty.

embraced modernism in her work; her 1930 watercolor of Fenwick Hall, a planta-
tion house on Johns Island, moves decidedly in the direction of abstraction (Fig-
ure 1.37 [Plate 6]). Her forte, however, proved to be the block print. In the 1930s
she completed a series of prints of black workers harvesting rice, indigo, cotton,
and tobacco. Chosen to illustrate the centennial history of the Agricultural Society
of South Carolina, her elemental black-and-white images apparently were seen as
potent reminders of plantation-era successes.[65] Alice Smith proved to be the
Charleston artist most interested in plantation scenery (see Chapter 7). In 1914 she

FIGURE 1.36.
*Elizabeth O'Neill
Verner,* Avenue of
Oaks at Litchfield
Plantation *(ca. 1940).
Oil on board. Morris
Museum of Art,
Augusta, Georgia.*

FIGURE I.37.
Anna Heyward Taylor,
Fenwick Hall *(1930).*
Watercolor on board.
Greenville County
Museum of Art,
Greenville, South
Carolina. (Reproduced
in color as Plate 6.)

provided almost one hundred illustrations for Elizabeth Allston Pringle's book *A Woman Rice Planter* and would go on to produce her own volume on plantation life, *A Carolina Rice Plantation of the Fifties* (1935), which she illustrated with a portfolio of thirty watercolors done in her distinctive impressionist style.

Even though plantation images have never been a pivotal element in American art, considering various treatments of the subject over time reveals a complex history full of intriguing twists. A wide array of artists, including both well-known professionals and obscure amateurs, have all contributed to what must be seen as a substantial body of work. Created over a period of almost 200 years, these im-

ages display considerable variation in form, media, style, technique, and purpose. The earliest landscapes were close imitations of works in the English topographical tradition. Private commissions of pictures of private property, these images were not displayed to the public and thus remained largely unknown. Up to 1850 the general public got to see images of plantations only by thumbing through the pages of illustrated travel books or buying tickets to see moving panoramas. When no one joined T. Addison Richards in his attempt to treat views of plantations as pictorially equivalent to scenes of Niagara Falls or Lake George, the task of illustrating what are now regarded as fabled estates fell to energetic journalists who were exploring the region in the aftermath of the Civil War. The rise of the New South spawned new promotional images like those produced by William Aiken Walker, which showed that the plantation system was once again up and running. But stridently pro-South images would diminish with the rise of a growing demand for nostalgic scenes; paintings of working plantations were replaced by paintings of beautiful plantations. Artists who were influenced by the "moonlight and magnolias" stereotype that became so popular during the early decades of the twentieth century produced another round of paintings, prints, and drawings— all of them marked by romantic inclinations. What is particularly interesting about plantation images is that during each discernible era so little reference was made to earlier efforts. With the exception of works created by artists of the colonial era, there was almost no recognition of useful antecedents or historical models. The narrative of plantation landscape painting in the South emerges only in retrospect, only after revisiting the choices made by each subsequent generation.

Although many plantation images can be identified, only a modest number of them are paintings. The following chapters present biographical assessments of six artists who produced a significant number of works. For each, the connection to the plantation as subject was considerably deeper than for artists who produced only one or two such paintings. When considered as an ensemble, then, these case studies constitute an episodic history of landscape paintings of American plantation estates from the early nineteenth century up through the first three decades of the twentieth.

T he career of Francis Guy provides an example of the intense effort at self-reinvention that is frequently noted as the definitive characteristic of American life at the dawning of the new republic. Born in England in 1760, Guy first displayed an inclination toward art as a child, but his father advised a more trustworthy career and apprenticed him to a tailor. After a few years, Guy ran away from his master and tried to make his mark in the fabric trade as a silk dyer. While he was eventually able to garner royal patronage, he nevertheless found himself plagued by insurmountable debts. Seeking a fresh start, he emigrated to Brooklyn, New York, in 1795, but success still eluded him. After a brief interval in Philadelphia, he moved on to Baltimore in 1798.[1] Art historian J. Hall Pleasants lists among Guy's Maryland ventures the following professions: dyer and stainer, minister, religious controversialist, versifier, dentist, and oil cloth and patent paper carpet manufacturer.[2] That Guy is today best known as a landscape painter might seem something of a surprise, especially when viewed against the background of his experimentation with such a wide range of pursuits. The wonder one has regarding his ultimate career choice only increases when one learns that Rembrandt Peale, a prominent Baltimore artist, reported in 1856 that Guy "boldly undertook to become an artist, though he did not know how to draw."[3]

Having seesawed his way through several ventures, Guy was always ready to pounce whenever the promise of an opportunity came his way. He fortuitously found a measure of success as an artist when his perpetual sense of urgency happened to combine with a considerable dash of mechanical cleverness. Reasoning that a landscape was pictorially something like the view that one might see out of a window, he devised a type of drawing machine that allowed him to capture the outlines of any scene that he might choose to render.[4] Peale, who had developed a national reputation as an art teacher for his instructional book *Graphics: A Manual of Drawing and Writing* (1835), was quite taken with Guy's invention, which he labeled "novel and ingenious." Describing Guy's technique in considerable detail in an article published in *The Crayon*, Peale wrote:

He constructed a tent, which he could erect at pleasure, wherever a scene of interest offered itself to his fancy. A window was contrived, the size of his intended pictures—this was filled up with a frame, having stretched on it a piece of black gauze. Regulating his eyesight by a fixed notch, a little distance from the gauze, he drew with chalk, all the objects as seen through the medium, with perfect perspective accuracy. This drawing being conveyed to his canvas, by simple pressure from the back of his hand, he painted the scene from Nature, with a rapidly-improving eye, so that in a few days his landscape was finished, and his tent conveyed in a cart to some other inviting locality.[5]

Guy's drawing machine, basically a portable sketching room, anticipated by some twenty years a related device that Rufus Porter, founding editor of the *Scientific American*, would develop to facilitate the speedy rendering of small portrait likenesses in less than fifteen minutes.[6]

To the scenes that he sketched Guy always added tiny figures. Given the distant perspective of his paintings, the people and animals in his landscapes had to be diminutive, a limitation that suited Guy since his command of anatomy was rather weak. Yet he was able to render convincing figures as long they were not more than three inches tall. Details of clothing and posture were used effectively to convey a person's identity and status: a lady was known by her hat and ruffled dress, a gentlemen by his coat and vest. Pleasants thought Guy's diminutive figures so lovely that he went so far as to suggest that the landscapes were undertaken to provide a pretext for painting small images of people.[7] These figures— often stiff, formulaic, and placed in contrived situations—were nevertheless well received by Guy's clients. They were charmed not only by the views that he provided but also by the fact that he gave them plausible, and flattering, images of themselves shown promenading about the scene.

Having overcome his inability to "draw," Guy threw himself into his painting career. His enthusiasm for his work was reflected in the rate at which he turned out paintings—so many in one instance that when he had finished a sufficient number, he propped them up in a vacant lot near his house and sold them by raffle. In fact, he treated the very act of painting as something of a spectacle. Working in the open air rather than in a studio, he frequently drew the attention of passersby. At his easel, he was always in motion, making a few strokes with his brush and then quickly stepping back to take in the effect. Pacing himself with frequent pinches of snuff from a large open jar that he kept nearby, he was a blur of action, constantly advancing and retreating, daubing and sniffing and sneezing, and waving his brushes in the air above his head with a dramatic flourish, all the

while proclaiming in a loud voice the virtue of his every accomplishment. To Peale, it seemed that Guy was trying to emulate Gilbert Stuart, who was at that time known as the most celebrated painter in America as well as a notorious snuff addict.[8] It is clear, however, that Guy had at last found a promising trade after a depressing string of failures. While he was full of pretense, he also had a talent for art, which he developed with the support of his Baltimore patrons.

Guy produced many paintings during his eighteen years in Baltimore, reportedly as many as 300, although less than 20 are known today. He was most often asked to provide views of the homes of prominent citizens, but on occasion he would produce ambitious panoramic vistas that presented the broad sweep of the city and its harbor. Gradually he expanded his repertoire to include maritime scenes and renderings of naval battles from the War of 1812, which were meant to satisfy the growing public demand for patriotic images. The strength of these sentiments may also explain his decision to render a view of Washington's tomb at Mt. Vernon.[9]

Although his Baltimore clients were clearly enthusiastic about Guy's scenes, he did have his detractors. In 1807 Eliza Godefroy, the city's self-appointed art critic writing under the pen name Beatrice Ironsides, declared that Guy was merely "a wild plant." Concerned that he lacked the polish that was presumed to come only after years of studio training, she described his landscapes as only "a sort of mosaic." Rembrandt Peale concurred with this comment, suggesting that Guy's tracing technique allowed him to assemble little more than "rough transcripts of Nature." He also described Guy's scenes as "manufactured" rather than painted, suggesting that although he had command over some of the basic tenets of technique, he was not fully informed about all the requirements of art. Other snide comments came from John Neal, editor of the *Portico* and a regular contributor to the *Federal Republican and Baltimore Telegraph*. Neal offered the opinion that Guy's landscapes were derivative works created from elements he had pirated from the paintings of French artist Claude Lorrain, though he moderated his criticism somewhat by noting that, although Guy may have pilfered, "he stole very judiciously." In a similar assessment, architect Benjamin H. Latrobe also provided a mixed report, stating that Guy's work had "some charming parts—some detestable ones."[10] These mild rebukes, however, stung the thin-skinned Guy more than they should have. He fired back his own salvos and complained that these chiding remarks had unfairly hurt his painting business. At times he responded by entering into schemes for toothache cures and other will-of-the-wisp ventures. He fumed and fussed and fretted, but, in hindsight, he really had no cause to worry. There was a constant, albeit modest, market for his works.

Guy's abilities held a particular appeal among the city's businessmen, a group

of prosperous social climbers who regularly called upon Guy to render portraits of their properties. John Tagart and John Pennington, for example, had constructed a thriving industrial complex at Jones Falls, located just to the north of the city. The site included a flour mill, a cooper's shop, and quarters for the mill workers, along with other necessary structures. Above the flowing stream stood their own substantial houses. In 1804 Guy produced three views of the site: one showed Tagart's house, which he named *Prospect*; the other two provided upstream and downstream perspectives of Pennington's residence. Since it was readily apparent that he could transform even a gritty locale into a picturesque site, other merchants soon realized that they too could use Guy's talent for landscape (Figure 2.1). Several of them who had recently acquired country residences, villas located out in the hinterlands of Baltimore County, offered him commissions to paint their estates. Guy accepted, again providing multiple views of their properties as he had at Jones Falls. In so doing, Guy was following the established practice in the English tradition for landscape paintings, in which an artist customarily produced views of a great manor house from several different vantage points.[11]

David Harris, a prominent shipping merchant, acquired a 260-acre tract located in the forested hills northeast of Baltimore, where he had constructed a large country house that he called Mt. Deposit. A notice in the *Baltimore News* offered the following description: "a large and elegant dwelling, containing ten rooms, besides kitchen and garrets, with extensive porticoes, a large barn, stables and granary, coach house, ice house and smoke house, two orchards of choice fruit and a well-cultivated garden."[12] The name of the estate puns on one of Harris's professional titles, Cashier of the Office of Discount and Deposit. Guy was commissioned to paint Mt. Deposit some time around 1805, and he rendered two views of Harris's farm, scenes that included all the requisite fences and outbuildings needed for a polite dairying and cattle-raising enterprise.[13] In the painting that shows the house from the front, several work buildings and pastures can be seen clearly; also visible, in the distant background, is a bit of Baltimore, probably Fells Point, the area that served then as the city's shipping section (Figure 2.2). Guy had cleverly contrived the scene to include this visual link between the estate and the source of the wealth that had allowed Harris to acquire it.

The companion painting, showing a view of the back of the house, shows the mansion and its terraced gardens in the far distance and emphasizes the interval between the house and the two figures, Harris and his neighbor Daniel Bowly, who are shown walking together in the foreground.[14] Inescapable in both views is the territorial prerogative of a wealthy person; the implied statement is that the whole vista belongs to Harris. By showing the estate from both the front and the back, far and near, and in ways that emphasize alternately the official and the in-

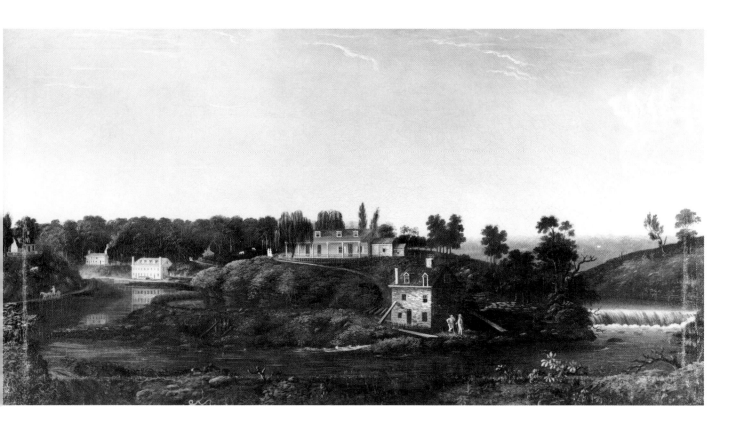

timate aspects of the property, Guy provided an appealing collective portrait of
the property. Art historian James Thomas Flexner locates the attraction of Guy's
paintings in his "conviction and wild joy," which insistently pushed him to beau-
tify whatever his eye fell upon. Flexner observed, "No one could be lonely in this
ecstatic world; even the cows and the dogs have mates."[15] Guy not only managed
to render an Eden on the outskirts of Baltimore, but he also found a way sell Har-
ris two paintings when a single frontal view might have sufficed.

Another shipping merchant, George Grundy, sought Guy's services in 1805. Guy
responded with three paintings of Grundy's villa, which was called Bolton. Situ-
ated on a relatively small 30-acre parcel, the house and grounds were depicted in
a manner that made the property seem quite expansive, even though it was a mere
fifteen blocks from the docks of Baltimore's Inner Harbor. That Howard Street, a
major city thoroughfare, was paved to within a few feet of the premises was, ac-
cording to Grundy, a beneficial asset, for it made "communication with the busy
part of the city easy and agreeable."[16]

In Guy's view of the front of the house, the mansion was placed in the middle
ground of the painting, where it was framed between two Lombardy poplars (Fig-
ure 2.3). However, two well-dressed female figures and small dog, who are shown

FIGURE 2.1.
Francis Guy,
Prospect *(ca. 1805).*
Oil on canvas. The
Maryland Historical
Society, Baltimore,
Maryland.

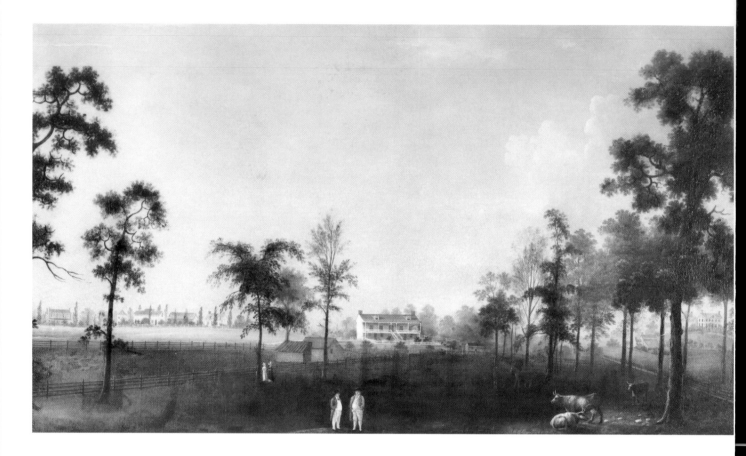

FIGURE 2.2.
Francis Guy, Mount
Deposit *(ca. 1805).*
Oil on canvas. The
Maryland Historical
Society, Baltimore,
Maryland.

walking along a dirt road in the foreground, draw more of the viewer's attention. The trees, the road, and a rough wooden fence that runs alongside of it all combine to give the image a rural aspect. This was perhaps Guy's chief task: to transform a suburban home into the semblance of an estate set in the far countryside. In a second painting of Bolton, Guy seems to have set up his drawing tent at the edge of downtown Baltimore.[17] From that location, looking northward toward the rear of the house, he rendered the building as a palatial abode standing in the center of its cleared fields; a number of service buildings—including a stable, coach house, wash house, and a gardener's residence—are depicted as well. A third painting, offering a view from within the fence lines, again shows the house from the rear (Figure 2.4). In this view Guy includes many features of the garden and the service buildings; the gardener's house and its adjacent yard are especially prominent. The fences, the cold frames, and the water pump, as well as children at play and Mr. and Mrs. Grundy, who are shown strolling the grounds, are all rendered with precise strokes. This painting of the inner core of the estate complements the other two images that were done from more distant vantage points. Like the view of Mt. Deposit that was painted from the rear, this image offers a

tranquil scene of domestic intimacy, one in which leisure pursuits are the order of this and every day.

When Grundy put his house up for sale in 1821, he described the building and its grounds in the *Federal Gazette*. The published notice is worth quoting at length because it provides such a thorough description of the mansion's domestic spaces as well as an inventory of the outbuildings, some of which are seen in Guy's paintings.

> On this estate which contains about 30 acres is a large two story Brick DWELLING HOUSE, 65 × 37 feet (clear of an octagonal projection of 11 feet off the south east front). Slate roofed, with a basement of hewn quarry stone, in which is every necessary apartment for the domestics of a large family, Viz: kitchen, larder, housekeeper's room, servants bed rooms, scullery, and waiter's closet, etc., etc. . . . One of the largest ice houses in the city with a brick passage underground, 30 feet long, which has recesses for milk and butter is within a few steps of the dwelling. There are also on the estate a large brick barn with foundations of stone and roomy stables and sheds for horses and cows, two coach houses, wash house, smoke house, etc., together with orchards of fine peach, apple, and cherry trees. In the garden which is well inclosed, and to which is attached a comfortable two story frame dwelling for the residence of a gardener or overseer, is a spring of pure water which passes off through two of the fields and affords abundant supplies for cattle turned in for pasturage. About 10 acres of this property has recently been set in rye, and the remainder is in timothy and orchard grass, from which a large crop has been obtained.[18]

It is hard to imagine today that all of these farming activities were carried out a mere stone's throw from paved city streets, especially on such a small tract of land.

What is missing, however, in the preceding description is any mention of the legal status of the people who did all the required work. Since Grundy was listed in the 1800 federal census as the owner of eleven slaves, what he failed to say, and what Guy seems to have overlooked, was that Bolton was a place populated by an enslaved black majority. Although there is some hint of African American bondage in Grundy's real estate notice—when it mentions that the gardener's quarters could also serve as an overseer's house—the language is ambiguous. The people who were quartered in the basement of his house were obviously expected to perform domestic duties, but clearly some of his bondsmen were charged with outdoor tasks. There may have been another slave house among the wash house and other dependencies, but Grundy merely added an "etc." to indicate the possibility. If we could imagine the landscape that Guy actually saw, we would find

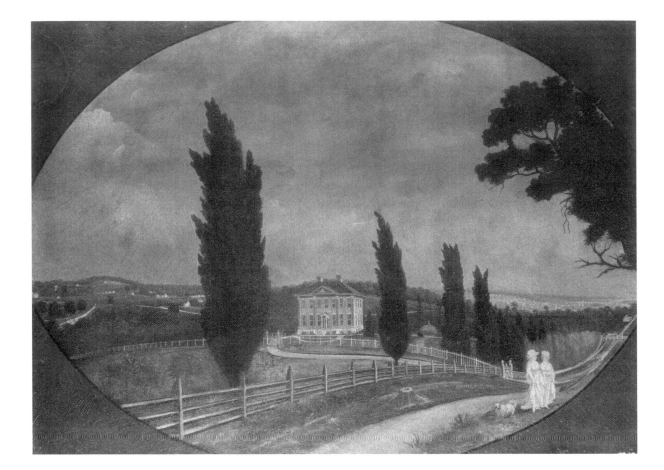

black men and women carrying out the numerous tasks of maintaining a large house and tending to chores in the barns, stables, fields, and orchards. Bolton would then look more like a plantation than an urban villa. In fact, it was a suburban plantation, a slave-operated estate at the edge of a city.[19] Seen in this light, Guy's paintings of Bolton are as interesting for what they hide as for what they reveal. He clearly used his brush not only to create the image but also to edit out the people whose presence might disturb the feeling of idyllic perfection shown in his three portraits.

In 1774 Baltimore businessman Harry Dorsey Gough purchased a property located in northeastern Baltimore County known as "The Adventure." There, far from commotion of the city, he took up the life of a country squire, changing the name of the estate to Perry Hall, the name of the ancient estate of his English forebears. Gough ultimately increased the size of his holdings to 2,000 acres.[20] He also commissioned Guy to create several paintings of his estate. One of them was a pastoral composition that showed the vast expanse of the estate.[21] In a scene of rolling hills, woodlands, and sheep grazing in their pasture, the massive Perry Hall man-

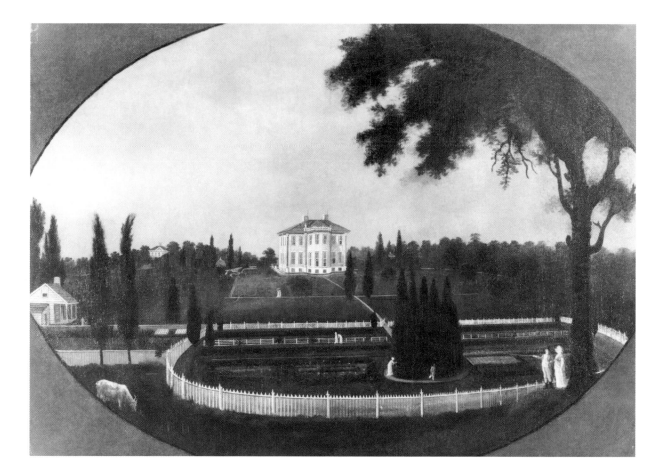

sion appears as little more than a speck on the far horizon. In the foreground a mounted hunting party—consisting of Gough, his son-in-law, two of his grandchildren, an African American servant, and two dogs—chases down a rabbit. Despite all this raucous action, the painting suggests a feeling of quiet repose. All that one can see—the land, the animals, the people—are, Guy implies, under Gough's control.

A second painting focuses more closely on the Perry Hall mansion (Figure 2.5 [Plate 7]). The immense house, designed according to the requirements of the Georgian style, consisted of five units: a huge main block flanked by two smaller wings, which in turn were flanked by matching terminal buildings. These last structures were the most distinctive elements of the house. Topped with pyramidal roofs and unusual steeplelike finials, one of them was used as a Methodist chapel, which could hold up to seventy-five worshipers, and the other was outfitted as a bath house, complete with a marble-lined pool and steam room. The entire ensemble measured more than 150 feet from end to end. Methodist minister Francis Asbury, who visited the estate several times, proclaimed that the great

FIGURE 2.4.
Francis Guy,
Bolton, View From
the South *(ca. 1805).*
Oil on canvas. The
Maryland Historical
Society, Baltimore,
Maryland.

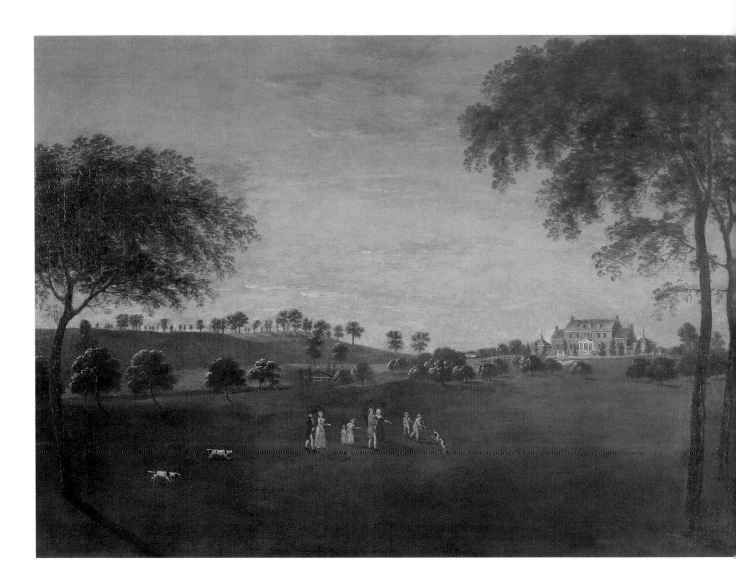

FIGURE 2.5.
Francis Guy,
Perry Hall *(ca. 1805).*
Oil on canvas. The
Maryland Historical
Society, Baltimore,
Maryland. (Repro-
duced in color as
Plate 7.)

house was "spacious and splendid."[22] The grounds, consistent with the design of the house, were planned according to eighteenth-century English landscape theory. A broad expanse of lawn is shown dotted with randomly placed trees, although the pathway to the house, lined with trees planted at regular intervals, was more formally arranged.[23] Gough and his family, along with his hunting dogs, are shown in the foreground, strolling leisurely in front of the house, dressed in their best clothes. All the perquisites of power are clearly on view here in a scene of conspicuous display on what appears to be a very nice day.

But in a slave-owning society, nothing conveyed one's right to be respected as a person of high status more than the presence of captive African American laborers. Guy certainly knew this, and he moved to the margins of the mansion grounds

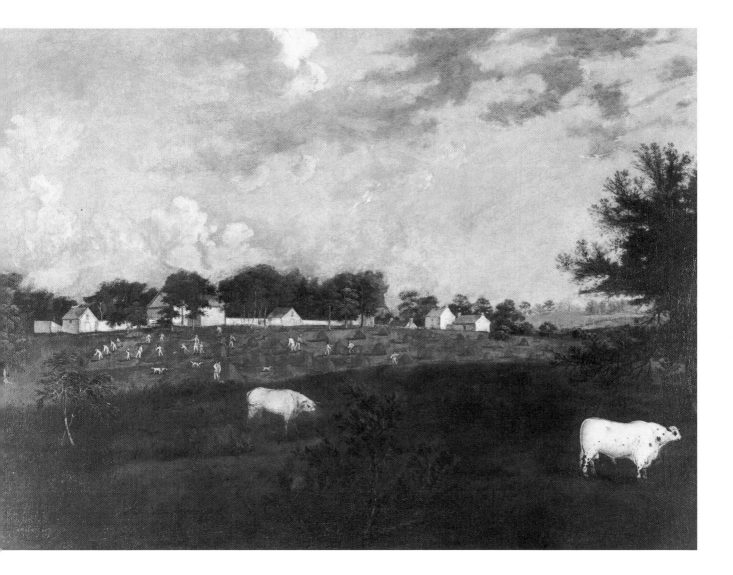

to paint a slave gang working in a hay field (Figure 2.6). In the resulting image, sixteen men, aided by a water boy, are shown cutting, raking, and stacking hay. Gough, accompanied by two of his grandsons and two hunting dogs, who have again chased up a rabbit, stands in the middle of the gang supervising their work. Behind them stretches a row of farm buildings. An inventory of Perry Hall made in 1808 mentions a blacksmith shop, a cooper's shop, a paint shop, a stable, a wash house, and an overseer's house.[24] While some of these structures are probably seen in this painting, there clearly were other buildings at Perry Hall that the estate's assessors failed to record. In 1808 there were fifty-eight black people living on Gough's plantation, six of them free and the remaining fifty-two enslaved. The inventory makes no mention of slave houses nor of the slave jail, but in Guy's

FIGURE 2.6.
Francis Guy,
Perry Hall, Slave
Quarters with
Fieldhands at Work
*(ca. 1805). Oil on
canvas. The Maryland
Historical Society,
Baltimore, Maryland.*

painting three small houses stand at the end of the range of work buildings, apparently a set of slave quarters.[25]

In this image Guy fused bucolic atmosphere with a candid portrayal of slave life and labor. While Gough is again shown to be in charge, this was an unusual painting for a gentleman to hang in his parlor. Slaves were considered valuable property for the work they performed and because they signaled the great wealth of their owner, but they were not accepted as a suitable subject for a work of art. This painting was jettisoned from the Gough estate around 1816 (a mere eleven years after it was commissioned) and given to Esther Hall, a former slave and trusted confidant of Gough's daughter Sarah. Shortly after Sarah died, Esther was given both her freedom and the painting of the slave gang as a token of remembrance.[26] The gift, however, was something of a hollow gesture, since the painting was one the Gough family did not want to keep.

In Guy's views of Perry Hall he used the same compositional strategies that he had employed when painting Bolton and Mt. Deposit. His alternate views presented both the public and private faces of the estate. While his patrons were usually pleased with his inventiveness, at Perry Hall he seems to have gone too far when he rendered a slave gang. Apparently, he had allowed his enthusiasm for the act of painting to cloud his thinking regarding his choice of subject matter. He had failed to understand that not everything that could be painted should be painted.

Guy certainly knew what was expected in a house portrait. He learned the basic rules from his study of European paintings owned by private collectors in Baltimore and from similar works executed by local artists working in the region. Charles Willson Peale had painted Mount Clare, Charles Carroll's prominent estate just outside of Baltimore (Figure 1.2). When Guy visited this house some time around 1804 to make sketches for designs that would be painted on a set of chairs that Carroll had ordered, he surely had the opportunity to take notice of Peale's painting, done some thirty years earlier. Peale, looking up from below, showed the mansion as far away, on top of a ridge. Formal decorative gardens and productive fields and pastures filled the center of the canvas, while in the foreground a group of mounted riders have stopped to converse before proceeding on their way, presumably up to the house. Having absorbed the same Claudian landscape formulas that Guy had been accused of "stealing," Peale used a large tree on the left to frame the presentation of the house, which is staged as an inviting manor.[27]

Harry Gough provided Guy with another model to follow: a painting of Perry Hall done circa 1795 by an artist identified only as an itinerant English landscapist (Figure 2.7).[28] This artist placed the mansion in the center of his canvas so that the viewer looks straight up at it at the top of the hill. Various outbuildings stand lower than the house or are set off toward the edges of the scene. In the fore-

ground, family members converse while Gough approaches them on horseback. Because Gough apparently preferred to display this painting in his Baltimore residence, he asked Guy to render a comparable image that he would keep at his country estate. Guy's frontal view of Perry Hall is very similar to this painting; the key difference is that his scene was rendered from a point about 300 yards north of the location where the unknown British painter made his preparatory sketches. Consequently, in Guy's version the house stands close to the right-hand edge of the canvas, and the road has more prominence, since it extends across much of the canvas. Guy also framed his picture with large trees on either side, directing the viewer to focus closely upon the mansion. While the two views are obviously quite similar, one finds that the British itinerant extended his image out to edges

FIGURE 2.7. *Anonymous,* Perry Hall, Home of Harry Dorsey Gough *(ca. 1795). Oil on canvas. Courtesy, Winterthur Museum, Winterthur, Delaware.*

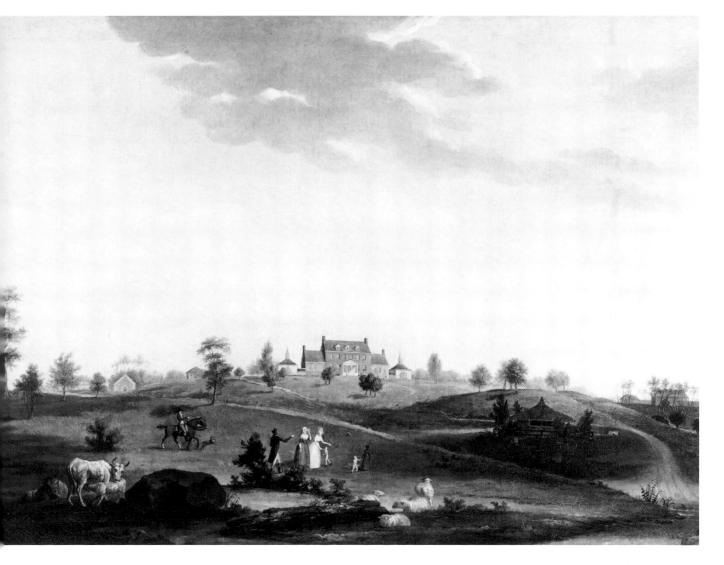

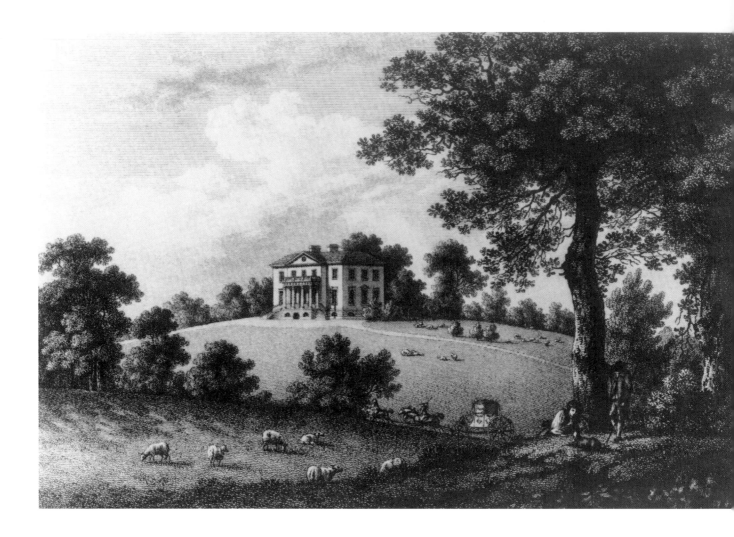

FIGURE 2.8.
William Watts,
Mount Clare in Surry,
the Seat of Sr. John
Dick *(ca. 1784).*
Engraving for Watts,
Seats of the Nobility
and Gentry, *in a*
Collection of the
Most Interesting and
Picturesque Views
(London: J. & J. Boy-
dell, 1786). Library of
Congress, Rare Books.

of the canvas, suggesting the expansive reach of Gough's holdings and, by implication, his personal authority. Guy's work makes a similar statement about Gough's social achievements but implies that one must go into the landscape to encounter its master rather than merely stand outside while taking in the scene. Comparison of these two works shows that Guy was not merely a copyist; his alleged "rough transcripts of Nature" reveal a sophisticated concern for imagery and composition and their impact on the viewer.

Given that books featuring illustrations of British manor houses, such as Kip's *Britannia Illustrata* (1707) or Watts's *Seats of the Nobility and Gentry* (1782) (see Figure 2.8 for an example), were readily available in America, all the key features of English landscape painting could easily have been absorbed by an aggressive self-starter like Guy. In 1819 Guy organized a showing of his recent works, which included scenes of Malta and Lisbon, distant places that he had never visited — an

indication that he was working from printed sources.[29] Thus he would have known something about the usual formulas employed in renderings of English estates: the great house as seen in a parklike setting, such as George Lambert's *Wotton Park, Surry* (1739); or a magnificent house seen in close detail, like William Hodges's *View of the North Front of Worksop Manor, Nottinghamshire* (1777).[30] In the second format the client's house becomes the central focus of the artist's attention, almost a surrogate for a portrait of its owner.

In 1811 Guy completed such a painting of the residence of Nicholas Rogers, a prominent Baltimore architect. Known as Druid Hill, the house stood in a wooded location lying along Jones Falls, northwest of the city (Figure 2.9).[31] Guy filled his canvas chiefly with an image of the house while providing only the slightest hint that it was surrounded by almost 600 acres of fields and pasture or that this estate was worked with the assistance of twenty-two slaves.[32] Further, little attention was given to Rogers's elaborate landscaping scheme, in which he grouped trees "with regard for their autumnal tints" and backed them with rows of evergreens in order to make their colors stand out all the more.[33] Guy's image thus contrasts noticeably with later renderings of Druid Hill by John R. Murray in 1844 and John

FIGURE 2.9.
Francis Guy,
View of the Seat
of Col. Rogers,
Near Baltimore *(1811).*
Oil on canvas. The
Maryland Historical
Society, Baltimore,
Maryland.

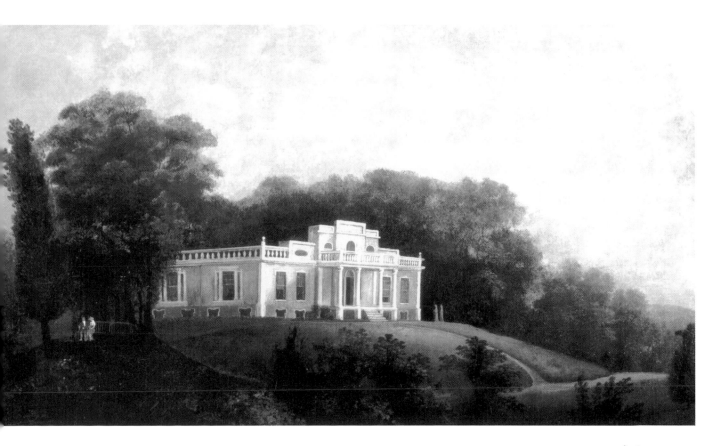

FIGURE 2.10.
Francis Guy,
Mount Clare
(ca. 1803).
Decoration on the
back of a settee.
The Baltimore
Museum of Art,
Baltimore, Maryland.
Gift of Lydia Howard
de Roth and Nancy H.
De Ford Venable and
museum purchase.
BMA 1966.26.11

Kensett in 1864, both of which show the house from a greater distance. Rendered as pastoral scenes, the work of both these later artists included depictions of livestock and outbuildings. Guy might have rendered scenes at Druid Hill that were the equivalent of his distant views of Perry Hall, Mt. Deposit, and Bolton, but he opted instead to focus in on the villa alone and let it stand for Rogers and the record of his achievements.

While this style of architectural portraiture had been well-known in English circles for more than a century, Guy may have been moved to choose this format partly because of a partnership he had established with Baltimore furniture makers John and Hugh Finlay in 1803. One of the ploys that the Finlays used to attract commissions was an offer to have Guy paint views of the client's house on the backs of custom-made chairs and settees. Measuring roughly two inches by four inches, these decorative devices were basically miniature portraits of their clients' homes, unique insignias that effectively transformed a house into an icon of self (Figure 2.10). In a Finlay brothers' advertisement in 1805, an additional service was mentioned: "Real views taken on the spot to any dimension in oil or water colors."[34] Guy had, by this time, improved his skills to the point where he thought that no commission was too challenging, and, with access to the Finlays' wealthy customers, he was ready to expand the range of his commissions. Apparently this is how David Harris and George Grundy came to have paintings made of their estates, for they also had ordered chairs decorated with images of their houses. The panoramic views that they received from Guy followed the mode of English landscapes generally labeled "topographical country-house portraits."[35] Six years

later, we find in his *View of the Seat of Col. Rogers, Near Baltimore* that Guy had painted a tightly cropped architectural image, something akin to one of his many house icons but scaled up to the size of a conventional painting.

Whether he was providing a house portrait or a vista showing an entire estate, Guy's paintings were used by his clients as visual proof that they had raised themselves up to the highest rungs on the social ladder. The size of Baltimore's merchant class was expanding markedly during the first decades of the new republic, and the most successful among them were soon able to contend for the respect and admiration that previously had been granted solely to members of the landed gentry, a group of planters descended from old aristocratic families. What ensued in Baltimore at the beginning of the nineteenth century was a social schism between the county and the city, between the descendants of the "first families" and recently arrived men of commerce. The old guard, those with long-standing claims to historic tracts of land, despised the upstart businessmen flush with cash and strong lines of credit, but in the end the planters were powerless to block the rise of these merchants.[36] Men like Gough, Grundy, and Harris did so well in their business ventures that they were able, as we have seen, to obtain elaborate country seats and thus to seize the chief symbol of the landed gentry for themselves. Guy was drawn into this process because his paintings were more than decorations; they served as crowning proofs of success, as luxury goods par excellence, which were charged with the ability to confirm one's improved status. When hung on the walls of parlors or drawing rooms, Guy's landscapes underscored what was already evident: that the owner of the painting was a wealthy man now worthy of even greater deference and respect. Even if the new merchant princes of Baltimore City did not receive the full recognition that they anticipated, their paintings at least suggested that such was their due. With Guy's images in hand, arriviste merchants documented that they could behave like members of the landed gentry, that they could live like the fabled planters of the founding generation if that was their choice.

As wealthy Baltimore merchants celebrated themselves as men of achievement, Guy attempted to ride on the coattails of their success. In the process he transformed British landscape formulas into the means by which he could describe an emerging American scene.

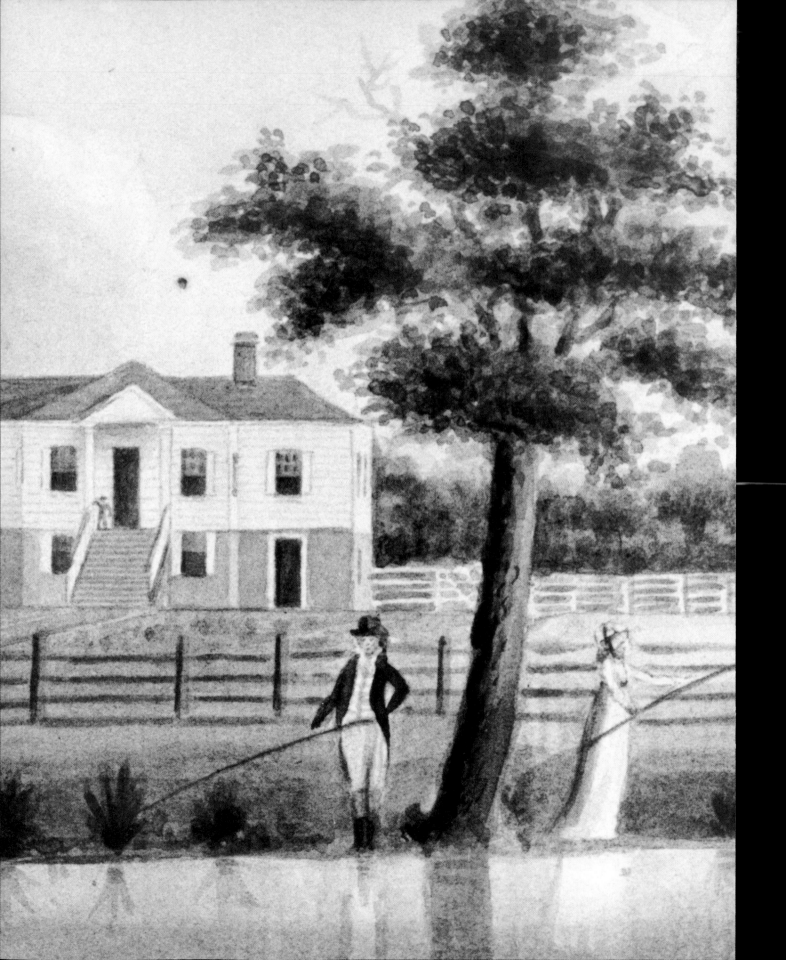

In 1857 a group of prominent citizens from Charleston, South Carolina, opened a retrospective exhibition of the life's work of Charles Fraser, who was at that time the city's most prominent living artist (Figure 3.1). Called "The Fraser Gallery," the exhibition was staged in one of the city's largest meeting halls and was filled with hundreds of artworks that had been loaned by their appreciative owners. Listed in the published catalogue were 313 portrait miniatures as well as 139 oil paintings, consisting principally of "landscapes and other pieces."[1] Hundreds of well-wishers visited the gallery day after day for two months to offer their tribute. Fraser himself, then seventy-five years old, made several appearances and regaled any viewers who happened to be present with stories about his career. The exhibition was intended not only to honor Fraser as an artist but also to acknowledge his role as a central figure in the intellectual and social life of Charleston. Fraser had served as president of the Charleston Library Society, as a trustee of the College of Charleston, and as the manager of the St. Cecilia Society (a prestigious social club). He had also published a history of the city, given numerous public addresses, designed cupolas for two prominent buildings, and served as a member of the bar.[2] His achievements made him, in the view of his peers, an admirable and even an emblematic man.

That Fraser had become a noteworthy artist was a testament to his ardent belief in his own talents, abilities that he had been advised to suppress. The youngest of fourteen children, when his father died in 1791, he was sent to a local academy run by Bishop Robert Smith. It was there that Fraser, then only ten years old, first attempted to draw and paint. One of his fellow students (and his closest friend at the time) was Thomas Sully, who would go on to become one of the most celebrated of American portraitists.[3] In his later years Fraser affectionately recalled that it was Sully who gave him valuable hints about artistic technique; Sully had, he declared, "determined the course of my future life."[4] His brother Alexander also offered encouragement. Twenty-six years older than Charles, Alexander was more like a parent than a sibling, and together they created a portfolio of watercolor drawings that they titled *Sketches from Nature by A. Fraser and C. Fraser*. Noteworthy for its scenes of local theater productions, one of the images in this collabo-

rative collection was a drawing of two males, possibly the two brothers, shown seated together at a table. The older man draws while the younger one watches.[5] It was most likely Alexander who arranged for Thomas Coram, a local engraver and painter, to give Charles a few lessons in 1795.

Fraser's other brothers were less enthusiastic about his passion for art. After Alexander died in 1798, Frederick Fraser seems to have assumed the parental role. Sensing no prospects for making a reasonable livelihood by painting pictures, he encouraged Charles to pursue a career in the law. Accordingly, after he turned sixteen Charles was sent to "read" at the offices of John Julius Pringle, then the attorney general for South Carolina. Fraser spent a total of six years with Pringle and was eventually admitted to the bar in 1807. While he experienced some success as an attorney and even held for a time the position of judge advocate with the local militia, he nevertheless would eventually claim that he had been "misdirected" away from art.[6] In 1818, having given what he viewed as more than enough time to lawyering, Fraser decided to return to his palette and brushes, a move that he never regretted.

The kind of art that nineteenth-century Charlestonians most wanted to hang on the walls of their splendid parlors was images of themselves. This desire was so strong that art historian Anna Wells Rutledge has characterized Charleston during that era as a "portrait society."[7] Fraser found, however, that the local demand for portraits was already well satisfied by northern painters who regularly came south during the winter months, not only in search of more pleasant weather but to secure commissions. The local clientele, flush with cash derived from their

extensive rice plantations, offered a ready market for an enterprising artist. Samuel F. B. Morse from New York was a frequent seasonal visitor, and he dominated the city's portrait scene.[8] Faced with a strong competition for the attention of potential sitters, Fraser prudently turned away from full-scale images to miniatures that were painted on ivory and often worn as elements of costume. There were approximately fifty painters of miniatures in Charleston during the period when Fraser was active, but he proved so skillful that he was soon recognized as the superior talent. His

reputation as the local master of the genre was confirmed in 1825, when he received the official commission from the city for a miniature of the Marquis de Lafayette, which was presented as a gift to the famous French patriot as a remembrance of his triumphant visit.[9] Only in 1839, with the invention of the daguerreotype, which could provide a highly realistic image for a mere fraction of Fraser's $50 fee, did his commissions begin to decline.

During the 1830s and 1840s Fraser developed new painting interests. He turned to landscapes, still lifes, genre scenes, and so-called fancy pieces. The range of these works, as revealed in the catalogue for "The Fraser Gallery," was quite extensive, including scenes from Shakespeare's plays, copies of works by European masters, and mundane subjects such as "Cat looking wistfully at dead partridge, snipe, and woodcock." But the majority of his new paintings were depictions of landscape, both European and American. The majority of his scenes of the United States were renderings of noteworthy northern sites that had already become celebrated as icons of American identity, places like Niagara Falls, the Hudson River, or the White Mountains of New Hampshire.[10] He was equally taken with the Mediterranean and did paintings of Mt. Vesuvius, Lake Averno, and various well-known Roman ruins. Fraser deliberately looked beyond his native South Carolina in an effort calculated to establish himself as an artist worthy of national and, hopefully, even international attention. Art historian Martha R. Severens identifies this phase of his career as one of the two periods during which he was "most experimental."[11] According to Severens, his other experimental phase occurred during the years just before he was forced to abandon his interest in art.

Fraser was tutored in the law over two three-year periods: first from 1798 to 1801 and then again from 1804 to 1807. But while he was reading books on case law and serving as John Pringle's clerk, he also found time to paint. A significant sample of the work that he produced during this crucial period is contained in a small sketchbook filled with watercolors done between 1796 and 1806. What held Fraser's attention during this critical time, as he matured from a 14-year-old schoolboy into a member of the bar, was the lure of the local and the familiar. The forty postcard-sized pages of his little portfolio contain scenes of Charleston streets and country churches, but fully half of his images were views of plantations. This choice of subject may be traced in part to his lessons with Thomas Coram, who during the 1790s had painted several views of the estates owned by planters in the Charleston area, including a now frequently reprinted image of Thomas Broughton's Mulberry Plantation up on the Cooper River (Figure 1.3). Coram had also copied a number of illustrations of the English countryside, which contained images of castles and abbeys, estates that were the functional equivalents of South Carolina's plantations. Since Coram certainly would have shared

his works with Fraser as examples that he might copy, one can easily understand Fraser's particular choice of subject.

Another reason why Fraser focused so intently on plantations was that he was himself a member of the plantation class. His grandfather John Fraser, who immigrated to South Carolina from Scotland in 1700, developed a sizable estate along the shores of Huspa Creek, in what is today Beaufort County. Fraser's father, Alexander, inherited this plantation and acquired several others in different parts of the state. In a will dated 1789 he listed, in addition to the Huspa Creek plantation, two additional holdings on the Ashepoo River, as well as estates near Charleston, two of them on the Stono River and one on Goose Creek. The Goose Creek property was large enough that in a codicil he stipulated that it was to be divided into two smaller estates insuring that all his adult children would become substantial landowners.[12] Consequently, Fraser would have looked upon plantations as a normative topic. Family visits among the Frasers meant basically traveling from one plantation to another. Indeed, after his father died, Fraser spent much of his time being shuttled among various family estates. Painting plantations was for Fraser, at first, a biographical act.

The earliest works in Fraser's sketchbook are scenes of Charleston sites, places inscribed with boyhood associations, such as the place near Savage's Green where he and his pals went swimming or the view out the window of his bedroom (Figure 3.2). In this latter image, a painting of the middle of the block behind 25 (now 55) King Street, one senses his itchy enthusiasm to draw the first thing to catch his attention at any particular moment. While intriguing to architectural historians, this sketchbook painting was little more than an impulsive test that Fraser set for himself to see if he could make the jumble of houses, work yards, outbuildings, trees, and gardens into a picture. The image he created was essentially an act of reportage, an instant of inquiry. This seems to have been the motive behind his first plantation scenes as well.

In 1798 Fraser paid a visit to Belleview, the family plantation in Beaufort County about eighty miles southwest of Charleston, which belonged then to his brother Frederick.[13] Established by Fraser's grandfather, this estate held considerable importance in the Fraser family saga. Since Charles's brother Alexander, his surrogate father, had just died, the would-be painter may have had significant personal reasons to visit the site where his family had first put its mark on South Carolina. Attempting to produce a view of the entire property, Fraser stood out on its tidal flats where he had an unobstructed view (Figure 3.3). From there he could see the ridge of high ground where the plantation's main buildings were perched. These included in addition to the residence—a rather modest one-story house with a porch—a kitchen and a couple of outbuildings that might have been slave

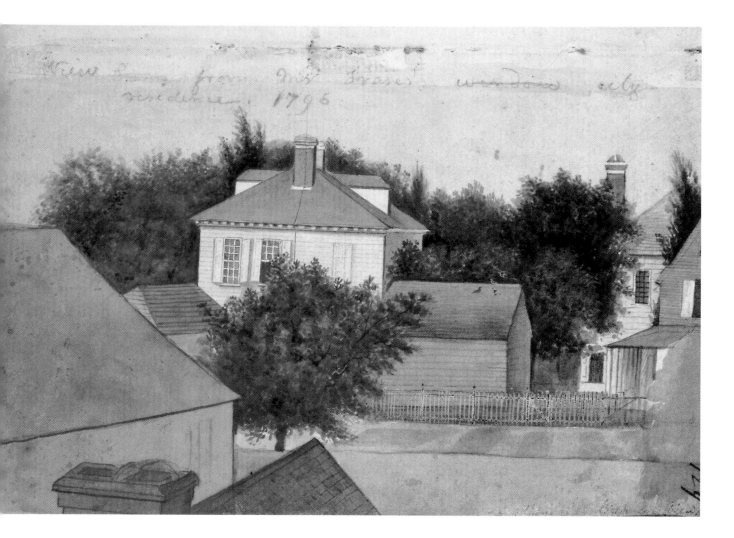

quarters. Like the view from his bedroom window, this picture also presents an inventory. The image is chiefly a record of the visible contents of the estate, land and buildings. While this scene would have appeared mundane and unremarkable to most, for Fraser this was a potent place, a genealogical point of origin. To further document this location, Fraser also painted the estate that stood on the opposite shore of Huspa Creek (Figure 3.4). This neighboring plantation was Sheldon, a 6,000-acre estate developed in 1732 by William Bull, a very prominent planter who had served for a time as colonial governor. Standing at the Belleview dock, which appears in the foreground of the image, Fraser painted a vast expanse of tidal marsh bounded by densely forested bluff lands. No signs of agriculture appear anywhere in the image, even though Bull had assigned 107 slaves to work this site.[14] Fraser provides only three faintly sketched figures in the foreground, who are seen gliding by in a small boat. They provide a human scale against which the

FIGURE 3.2.
Charles Fraser,
View from Mr.
Fraser's City
Residence *(1796).*
Watercolor on paper.
Gibbes Museum of
Art/Carolina Art
Association, Charleston, South Carolina.
Gift of Alice Ravenel
Huger Smith.

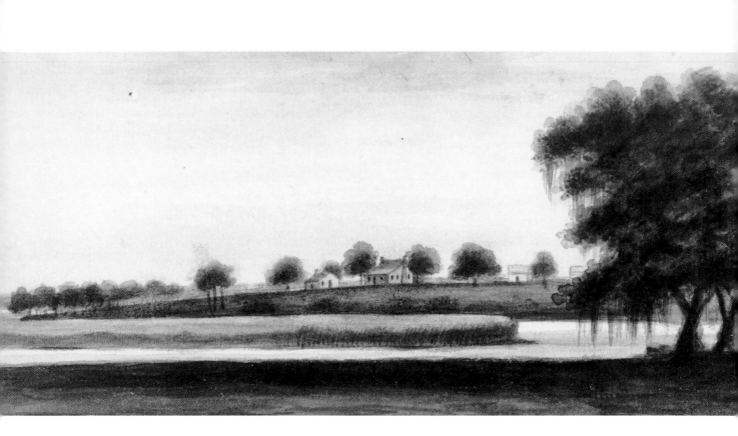

depth of the scene might be measured. He aimed here not so much to document Sheldon plantation but to illustrate the view from Belleview, the Fraser home-place. His frame of reference is thus not to place but to self, indicating that he was engaged more with the act of painting than with his subject. Moreover, he was most concerned with matters connected to his own personal history.

A few years later, perhaps in 1800, Fraser visited his brother James, who had been granted a plantation on Goose Creek just north of Charleston. Called Wigton, the name recalled the town in Scotland from whence the Frasers had come (Figure 3.5). On this occasion Fraser painted a detailed picture of the plantation house, a two-story, wood-framed building featuring a decorative cornice, paneled shutters, and a wide veranda guarded by an elaborate "Chinese" railing. The grounds were laid out with rigorous symmetry, and Fraser shows an axial pathway leading straight to the front door that is flanked by matching flower beds and balanced ornamental bushes. The order seen in the yard extended well beyond the house; a map of the estate drawn up by surveyor Joseph Purcell in 1801 shows that the house was flanked by a pair of matching outbuildings.[15]

Because Brighton, the estate belonging to Fraser's sister Mary, was carved out of Wigton's acreage, she and her husband, James Winthrop, lived nearby. Conse-

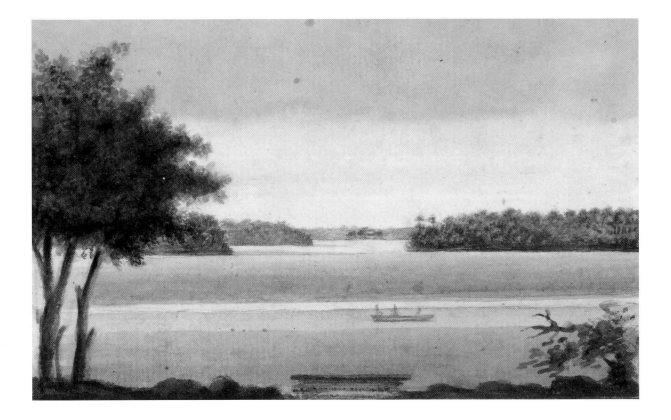

quently, Fraser could readily call on them whenever he visited Wigton, and on one occasion he produced a painting of their plantation as well (Figure 3.6). In this case he seems to have made his sketch while seated in a boat anchored slightly offshore. This was, in all likelihood, the view from a site on the estate known as Bailey's Landing, one of the few places where the shoreline of Goose Creek was firm ground rather than tidal marsh. Fraser again rendered a balanced, frontal view. The house, a one-story building raised on a high brick foundation, was shown in the center of an expansive fenced yard. Diminutive outbuildings standing at the edges of the yard emphasized the importance of the house. Fraser interrupted the formality of his composition only by placing two well-dressed people, apparently his sister and brother-in-law, on either side of a prominent tree down at the edge of the creek. Shown with fishing poles, they appear to be enjoying the perquisites of leisure on a calm sunny day while the more onerous and demanding tasks of the plantation are carried out well beyond this scene. The images of Wigton and Brighton taken together show that the Fraser family was able to bask in the privileges of wealth. Now eighteen years old, Fraser had begun to assess just where his family stood on the social ladder.

Although he must have understood that his family was economically secure, he

FIGURE 3.4.
*Charles Fraser,
Sheldon (ca. 1799).
Watercolor on paper.
Gibbes Museum of
Art/Carolina Art
Association, Charleston, South Carolina.
Gift of Alice Ravenel
Huger Smith.*

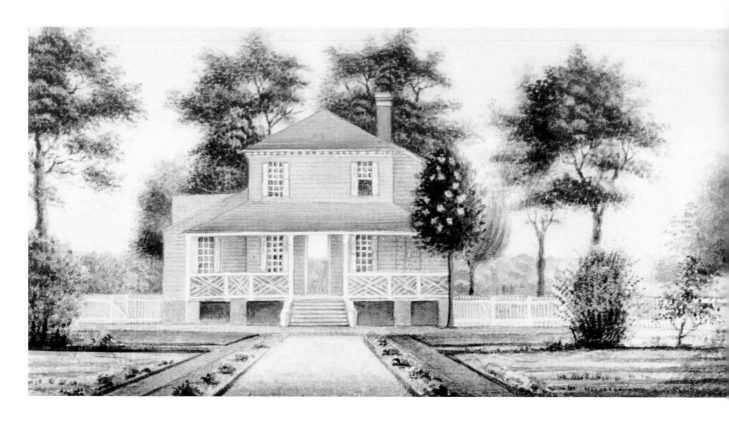

also knew that they were positioned well below South Carolina's social leaders. That he was the only Fraser not to be granted a parcel of land by his father's will probably made him somewhat uneasy about his future prospects. He was thus inclined to pay considerable attention to signs of status as he assessed his own social fate. On his trips down to Belleview he had traveled along the Stono River and thus had encountered Peaceful Retreat, one of Robert Gibbes's several estates. His painting of this plantation, done in 1797, shows a house that was much larger than any of his family's homes (Figure 3.7). In fact, either of the two dependencies that flanked Gibbes's house, the kitchen and the laundry, was almost as large as the house at Wigton. The central component of Gibbes's house was a large Georgian villa, very restrained in its decoration but crowned impressively with a tall hipped roof that was, in turn, topped by two towerlike chimneys that extended well above its ridge.[16] The house had the lines of a strongbox, suggestive of the great wealth that was contained inside. This was in fact the case, for an inventory of the property compiled in 1794 revealed that the family owned, in addition to the most sumptuous furnishings, 279 slaves, a total that clearly placed them in the upper echelon of South Carolina's slaveholders.[17] More than a document of the house, this painting seems to embody Fraser's youthful aspiration to live in such a house someday.

In 1800 Fraser visited the country villa of John Pringle, his future mentor in the law. Located at a plantation called Runnymeade, the estate was about eight miles north of Charleston on the Ashley River. Pringle acquired the property in 1795 and undertook to have a new house built there the following year.[18] The house that Fraser encountered was essentially a brand new mansion and, like the homes belonging to the other great planters of the Carolina low country, it conformed to the requirements of the Georgian style. Similar in many ways to the Gibbes house, Pringle's mansion was noteworthy for its wide veranda and the decorative gable that graced its roof line. While the house was situated on a bluff overlooking the river, so it could make a showy display to travelers who sailed by, Fraser approached the estate via the old coach road. He stood well back from the house while rendering, once again, a balanced frontal view (Figure 3.8). He placed himself directly in line with its front door, making sure there were no trees in his way. Focusing mostly on the building, he minimized the prominent river, which held the favorable gaze of so many visitors. Only a few strokes of blue just beyond the carefully delineated picket fence indicated that a river deep enough to be navigated by oceangoing ships ran just behind the house. Eager, and perhaps even

FIGURE 3.6.
Charles Fraser,
The Seat of Joseph
Winthrop, Esq., Goose
Creek *(ca. 1802).*
Watercolor on paper.
Gibbes Museum of
Art/Carolina Art
Association, Charleston, South Carolina.
Gift of Alice Ravenel
Huger Smith.

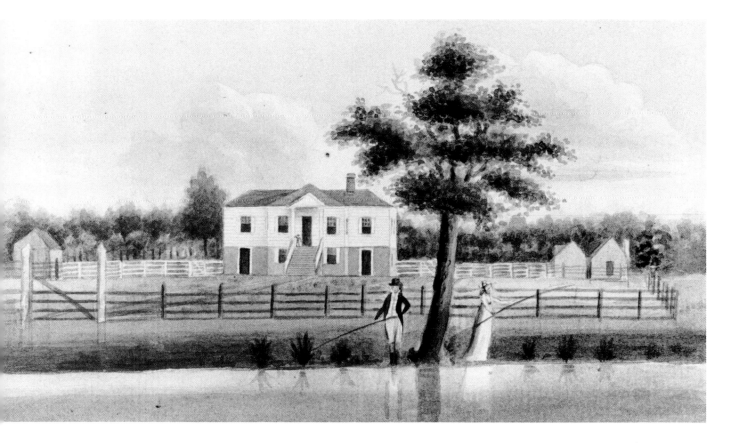

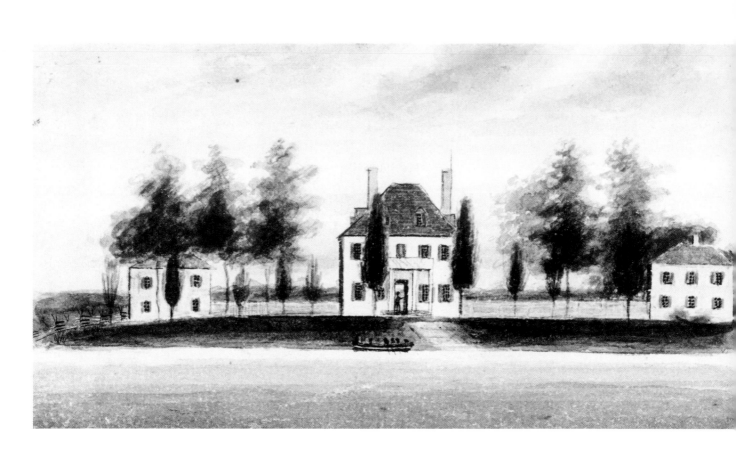

anxious, to understand how status was reckoned, he concentrated on the mansion above all else. Transforming his image of the building into something like a portrait of its owner, he took pains to render it clearly without any visual obstructions.[19] Painting houses in this direct and simplified manner, that is, making the buildings stand out and apart from their surroundings, he could more easily contemplate the success of others while he compared his circumstances to theirs.

By 1802 Fraser's plantation paintings reflected a perceptible shift to a new approach. He now filled his images with diverse scenic elements, reflecting, perhaps, his growing awareness of the decorative potential of the environmental features of a setting. His painting of Steepbrook, Gabriel Manigault's estate on Goose Creek, provides a good example of the change in his painterly concerns (Figure 3.9 [Plate 8]).[20] Here he tucked the house, again a substantial building topped by a pyramidal roof, into the background, where it barely manages to peek out from a grove of trees. At the center of this picture is the cleared and open ground. A pair of oak trees, appealingly draped with hanging strands of Spanish moss, stand guard in the lower left foreground, where they help to frame the view. One is pulled into the scene by a sequence of horizontally arranged elements: first the creek, then a cultivated field, next the pasture, shaded here and there with trees,

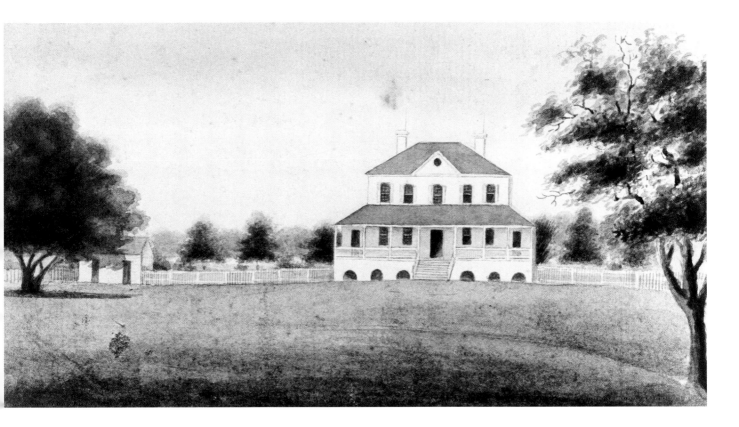

and finally the forested background. Peter Manigault, a previous owner, had called the plantation Steepbrook after a creek that ran across the property. The flow of this stream had, in fact, washed away much of the bluff, creating an unusual ravine. It was in this distinctive gully that he built this house.[21] That Fraser showed the trees in the background standing higher than the house indicates that he had become a careful observer of topographical details and further that he took pains to capture these features accurately.

The following year, while on a visit to Ashley Hall, the estate established in the seventeenth century by the Bull family, he again amused himself by painting pictures of the property. He completed several images, including two of the house and its grounds. For one of these paintings, Fraser returned to the same tactics that he had employed in his portrait of the Pringle mansion. While again showing a house standing in an open clearing, here he rendered the view from the right-hand corner rather than straight on (Figure 3.10). Thus, he was able to highlight the house's porch tower, a unique archaic feature that would have been lost had the house been shown only from the front.[22] Not content with the results of a single image, however, Fraser did a second painting (Figure 3.11). Standing out on the oak-lined avenue that ran up to the front door of the large house, he empha-

FIGURE 3.8.
Charles Fraser,
The Seat of John
Julius Pringle, Esq.,
on the Ashley River
*(1800). Watercolor on
paper. Gibbes Museum
of Art/Carolina Art
Association, Charleston, South Carolina.
Gift of Alice Ravenel
Huger Smith.*

FIGURE 3.9.
Charles Fraser, Mr.
Gabriel Manigault's
Seat at Goose Creek
*(1802). Watercolor on
paper. Gibbes Museum
of Art/Carolina Art
Association, Charles-
ton, South Carolina.
Gift of Alice Ravenel
Huger Smith. (Repro-
duced in color as
Plate 8.)*

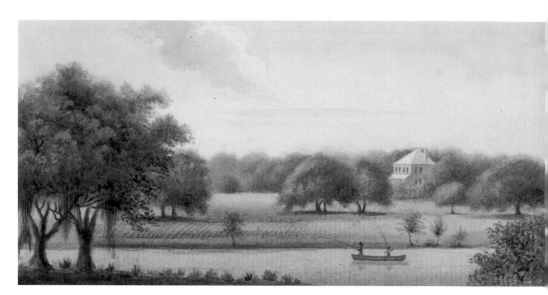

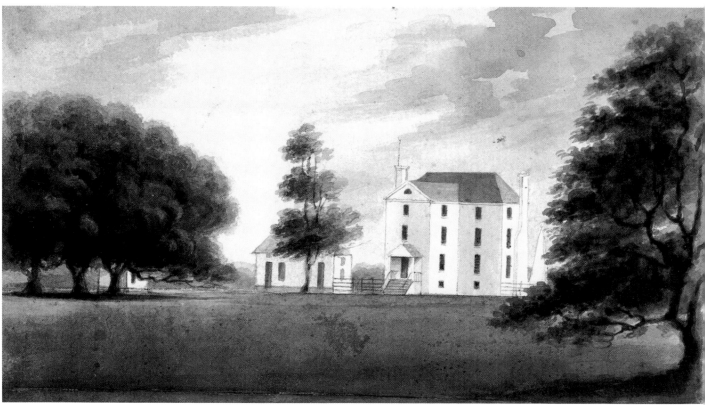

FIGURE 3.10.
Charles Fraser, Ashley Hall *(1803). Watercolor on paper. Gibbes Museum of Art/Carolina Art
Association, Charleston, South Carolina. Gift of Alice Ravenel Huger Smith.*

sized the size of the house by providing only a glimpse of its foundation and first story. Beyond this tunnel of tree trunks and branches, he suggests, there stood a noteworthy destination. That he created two different views indicates that he was becoming more interested in the pictorial possibilities of a site. His earlier concern for creating a clear visual inventory apparently was displaced by a growing concern for the scenic qualities of a location. There were many other features of Ashley Hall that might have stimulated Fraser's artistic muse: a formal garden laid out in the Italian style; an Indian mound topped by a statue of Diana, goddess of the chase; a water-powered mill; a family cemetery.[23] However, it seems that Fraser found the creation of two alternate views of the house sufficient to satisfy his need to test and expand his artistic abilities.

Between 1803 and 1805 Fraser made several trips up the Cooper River, one of the state's most productive rice-growing regions. This was a territory thick with plantations and consequently a place that held much appeal for Fraser. At Rice Hope, the optimistically named estate of Dr. William Read, former physician and surgeon in the Continental Line, he did two views. One of these showed Read's

FIGURE 3.11.
Charles Fraser,
Another View of
Ashley Hall *(1803).*
Watercolor on paper.
Gibbes Museum of
Art/Carolina Art
Association, Charles-
ton, South Carolina.
Gift of Alice Ravenel
Huger Smith.

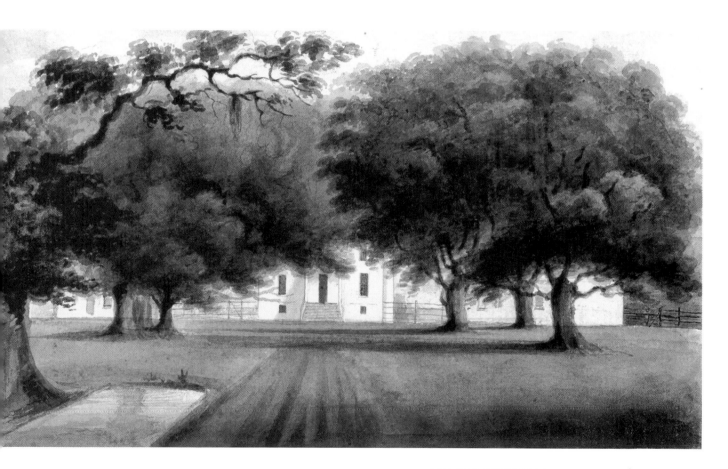

opposite:
FIGURE 3.12.
Charles Fraser,
Rice Hope, The Seat
of Dr. William Read
on the Cooper River
(ca. 1803).
Watercolor on paper.
Gibbes Museum of Art/
Carolina Art Associa-
tion, Charleston, South
Carolina. Gift of Alice
Ravenel Huger Smith.

FIGURE 3.13.
Charles Fraser,
Rice Hope *(ca. 1803).*
Watercolor on paper.
Gibbes Museum of
Art/Carolina Art
Association, Charles-
ton, South Carolina.
Gift of Alice Ravenel
Huger Smith.

house atop a slight rise, as seen from the plantation's rice fields (Figure 3.12). The house was a modest home, as unpretentious as any common farmer's house, except that it was served by a separate kitchen and slave quarter. The second image offered an impressive panorama of Read's holdings as seen from his yard (Figure 3.13). Looking southward, Fraser rendered the Cooper River winding its way into the distance. Rice paddies, each one a matching square bounded by an earthen dike, extend from the foot of the bluff where the house was located out as much as a mile to the river's edge. All of the picture's elements—sky, trees, hills, river—are marginal to these fields. If there was any truth to the plantation's name, it was represented more in this scene than in the view of the modest house on the hill.

A bit farther up the Cooper, Fraser visited Mepkin, the plantation of Henry Laurens, who was reputed in his day to be the richest man in all of South Carolina.[24] Since Henry Laurens Jr. was married to one of Fraser's cousins, the young painter and now would-be barrister could claim that he was "family" and maybe something of a social peer. Doubtless he felt that he was free to take the measure of the estate, which comprised some 3,000 acres, and, further, he would have known immediately that one painting would not suffice to capture the place. He ended up making three. In two of these works, Fraser focused on Laurens's residence. Following the same strategy that he had used at Ashley Hall, he again rendered a view of the house as screened behind some trees (Figure 3.14). Even though only part of the first story and a bit of the roof were visible, one can still see that it was a substantial Georgian house. The tremendous rice harvest upon which much of Laurens's fortune was based was signaled by the huge barn, a structure almost as large as the house, standing nearby. In a second painting Fraser looked across the front of the house back toward the place where he had stood while making his other image (Figure 3.15). Here he showed even less of the house and focused more on the domain of work. The kitchen, a well outfitted with a pump, the rice yard where the grain was threshed and cleaned, and two untethered mules wandering about compete for the viewer's attention in front of the looming presence of the house. Since Mepkin stood on a prominent bluff overlooking the Cooper, the sight of the river pulled Fraser away from the house. In much the same way that he had rendered the fields of Rice Hope, here again he painted a river scene (Figure 3.16). But unlike the expansive view from Rice Hope, here the scene is more tightly framed, offering a glimpse of the Cooper as it flows past the estate. Considered as an ensemble, the three images of Mepkin suggest a desire to show the physical environment of the plantation as much as its social achievement. Fraser, like other travelers up the Cooper, was impressed with the high bluffs upon which great plantation houses like Mepkin stood. From that vantage point,

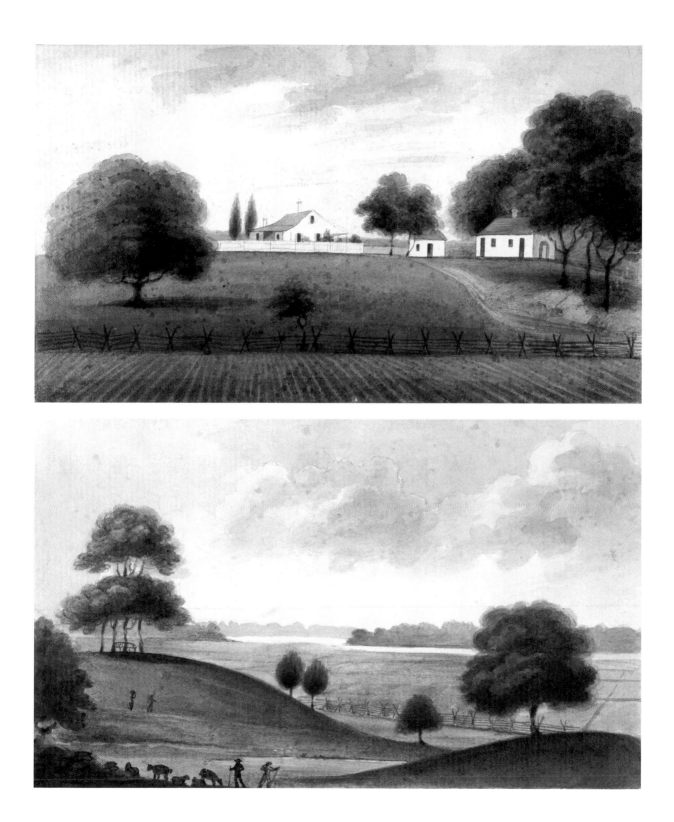

FIGURE 3.14.
Charles Fraser,
Mepkin, The Seat of
Henry Laurens *(May*
1803). Watercolor on
paper. Gibbes Museum
of Art/Carolina Art
Association, Charles-
ton, South Carolina.
Gift of Alice Ravenel
Huger Smith.

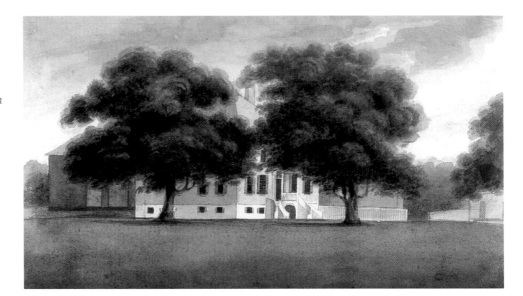

FIGURE 3.15.
Charles Fraser, Mepkin *(1803). Watercolor on paper. Gibbes Museum of Art/Carolina Art Association,*
Charleston, South Carolina. Gift of Alice Ravenel Huger Smith.

he considered not only how Laurens had "improved" the site, but he also beheld and portrayed a natural setting that lay beyond Laurens's control.

Just as he was about to embark on his career as a lawyer, Fraser had the opportunity to visit Richmond, the estate belonging to his cousin Edward Rutledge.[25] This plantation, located well up the eastern branch of the Cooper River, was visited some years later by John Irving, who wrote of it:

> A noble mansion is seen on the brow of a gently rising hill, about two hundred yards from the riverside. Having recently undergone a thorough repair—its white exterior—neatly fenced yard—carefully swept lawn of greenery, shaded here and there by majestic oaks, that with oriental pride, lift up their heads upon the hill, like a Persian satrap, betoken a commendable taste, and refinement, in its intimates. Everything about the premises is in the same excellent order and condition. The accommodation for the domestics—the stables—the negro houses—the barn, are all painted and whitewashed, and as seen from the river, have a very impressive appearance.[26]

FIGURE 3.16. *Charles Fraser, A View on Mepkin (1803). Watercolor on paper, Gibbes Museum of Art/Carolina Art Association, Charleston, South Carolina. Gift of Alice Ravenel Huger Smith.*

Fraser's images of Richmond, painted in 1803, present many of the features so flat-teringly described by Irving in 1842 (Figure 3.17). Two portraits of the plantation house, rendered from different vantage points, make reverential statements that reflect the eminence of the planter and the praiseworthiness of his achievements. Two years later Fraser was again at Richmond, and on that occasion he painted a view from the bluff looking down to the river (Figure 3.18). In this rather peaceful image two weathered trees with twisted branches frame the distant sky while off to one side shepherds keep watch over their flock. The only indication that this image was painted at a plantation is the presence of a distant manor house seen in the lower right-hand corner, probably the residence at an estate known as the Villa, located about three-fourths of a mile downriver from Richmond.[27] Clearly, Fraser's artistic concerns had changed considerably in the span of two years. No longer as impressed as he once was with the architectural and agricultural com-ponents of a plantation, he now focused more extensively on its scenic aspects.

Fraser's experiments with landscape divide into two phases. At first he seems to have been challenged most by the task of accurate representation, and as a conse-quence, his images remained essentially documents of whatever he chanced to

FIGURE 3.17.
Charles Fraser,
Richmond, The Seat
of Edward Rutledge,
Esq., in St. John's
Parish *(1803).*
Watercolor on paper.
Gibbes Museum of
Art/Carolina Art
Association, Charles-
ton, South Carolina.
Gift of Alice Ravenel
Huger Smith.

see: the view out of the window, the vista across the creek, the house where he was staying. When creating these images, Fraser was decidedly object-driven, and even though his watercolors were made outdoors, elements of nature were suppressed or avoided altogether. These paintings were not yet landscapes but rather training exercises, tests that Fraser set for himself to determine whether or not he could render accurately. The product of a constrained vision, they betray the timid approach of a neophyte.[28]

By 1802 (when Fraser was twenty years old), he had become considerably more confident and worldly-wise. He now explored and developed the scenic potential of the plantation sites. The manner in which he integrated elements of vegetation into his portrayals of plantation houses and his decision to undertake more than one view suggest a growing appreciation of their natural settings. These moves foreshadow his ultimate recognition of the value of nature as the appropriate subject of landscape art. At Rice Hope, Mepkin, and Richmond he produced river vistas that he hoped would capture the rustic beauty of these estates, instead of making his usual record of the financial successes of their owners, faithful but mundane portraits of the main house and associated outbuildings. Fraser eventu-

FIGURE 3.18. *Charles Fraser,* A View on Richmond *(1805). Watercolor on paper. Gibbes Museum of Art/Carolina Art Association, Charleston, South Carolina. Gift of Alice Ravenel Huger Smith.*

ally discovered that painting the landscape could satisfy his need for creative expression. As revealed by the pages of his sketchbook, the ten years between 1796 and 1806 were a crucial period in Fraser's personal development. Progressively drawn to painting by this sequence of plantation images, he resolved that he would one day become an artist. Even though twelve years would pass before he would again take up his brushes, the ideals of artistic practice were now profoundly inscribed upon him. From 1807 to 1818 he may have walked through the streets of Charleston as a lawyer, but all the while he yearned to paint.

Instrumental in Fraser's transformation from a cautious amateur to a more confident painter was his exposure to the writings of Rev. William Gilpin, an English travel writer noted for his confident proclamations regarding the virtues of the landscape.[29] It was Thomas Coram who first directed Fraser to Gilpin's books, and he paged through them looking for models that he might imitate. Among the sketches found in one of his scrapbooks are several copies of illustrations published in Gilpin's *Observations on Several Parts of England, Particularly the Mountains and Lakes of Cumberland and Westmoreland*.[30] But in Gilpin's books Fraser found more than pictures of the English countryside; he also learned that a picturesque view was not simply to be found in nature but was to be created out of its diverse visual elements.

In *Observations on Several Parts of Cambridge, Norfolk, Suffolk, and Essex*, Gilpin wrote of the need for the enlightened traveler (one could easily substitute the word "artist") to manipulate the content of a setting. At the site of Castle Conway, where Gilpin encountered "all the ingredients of a sublime, and beautiful landscape," he still considered the scene "indifferent" and "displeasing." Yet, he opined, the prospect might be improved if the viewer would "add as much composition as the natural arrangement will allow." Gilpin advised that the castle be viewed only from the corner, which "would ease it of some of its regular towers." He further directed the viewer "to cut down part of the wood on the opposite bank, which would remove, in some degree, its heaviness," explaining: "As the wood, in fact, is periodically cut down, this liberty is very allowable. The picture might be improved also by planting a tree or two on the fore-ground; and hiding part of the regularity of their branches."[31] Fraser's images of the mansions at Ashley Hall, Mepkin, and Richmond, which are obscured by cleverly placed trees, suggest that he fully accepted Gilpin's advice.

In another of Gilpin's books, he claimed that agricultural landscapes could never provide a suitable scene for "*picturesque beauty*," arguing that fields were "in every part disfigured by the spade, the coulter, and the harrow" and that "on canvas, hedge-row elms, furrowed lands, meadows adorned with milk-maids, and hayfields adorned with mowers, have a bad effect."[32] These passages might have

troubled Fraser, since his native landscape had been thoroughly transformed by the impact of agricultural projects. One low-country planter even referred to his rice-producing estate as "a huge hydraulic machine, maintained by constant fighting against the rivers."[33] If agricultural development had made the Carolina low country artistically contemptible, then Fraser would have to use his brush to return its scenery to a more decorative condition. This was, in fact, Gilpin's explicit charge. If an artist encountered a less than perfect vista, Gilpin advised: "[H]e may certainly break an ill-formed hillock; and shovel the earth about him, as he pleases, without offence. He may pull up a piece of awkward paling—throw down a cottage—he may even turn the course of a road, a river, a few yards on this side, or that. These trivial alterations may greatly add to the beauty of his composition"[34] Instructions like these provided Fraser with permission to render Richmond as a pastoral scene inhabited by shepherds rather than as a rice plantation. Gilpin's influence is also effected in other ways. The trees in *A View on Richmond* (Figure 3.18), for example, appear to have been patterned on an idealized species that can be found in some of Gilpin's illustrations. Further, the composition of this painting follows Gilpin's sketch of the Isle of Thanet, except for the absence of rugged hills in the background (Figure 3.19). With guidance drawn from Gilpin's writings, Fraser gradually came to realize that a painter of landscape had to edit nature if he wanted to produce a worthy image.

Fraser's plantation paintings contain only a few human figures, and the few that can be identified appear to be members of his family. One might surmise that the crew of oarsmen seen rowing a boat in front of the Gibbes house on the Stono River are African Americans, since that was a common role for slaves on large estates. African American scale figures are also included in his painting of the fields at Richmond. But other than these few exceptions, Fraser's plantation images are empty places. There are signs that work gets done, but no workers appear.

In reality, rice plantations were sites characterized by unrelieved labor, carried out by large numbers of slaves. That Fraser so thoroughly eliminated black people from his renderings of fields and work yards signals more than a simple oversight on his part. It is unlikely that fields like those at Rice Hope would have been so empty of workers. In addition to field hands, there would also have been drivers, plowmen, ditch men, carpenters, carters, trunk minders, and watchmen. All the members of the "squad," as they were sometimes called, had specific duties to perform to insure that the crop was successfully raised and harvested.[35] But Fraser chose not to document the crucial work of the plantation. He hoped to portray the sublimity of nature, a quality that was said to be best appreciated in solitude and silence.[36] Given this goal, there was no place or purpose for the black majority in his paintings, even though they were the people who deserved most of the credit

FIGURE 3.19.
William Gilpin,
Isle of Thanet *(1774).*
Illustration from
Observations on the
Coast of Hampshire,
Sussex, and Kent.
Dumbarton Oaks,
Washington, D.C.,
Studies in Landscape
Architecture, Photo
Archive.

for giving the landscape its physical form. To capture what he considered the appropriate scenic effect, Fraser simply left enslaved workers out of his paintings. African Americans were handled in the same way that he had treated inconveniently placed trees, hills, or buildings. Elements of a locale that disrupted his painterly ideal were edited, adjusted, or erased in pursuit of the beauty of nature.

The African Americans who grew up on low-country plantations, when asked to recall those experiences, focused intently on the tasks associated with rice. They even manifested a measure of pride in what they were able to accomplish. Gabe Lance, a former slave from Georgetown County, asserted: "All them rice field been nothing but swamp. Slavery people cut canal and cut the woods—dig ditch through raw woods. All been clear up for rice by slavery people." Another former slave, Ben Horry, reassured his interviewer that "slavery time people *done* something."[37] Even at the end of the twentieth century the memories of work on rice estates remained vivid. Emily Frayer, who as a young girl lived at Hyde Park plantation on the Cooper River, a place close to Richmond, recalled the prodigious effort demanded by the rice harvest: "I used to sit in the door, and I would see them have the rice stacked way up on the cart, and the people would be up there drivin'. I

used to be so frightened, think the man was going to fall off. I watched them all day, watching people haul that rice down to the barnyard. There was a big barnyard, and they stack rice in that yard, right off the river. The yard run right to the river, and from there they carry the rice away by boat."[38] In one of Fraser's paintings of Mepkin he shows a part of the yard where rice was threshed and cleaned before it was shipped off to Charleston. But since he included no workers, his image indicates only that rice was produced there and relates none of the awe or amazement sensed in Frayer's account when all available field hands joined together to complete the most crucial task on the estate. How the work at Mepkin, Richmond, or any of the other plantations that Fraser documented was done and by whom were questions that went unasked. Perhaps these were not questions that he felt he needed to ask. But the fact that they were not addressed in any way only served to heighten the significance of the plantation owners and further marginalize the members of the slave community upon whose labor so much of the owners' social eminence was based.

Fraser's images were private exercises, but he probably showed them to the owners of the different estates during his prolonged visits. In one case he apparently sliced a page out of his sketchbook in order to present the picture as a gift to his host.[39] In any case, his pictures would have appealed to members of the planter class for two reasons: he not only offered charming portrayals of their agricultural and architectural achievements, but he also allowed them to avoid the moral and social dilemmas that were inextricably linked to slavery. While Fraser's plantation paintings were created principally as a test of his own talents, the works that he produced also served an important social function: they made a positive visual argument on behalf of plantation society. By leaving slavery out of his images, by situating the institution essentially beyond the edges of his pictures, Fraser gave the "peculiar institution" his tacit approval. What was there to fear, his peers might have asked, from such pleasant prospects spread out so neatly under cool, reassuring skies?

I n 1867 the Mechanics and Agricultural Fair Association of New Orleans staged its first "Grand State Fair." Included on its program of events was a full slate of artistic competitions, whose judges awarded to one A. Persac four diplomas and the sum of $20 in the following categories: best drawings with crayon, best drawings with stump, best composition in watercolor, and best watercolor landscape. Four years later he would receive the prestigious silver medal for the best painting in watercolors.[1] This A. Persac, who listed himself in the city directories as Adrien Persac, was a French immigrant who had come to Louisiana sometime before 1851; his full name was Marie Adrien Persac. Since he identified himself in various editions of the New Orleans city directory as either an architect, a civil engineer, or, finally, as an artist, he apparently arrived in Louisiana possessing useful skills and a certain amount of learned sophistication. He is known to have been born in 1823 in Saumur, a village located in the wine country of the Loire Valley in northwestern France, but very little is known of his youth or schooling. It is suggested that a cousin, ten years his senior, who was a graduate of the prestigious École Polytechnique in Paris, could have served as his tutor.[2] Of the meager facts that Persac provided about his past, he indicated only that he had been living in Lyon, France's second largest city, when he immigrated to the United States. Yet this single indication of a place may be enough to suggest why he left France.

Given the time required both to receive a thorough education in and to acquire some experience in technically demanding fields like architecture and engineering, Persac was probably about twenty-five years old when he first considered leaving his native country. If this was the case, it was 1848, an anxious year in French history that witnessed the collapse of the First Republic. The Second Republic was quickly formed but failed to gain broad popular support, particularly among artisans and laborers. Lyon, at this time France's chief industrial center, was the site of considerable political unrest. One Lyon businessman, describing the repeated demonstrations against the new government, wrote, "Workers are always parading and all peaceful men begin to grow alarmed. Everyone hides his money." Protests continued on through the summer of 1849, when the captain of police observed of a recent Lyon riot, which left more than fifty dead: "A few more

days and the entire society will be no more than a mass of debris and ruins." The following year another official observed, "There is much misery in Lyon."[3] We will probably never know precisely why Persac chose to leave France, even though a family story holds that he came to America to shoot buffalo.[4] But it is most likely that a man of his erudition and apparent social standing would have thought it prudent to avoid the problems of Lyon and try to make a fresh start somewhere else. Understandably, the French-speaking territory of the United States beckoned. Although the date of his arrival in Louisiana was unrecorded, we may presume that it was not much later than 1850, for on December 8, 1851, he married Odile Daigre in Baton Rouge.

Persac was living with his wife's family in Bayou Manchac, a small settlement on the outskirts of Baton Rouge, when his career took what, in hindsight, could be considered a strange turn. Receiving a substantial sum of money from the estate of his mother, he invested it in apple orchards in Indiana, and after 1853 he traveled there to supervise their operation. That he returned regularly to Manchac is indicated by the birth record of his second son, Octave Joseph, who was born in the Daigre house in 1854. Persac returned to Baton Rouge in 1856, when he undertook a full-time partnership with photographer William Vail, but by 1857 he had moved on to New Orleans. Raising apples in the Midwest had doubtless proved too burdensome. Back in Louisiana, Persac found himself in a familiar French social milieu, where he was able to initiate a career better suited to his training and temperament.

It was his artistic skill that attracted the attentions of New Orleans publisher Benjamin Moore Norman. In 1857 Norman announced his plan for a detailed chart of the Mississippi River, which would feature decorations "done in the first style of art by A. Persac."[5] Although Persac was not a cartographer by trade, working on this map project provided him with the opportunity both to demonstrate his abilities as a draftsman and to utilize some of his knowledge of surveying. According to a story that appeared in the *New Orleans Daily Crescent* on April 2, 1858, Persac had to check property boundaries along many miles of twisting shoreline in order to verify the accuracy of their locations. His efforts were lauded as a valuable achievement: "Mr. A. Persac, who descended the river in a skiff, landing at every mile, and drawing every plantation line and taking down every name and landmark on both banks of the river, deserves the highest praise for his able and useful labor."[6]

Norman's Chart of the Mississippi River was noteworthy not only for the utility of its data but also because it was impressive in both its dimensions and its decorations. The published map measured more than five feet long and almost three feet wide, and, as an advertisement in the *New Orleans Daily Picayune* noted, it con-

tained "all the principal points on the River, Public Buildings, Churches, Post Offices, & c.; limits of Parishes and Counties; Landings, Islands and Bars; Creeks and Bayous; Railroads and Canals; Hills, & c.; most faithfully portrayed, whenever they become important or interesting matters of reference."[7] But more than this, the chart marked and identified by name hundreds of plantations and farms that stood upon the river's shores between New Orleans and Natchez. The chief commodity produced at each estate was indicated by a designated color: pink and blue for cotton, green and yellow for sugar cane. Further, Persac graced the map with a fabulous border of enormous morning glories. He also provided four decorative cartouches. In addition to representations of Baton Rouge and New Orleans, these images also included depictions of two plantations, Persac's first efforts at rendering the plantation landscape.

Although the two estates depicted on the Norman chart were labeled generically, as "Cotton Plantation" and "Sugar Plantation," the sugar estate is unquestionably Belle Grove, the property developed by John Andrews in Iberville Parish in the 1850s (Figure 4.1). Since the construction of the Belle Grove mansion was completed in 1857, just as Persac was mapping the shoreline of the Mississippi, it was the newest and most up-to-date example of a sugar plantation that he could hope to encounter. Painted pink, the 75-room mansion was surely an eye-catching and memorable house.[8] Persac rendered a panoramic view of the entire estate as seen from just inside the fence that separated the mansion from the plantation's other production zones. The grand house, designed by prominent New Orleans

FIGURE 4.1.
Marie Adrien Persac, Sugar Plantation *(1858). Steel engraving for* Norman's Chart of the Lower Mississippi River. *Library of Congress, Geography and Map Division.*

architect Henry Howard, is centermost.[9] Its most distinctive features—two Corinthian porticoes, one facing north and the other to the west—are clearly visible. To the right of the house extend vast acres of cane, while to the left Persac recorded both the plantation's sugar and saw mills, their tall smokestacks sending black plumes skyward. He also included several slave houses in this scene, although they do not seem to correspond to the double-cabin variety that Andrews is known to have used to quarter his 150 captive laborers.[10] The close-cropped lawn in the foreground, crossed by curving gravel paths and newly planted trees, conveys a feeling of gentility that contrasts markedly with the work depicted in the background. Persac deliberately presented the planter's prospect.

The other plantation image on *Norman's Chart* offers no clear visual clues of a specific identity. Identified only as a cotton-producing estate, it was, according to Persac's survey, situated somewhere on the Mississippi above Pointe Coupee Parish (Figure 4.2). The hills that appear in the background imply that this plantation was situated on the eastern bank of the river in the area of the so-called blufflands, a region extending from St. Francisville, Louisiana, to Natchez, Mississippi.[11]

That this scene presents an upstate location is confirmed as well by the rather diminutive size of the planter's house, a modest story-and-a-half farmhouse of a type common to the Anglo-American communities of northern Louisiana.[12] Persac, however, confirms the importance of this modest building by giving it a generous fenced yard and a grove of substantial trees that provide a comforting shade. But these elements are all confined to the background. At the center of Persac's image is cotton, the reason for this plantation's existence. The smoke rising from the tall chimney reveals that the steam-powered cotton gin is in operation and that the harvest is in process. Eleven finished bales, collectively weighing as much as 5,000 pounds, sit at the river's edge, ready to be shipped to some distant textile mill. The large structure at the center of this scene bears a sign affixed to the apex of its roof that proclaims in capital letters that this building is a "ware house," and from its far door a gang of men wrestle a few more bales down to the river just as the steamboat *Natchez* approaches. While this is a work scene, it depicts tasks connected principally to marketing rather than to cultivation. Captured here is the moment when the planter senses that his raw fiber is about to turn into money. Persac created, once again, an image calculated to appeal to plantation owners. The tree-sized cotton plants rendered along the left-hand side of the image blocks any view of the fields where the cotton was grown. Regardless whether these oversized plants were the work of Persac or an overly ambitious New York engraver, the cotton field directs attention mainly toward the managerial decisions of the owner.

Norman's Chart not only enhanced Persac's reputation as an illustrator but ap-

FIGURE 4.2.
Marie Adrien Persac,
Cotton Plantation
*(1858). Steel engraving
for* Norman's Chart of
the Lower Mississippi
River. *Library of
Congress, Geography
and Map Division.*

parently also led to commissions from planters who discovered that their estates were indicated on this authoritative map. Their requests no doubt appealed to Persac for at least two reasons: not only would he be able to express himself creatively, but he could also reclaim, to a degree, his identity as an architect. His plantation paintings are done essentially in the manner of record drawings, renderings of the sort that architects usually prepare for a client before a building is constructed. Such works are documents intended to present a property in considerable detail. They are, finally, pleasant, colorful sketches meant to show a client's residence in the most appealing manner.

During the early stages of his career as a painter, Persac concentrated mainly on rendering structures. Although he was capable of drawing human figures, he tended more often to cut images out of magazines and newspapers and then paste them into the scene in positions suitable to their size and scale. This collage technique suggests that Persac was more focused on the tasks of architectural illustration than on the ideals of landscape painting. He recognized that human figures might enliven a scene and he did sprinkle them liberally about his paintings. However, because buildings constituted the central theme of his paintings, people were never a dominant element.

Very few of Persac's paintings survive today—probably because he preferred to work in the relatively fragile medium of watercolor—but at least five of his known plantation images are renderings of estates that appear or are mentioned on *Norman's Chart*. One of these was a painting of Philip Hickey's Hope Estate, a plantation near Baton Rouge (Figure 4.3). Persac was well acquainted with the Hickey family, as he had recorded locations for both Philip Hickey's plantation and that of his son Daniel, which was located on the west bank of the Mississippi a few miles downstream from his father's plantation. Persac's image of Hope Estate is a record

of a plantation house and its grounds; there is no action in the scene except for the presence of a passerby on a horse and some grazing livestock. Hickey's home stands in the middle ground; the foreground is dominated by an impressive fence flanked by two equally impressive dovecotes. These structures served both as shelters for yard fowl and as prominent ornaments at the entrance to the estate. Octagonal in plan and topped by cupolas sporting weather vanes, they were among the most elaborate dovecotes in Louisiana's architectural history. Indeed, Persac lavished so much attention on the details of the fence that the house becomes almost a secondary element. Still, one can clearly make out its tall hipped roof, its two-story porch, and its balanced facade. Scattered around the edges of the scene are different work buildings, including a kitchen, smokehouse, dairy, stables, and several slave quarters. The federal census of 1860 listed Philip Hickey as the owner of seventy-seven slaves and indicated that they were housed in eighteen cabins; only four of these structures are visible in the painting.

Persac composed this image by flanking the house with equivalent buildings on the left and the right. Further, the view to the house is rendered with an unobstructed sight line leading straight to its front door. Persac was careful to stand slightly to left of center as he sketched the estate to make sure that the tall arched gate of the fence would not obscure the view of the house. Captured here are the attributes of order, authority, and control, qualities that were attributed to Hickey by his neighbors. While Hickey identified himself to census takers as a "farmer," he was always addressed by his neighbors with the prestigious title of "Colonel."[13]

Because Palo Alto plantation faced Bayou La Fourche rather than the Mississippi, its boundaries were not outlined on *Norman's Chart*. However, the estate was regarded as important enough that Persac listed the name of its owner, O. Ayraud, on the map next to the town of Donaldsonville, the point where the bayou breaks away from the river. Persac's rendering of Palo Alto, a lively panoramic scene containing several discrete vignettes, contrasts significantly with his rather sedate frontal depiction of Hickey's estate (Figure 4.4). The view of Palo Alto was made from across Bayou La Fourche, which occupies the lower third of the picture. Along the bayou's shores well-dressed figures stroll, converse, and take their rest. A small sailboat glides past, while another, featuring a striped awning, is tied up to the bank. Next to a small warehouse at the center of the painting a servant tends to a horse, while its recently dismounted rider brings some message to three men who gather closely around him. Over toward the left edge of the painting a horse-drawn carriage rolls past the plantation house.

This building (which is still standing today) is rather modest in scale but tastefully decorated. A hybrid structure, representing a fusion of American and Creole architectural features, it combines a Georgian four-room, center-hall plan with a

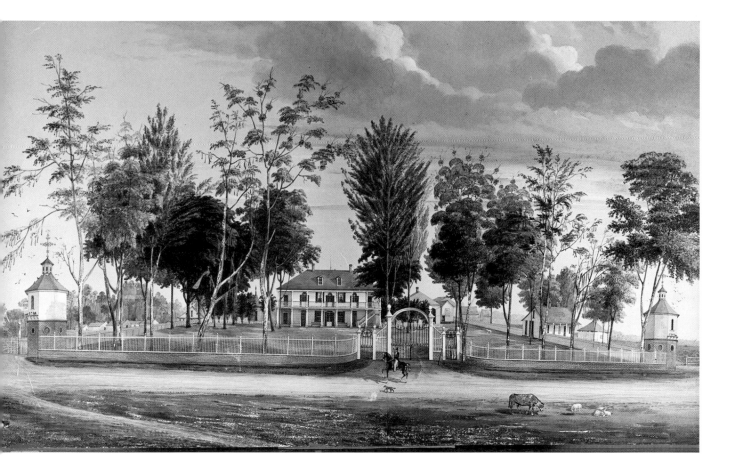

deeply undercut Acadian *gallerie*, or front porch. The social significance of the house and its owner are indicated by its Classic Revival elements, such as columns topped with Doric capitals and pedimented dormer windows. That this building is the residence of a planter is confirmed by the double row of slave cabins seen at the right-hand edge of the painting. According to the federal census of 1860 there were at that time forty-eight slaves living at Palo Alto in eighteen buildings. While these structures are also wood-frame buildings painted white, their diminutive size and the absence of any decoration marks them as places of captivity. The side-by-side contrast that Persac offers makes it very clear that even though Ayraud's house was rather diminutive when compared to most Mississippi River estates, it nonetheless functioned as a planter's "big house."

Because the estate was laid out on a narrow parcel of land that was almost four miles deep, it was logical for Persac to concentrate on the public face of the estate, which looked out on both the roadway (today Louisiana Highway No. 1) and the bayou. But Persac still managed to inventory many of the plantation's outbuild-

FIGURE 4.3.
Marie Adrien Persac, Hope Estate Plantation *(ca. 1857). Gouache and collage on paper. Anglo-American Art Museum, Louisiana State University, Baton Rouge.*

ings in his painting. When Jacob Lemann, a prominent Donaldsonville merchant, took over the estate in 1867, he noted that in addition to the "fine dwelling house" the property included stables, corn houses, a corn mill, a steam-powered sugar mill, and a set of what he called "laborers houses."[14] Persac provides glimpses of most of these structures. In fact, he is so careful with his delineation of the slave quarters that he even manages to capture the slight break in the angle of their roof lines that occurs where their front porches attach to the buildings.[15]

Both architect and artist, Persac blended his creative aspirations with the requirements of an accurate document. His painting of Palo Alto was both a lively, celebratory scene and a trustworthy statement of what was owned. Pierre Oscar Ayraud was proud of his financial success and proud to be an American (the estate was named after the great American victory over the Mexican army in 1846). He

FIGURE 4.4.
Marie Adrien Persac,
Palo Alto *(ca. 1857–1861). Gouache and collage on paper, Private collection. Arthur A. Lemann III, New Orleans.*

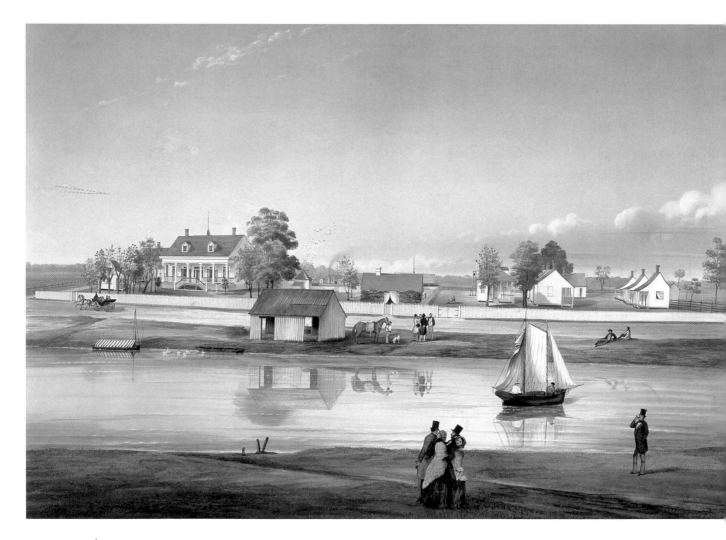

capped his achievements by commissioning Persac to create a visual record of his domestic and agricultural accomplishments. The resulting image was hung over his mantle, where Ayraud no doubt found it a reassuring proof that he had done well.

In 1857 Persac traveled farther down Bayou La Fourche, either in search of potential commissions or perhaps at the invitation of a planter who may have seen one of his plantation paintings. Venturing as far south as Terrebonne Parish, he encountered the Thibodaux family. Henry Schuyler Thibodaux had come to Louisiana from Albany, New York, in 1794 and by 1808 had settled on Bayou La Fourche. Elected to three terms in the state senate, and even serving a one-month term as governor, he was celebrated locally for sponsoring the legislation that allowed Terrebonne to be carved out of the older La Fourche Parish.[16] He also established a new home in this newly formed parish, a plantation that he named St. Bridgette; probably to honor the patron saint of his second wife, Bridgette Belanger. Located along Bayou Terrebonne near the town of Schriver, this sugar plantation would eventually encompass 1,720 acres and be worked by 177 slaves.[17] However, the founder of Terrebonne did not live to see his plantation's greatest financial success; he died in 1827 of a heart ailment. It was his wife who shrewdly built up the estate, and when she died in 1849, it apparently passed to their son Henry Claiborne Thibodaux. When Persac visited the region just eight years later, Henry Claiborne too had recently succumbed to illness, and his wife Marie, then a 37-year-old widow, was running St. Bridgette. It was either Marie or Henry Schuyler's son, Bannon Thibodaux, who commissioned Persac to paint a view of the family's first plantation.[18]

Persac's painting of St. Bridgette is very similar to his rendering of Palo Alto.[19] He again showed a modest plantation house standing on the opposite shore of a bayou, which fills out the foreground. Persac cleverly directs the viewer to look at the house by setting a wooden bridge at an angle that points right to its front door. Most of the scene is occupied by the house and its parklike yard, filled with tall shade trees. However, Persac has conveniently "pruned" the branches of those trees that stand close to the house to insure that it stands out clearly from its surroundings. Because all the people in the scene are costumed in stylish finery as they promenade and chat in small groups, there are few indications that there is any work to do or that will be done. Only the cattle that graze untended at the bayou's edge and the small houses standing at the edges of the fenced yard, probably a segment of the slave dwellings needed to house almost 200 people, serve as reminders that this is an agricultural estate. The serenity of the image is underscored by the two groups of waterfowl that glide over the placid surface of the bayou. Rev. H. B. Price, who visited this parish in 1849, lyrically extolled the

virtues of Terrebonne parish, commenting on the numerous scenes of "calmness and beauty." In a newspaper account, he observed that along the entire course of the bayou, "the houses are neatly built and with respect to comfort, and the orange and oak, and various kinds of evergreen foliage, set off the yards and present an air of tranquility to all around."[20] Price's words, which easily could have served as descriptions of Persac's paintings, were meant to encourage new investment in the expanding sugar industry. This aim was similar to Persac's artistic goal; he endeavored to create a positive view of the plantation system by rendering images that were both optimistic and genteel. His beatific scenes offered visual proof of the worthiness of the planter's vocation, one that Price had already labeled as both "profitable and pleasurable." Historian Sally Kittredge Reeves refers to the effect as one of "outright bliss."[21]

The majority of Persac's surviving plantation paintings depict properties located in the so-called Teche Country, the five parishes west of the Atchafalaya River that are all drained by Bayou Teche. Since all of these works were completed in 1861 and depict sites located very close to one another (indeed some of them were adjacent plantations), it is apparent that these images are all the result of a single prolonged visit. Why Persac chose to travel to the Teche region is unknown but nevertheless understandable; the area was full of potential clients, planters who were flush with sugar profits. Further, this was a region with a pronounced French identity; of the 170 planters in St. Mary and St. Martin Parishes listed in an 1853 census, 112 were French-speaking Creoles.[22] As a recently arrived French emigré, Persac was probably intrigued that the town of St. Martinville was known as "petit Paris."[23] With his curiosity peaked, he undertook a trip to see the place firsthand.

The Teche Country was easily accessible from New Orleans via regularly scheduled steamboat connections. A traveler needed spend only $8 for a ticket, and three days later he could step ashore in New Iberia, then the most prominent port on the Teche. It was here in 1860 that Persac met William F. Weeks, owner of several plantations, a salt works, and the most impressive house in town, called Shadows-on-the-Teche. It is uncertain whether this was the first property that Persac painted, but there is evidence that he produced more images for the Weekses than for any other local family. In addition to two views of Shadows, Persac also made preparatory sketches for a painting of the family residence on Weeks Island, and one other Persac painting is also described in the family's correspondence.[24]

Because Shadows-on-the-Teche is located right in the center of New Iberia, it is more accurate to describe the building as a villa rather than as a plantation house. Situated on a sizable town lot with 915 feet of bayou frontage, it also faced Main Street.[25] While rendering a view of the front of the house, Persac offers something

of a bird's-eye view as seen from across the street (Figure 4.5). The front yard of a neighboring home and the public street fill the foreground of the image. Shadows itself barely emerges from the trees, and because only the front wall of the house is visible, the building seems almost two-dimensional. The companion view of the back of the house, however, illustrates the depth of the lot (Figure 4.6). Sketched from the open ground on the opposite shore of the bayou, the scene is dominated by tall trees draped with Spanish moss. The viewer is compelled to peer deeply across the yard in order to catch a glimpse of the house: a bit of roof up here, a window over there, a doorway down here. The kitchen, several sheds, and the cistern can be made out as well. The bayou side of the property proves to be an active place, as men and women stroll along its banks and two small boats secured to the far shore are ready to receive passengers. One wonders if Persac painted these two contrasting views—one of them more public, formal, reserved, and rational; the other more private, casual, approachable, and emotional—in order to show the complexity of the place or simply because he was following a landscape tradition entailing the use of multiple views. While both are plausible motives, the paired views certainly show the property to have a visual prominence commensurate with the great wealth of William Weeks. He not only owned over 10,000 acres spread over seven plantation properties, but also, according to the 1860 federal census, 212 slaves, who raised his sugar and mined his salt.[26] It was probably Weeks who felt that more than one painting was needed to adequately record his home. Today they hang as pendant paintings on either side of the mantle in the parlor of Shadows-on-the-Teche, much as they must have when they were first commissioned.

Just ten miles down the bayou from New Iberia stands Albania, the plantation home built by Charles Grevemberg some time around 1850. While equivalent in scale to Shadows-on-the-Teche, Albania had classic revival decoration that was considerably more demonstrative. Its bayou facade, for example, featured an imposing two-story portico.[27] As Persac's painting shows, the house stood out more clearly to passersby than did Weeks's villa. Persac presented Albania as a gleaming white edifice behind an equally gleaming line of pickets.[28] Since the painting shows the rear of the house, it also shows the quarters for the house slaves, cisterns for storing drinking water, a pair of modest dovecotes, and other miscellaneous structures. Given the prominence of the Grevemberg family in the Teche region, it seems unlikely that Persac would have been commissioned to paint only the house's bayou (rear) approach. It is more likely that he was asked to produce both front and back views.

When Persac visited the area around Spanish Lake, just north of New Iberia, he momentarily abandoned his usual manner of rendering a plantation painting. Be-

FIGURE 4.5.
Marie Adrien Persac,
Shadows-on-the
Teche *(1861), front
view. Gouache and
collage on paper.
Collection of Shadows-
on-the Teche, New
Iberia, Louisiana,
a National Trust
Historic Site.*

FIGURE 4.6.
Marie Adrien Persac,
Shadows-on-the-
Teche *(1861), rear
view. Gouache and
collage on paper.
Collection of Shadows-
on-the Teche, New
Iberia, Louisiana,
a National Trust
Historic Site.*

cause the house of Despanet de Blanc stood on a prominent ridge overlooking the lake, it was initially dubbed Le Coteau (The Hill), but some years later de Blanc opted for a more lyrical name, appropriating the title of Sir Walter Scott's poem "Lady of the Lake." Wishing to focus on the oddity of a bit of high ground in bayou country, de Blanc clearly chose names that called attention to the unique scenic features of his plantation. Persac was equally impressed with the view from the hill.[29] Eschewing his usual frontal approach, here he stood behind and off to the side of the residence while making his sketches, a move that insured that Spanish Lake would be visible in the background. Had he kept the lake behind him and faced the house straight on, the resulting image would have been little more than a record of a house. But in Persac's rendering the outbuildings are given greater prominence, while the house is effectively screened from view by a dozen young saplings. Finding the Teche landscape a redundant sequence of levee vistas backed by stretches of marsh and swamp, Persac recognized that the slightly elevated position of Lady of the Lake was special. Here he abandoned his more architectural approach to painting plantations to try his hand at a bit of scenic landscape.[30]

Because the Teche Country was a major sugar-producing region, some of Persac's images understandably focused on sugar, the so-called white gold that was so emblematic of the agricultural economy of southern Louisiana during the antebellum period.[31] In his images of St. John and Olivier plantations, sugar refineries—usually called "sugarhouses"—are prominently featured. St. John plantation was established in 1828 by Alexandre de Clouet about a mile north of St. Martinville, and by 1860 he had become the largest slaveholder in St. Martin Parish; the census listed him as owning 226. Just as the ownership of large numbers of slaves was a proof of one's high social status, so too was ownership of a lavish estate. Persac records that the brick sugarhouse at St. John was more ornamented than most (Figure 4.7). Outfitted with tall, round-headed windows in its gables, the building also featured an unusual clerestory formed by two bands of windows running completely around its eaves.[32] But Persac gave most of his attention to the house at St. John, which was famous for its orange grove and its avenues of pines flanked by oaks.[33]

When Persac painted Olivier (also known as Orange Grove), which was located about four miles below New Iberia, he again surrounded the residence with an array of buildings (Figure 4.8 [Plate 9]). The brick sugarhouse, while lacking the decorative features of the St. John refinery, is nevertheless clearly delineated as a substantial building. Also included in the scene are a warehouse, a dovecote, and the overseer's house. All these buildings are reflected on the glassy surface of Bayou Teche, which fills the lower half of the painting, a mirrored image that cleverly doubles the visual impact of the plantation. Using this scenic technique, Per-

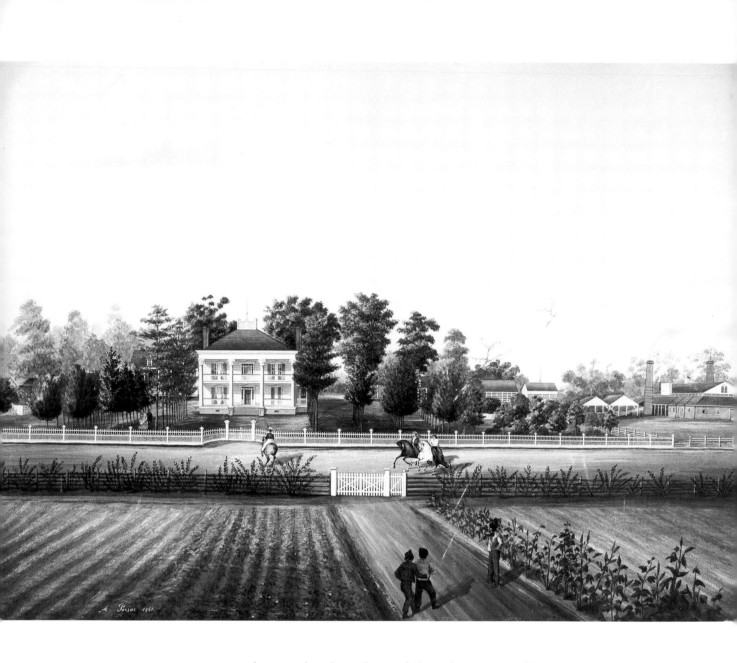

FIGURE 4.7.
Marie Adrien Persac,
St. John Plantation
(1861). Gouache and
collage on paper.
Anglo-American Art
Museum, Louisiana
State University,
Baton Rouge.

sac underscored and emphasized the achievement of the estate's owner Charles Olivier.

At the Bois de Fleche plantation in St. Martin Parish the Delhomme family raised cotton. In the same manner in which he had paired planter's houses with sugar mills in some of this other paintings, in his image of Bois de Fleche Persac placed the house on one side of the horizontally arranged composition and a cotton gin and a press for forming bales on the other (Figure 4.9). Careful to include a full complement of associated agricultural structures, Persac also highlights the different areas of the property and their designated functions by showing that

they are surrounded by the appropriate types of fences. The yard of the main house, an ornamental space intended to convey status, is surrounded by a fancy picket fence, while the functional work yard is enclosed by a barricade of unpainted rails. But what appears to have fascinated Persac most about this site was the garden seen in the foreground. Meticulously rendered plant by plant, the garden so dominates the painting that the plantation recedes into the background, almost becoming little more than atmospheric scenery. It seems that A. Persac, artist and engineer, became for moment A. Persac, botanist.

In all of his images of plantations in the Teche Country, indeed in all of his plantation paintings, Persac generally avoided painting black people. Given that in 1860 African Americans constituted approximately 65 percent of the population in the Teche parishes and more than 90 percent in Terrebonne Parish, their general absence from Persac's plantation landscapes was clearly the result of a deliberate choice.[34] While he regularly included slave quarters in his paintings, these buildings are never provided with any occupants. The resulting emptiness of his scenes contrasts markedly with the observations of Thomas Bangs Thorpe, who, after touring the booming sugar estates of Teche region in 1853, reported indications of significant slave initiative:

> In the rear of each [slave] cottage, surrounded by a rude fence, you find a garden in more or less order, according to the industrious habits of the pro-

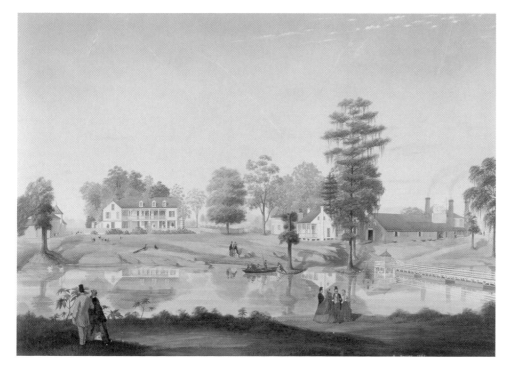

FIGURE 4.8.
Marie Adrien Persac, Olivier Plantation *(1861). Gouache and collage on paper. From the Collection of the Louisiana State Museum, New Orleans. (Reproduced in color as Plate 9.)*

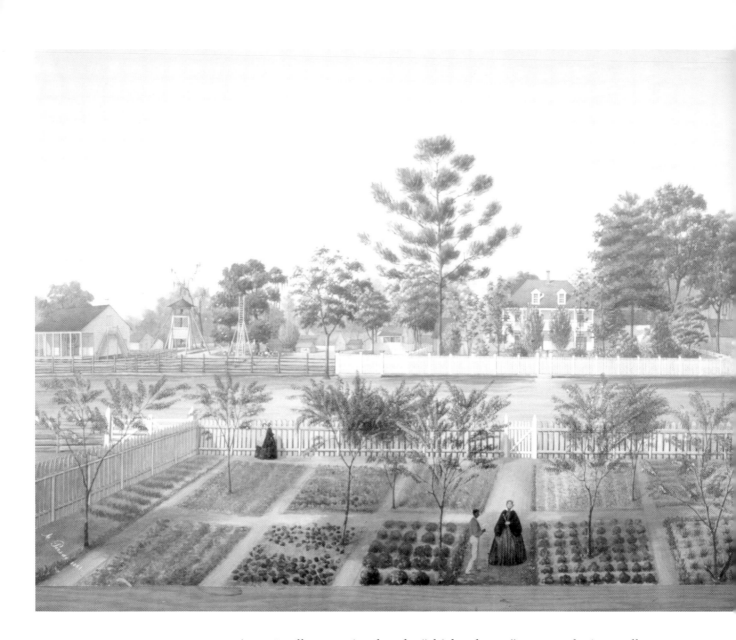

prietor. In all you notice that the "chicken house" seems to be in excellent con-
dition, its inhabitants are thrifty and well-conditioned. Above these humble
enclosures, rise many tall poles, with perforated gourds suspended from the
top, in which the wren, the martin, and other socially-disposed birds make a
home and gratify the kindly-disposed negro.[35]

Persac generally avoided those portions of the plantation that had been claimed
by African Americans. Not only are black figures scarce in Persac's paintings, but
when they appear they are presented in an unlikely manner, dressed in clothes
well above the standard provided for enslaved laborers.

One painting that unflinchingly indicates a large black presence is Persac's rendering of Ile Copal, the estate belonging to Alexandre Mouton.[36] Located on the banks of the Vermillion River just eight miles to the west of Bayou Teche, the plantation extended over 1,900 acres of what is today the eastern edge of the city of Lafayette.[37] The plantation's famous owner, Alexandre Mouton, after serving in the United States Senate, was governor of Louisiana from 1843 to 1846. At the end of his term he retired to his plantation but remained a force in state politics; he would later serve as president of the Louisiana Secession Convention in 1861.[38] Given that Mouton's strong state's rights and pro-slavery positions were well-known at the time Persac was preparing his painting of the governor's estate, the unobstructed view of a row of his slave cabins may have been included as a material confirmation of his client's political convictions.[39] However, given that the federal census of 1860 indicated that Mouton owned 131 slaves, who were quartered in twenty-five houses, Persac's inclusion here of a larger than usual number of slave cabins may have been nothing more than an accurate record of the buildings that stood in front of him. Falling back on his usual compositional strategies, Persac included no blacks in his painting. Instead he focused on an elegantly dressed white family, presumably the Moutons, who are shown cantering their horses in the front yard. This scene reads like all his others—that is, as an elegant place where white people have the opportunity to enjoy unlimited leisure. That was, in fact, the ideal that most planters hoped they would attain. It was a goal that Alexandre Mouton actually reached.

The one painting in which Persac treats chattel slavery as a subject is his image titled *Riverlake Sugarhouse*.[40] During his survey of Mississippi River estates in 1856, Persac had visited Riverlake, an estate located near the town of Oscar in Pointe Coupee and owned by Arthur Denis. However, given that the plantation was not too far from the home of his in-laws, Persac could have painted this scene of a sugar harvest as early as 1855. It is an ambitious panoramic view, three and a half times larger than any of his other known plantation paintings. Almost four feet long, this horizontally arranged composition presents a large sugar mill at harvest time, a rambling complex of buildings and sheds that occupies much of the upper half of the image.

In the lower portion of the painting Persac renders a slave gang at work. Under the watchful eye of a white foreman mounted on a white horse, a long line of black men are shown cutting cane. A handful of others gather up the fallen stalks and load them on wagons. While the scene is full of action, the antlike scale on which the enslaved workers are rendered causes them to be overshadowed by the mill. It is the sugar industry that stands out most in this painting. Nineteenth-century visitors to Louisiana, subjected to monotonous views of endless miles of cultivated

fields, were usually excited by their encounter with sugar mills. While traveling down the Mississippi, Pierre de Lausatt wrote that the sugarhouses in operation at harvest time were "a spectacle providing us with great entertainment on our journey."[41] To see a sugar refinery at night was like watching a display of fireworks. Persac, trying to capture the spectacle of harvest, strives in his painting of the Riverlake refinery to demonstrate the eminence of these huge factories, which rose up grandly in the midst of the fields.[42]

Although many slaves are included in the Riverlake painting, they are a minor visual element, minuscule black flecks in the sea of cane. Like the two generic images of sugar and cotton plantations that Persac created for *Norman's Chart* (Figures 4.1 and 4.2), *Riverlake Sugarhouse* focuses on the planter's achievement rather than the slave's condition. Consequently, the painting aligns with the prevailing sentiment of the day, which held that slaves were not to be seen as people but as the equipment necessary for the efficient operation of a plantation. During the harvest season the tasks required on a sugar plantation were particularly harsh. According to Ellen Betts, a former slave on a Bayou Teche estate, "to them what work hour in, hour out, them sugar cane field sure stretch from one end of the earth to another."[43] Striving to create a pleasant and entertaining prospect, Persac conveys not even a hint of the cruelty of plantation slavery. He was, after all, most interested in celebrating the achievements of his planter clients.[44]

All of Persac's plantation paintings were completed early in his career, at a time when his images display more the approach of a draftsman than an artist. His plantation scenes consisted largely of frontal views in which the house, the primary element in the composition, was placed very near the center of the image and was flanked by balancing elements. Alternatively, the house was located to one side of the painting and paired with a cluster of subordinate structures on the other. With the elements of his pictures commonly arranged horizontally, the content is presented laterally across the image, in the manner of a mechanical drawing. Persac tried to overcome the feeling of two-dimensionality in his landscapes by adding human figures in the foreground, but this tactic, in the end, proved inadequate. As an engineer, Persac was familiar with scaled drawings wherein no attribute of an object or structure remained implicit or was left to the imagination. Persac's landscapes thus share with mechanical drawings the same rigor of execution and intense focus on minute details. He felt compelled, it seems, to render every board, shingle, and brick. He was apparently delighted when required to include fences, since he was so good at drawing every individual picket. His discipline as a draftsman, while admirable, was also his chief flaw as a painter of landscape, for he seems not to have appreciated fully that a compelling landscape was, in fact, more than the recorded sum of the various parts of a scene. That one might

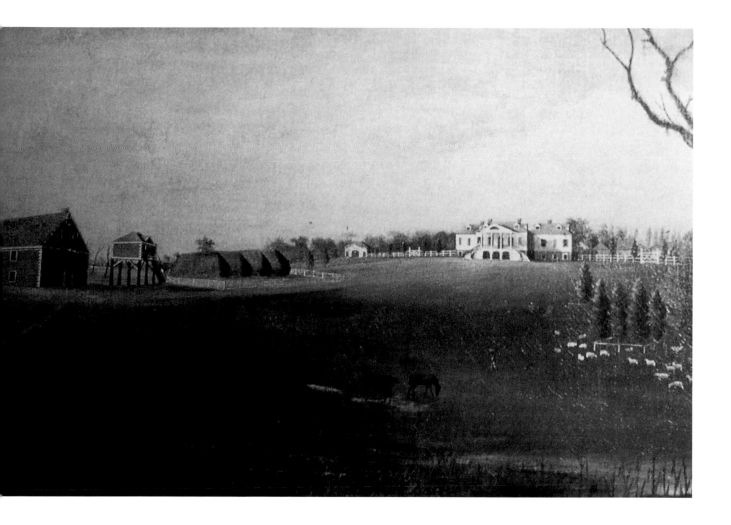

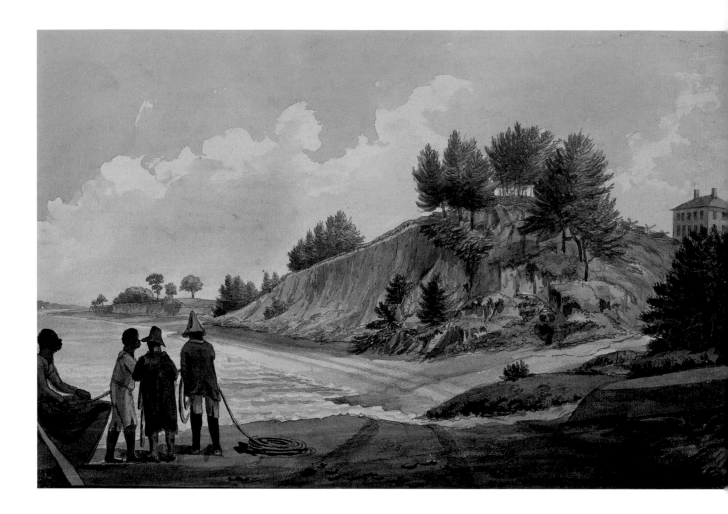

PLATE 2.
Benjamin H. Latrobe, View of the Fishing Shore on York River at Airy Plains, looking to the East *(1797).*
Pen-and-ink and watercolor on paper. Maryland Historical Society, Baltimore, Maryland.
(Also appears as Figure 1.16.)

ATE 3.

Addison Richards, River Plantation *(ca. 1855–60).*

l on canvas. Morris Museum of Art, Augusta, Georgia.

lso appears as Figure 1.22.)

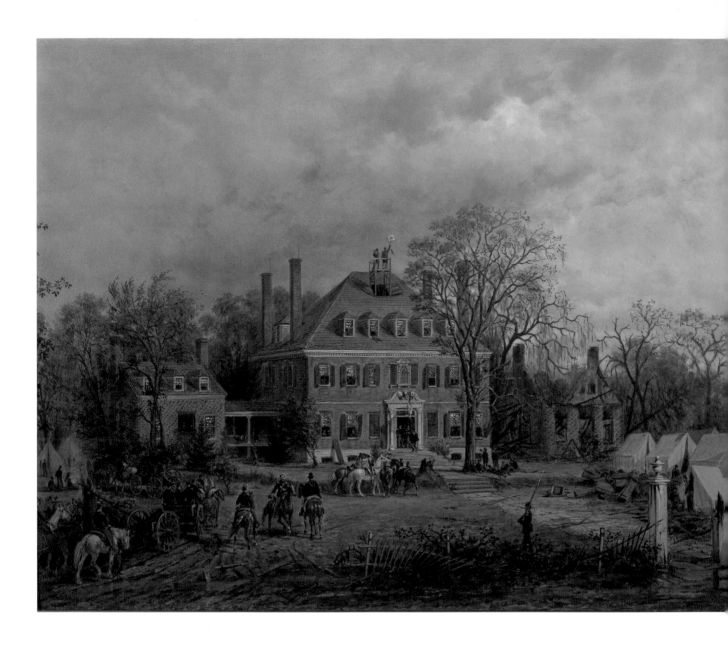

PLATE 4.

Edward Lamson Henry, Old Westover Mansion *(1869). Oil on panel.*

Collection of the Corcoran Gallery of Art, Washington, D.C. Gift of the American Art Association.

(Also appears as Figure 1.26.)

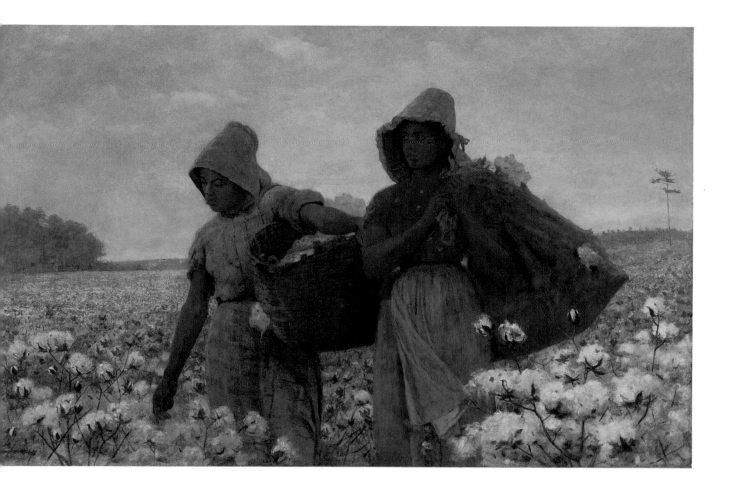

PLATE 6.
*Anna Heyward Taylor, Fenwick Hall (1930). Watercolor on board.
Greenville County Museum of Art, Greenville, South Carolina.
(Also appears as Figure 1.37.)*

PLATE 7.

Francis Guy, Perry Hall *(ca. 1805). Oil on canvas.*
The Maryland Historical Society, Baltimore, Maryland.
(Also appears as Figure 2.5.)

PLATE 8.
Charles Fraser, Mr. Gabriel Manigault's Seat at Goose Creek *(1802). Watercolor on paper.*
Gibbes Museum of Art/Carolina Art Association, Charleston, South Carolina. Gift of Alice Ravenel Huger Smith.
(Also appears as Figure 3.9.)

PLATE 9.

Marie Adrien Persac, Olivier Plantation *(1861). Gouache and collage on paper.*
From the Collection of the Louisiana State Museum, New Orleans.
(Also appears as Figure 4.8.)

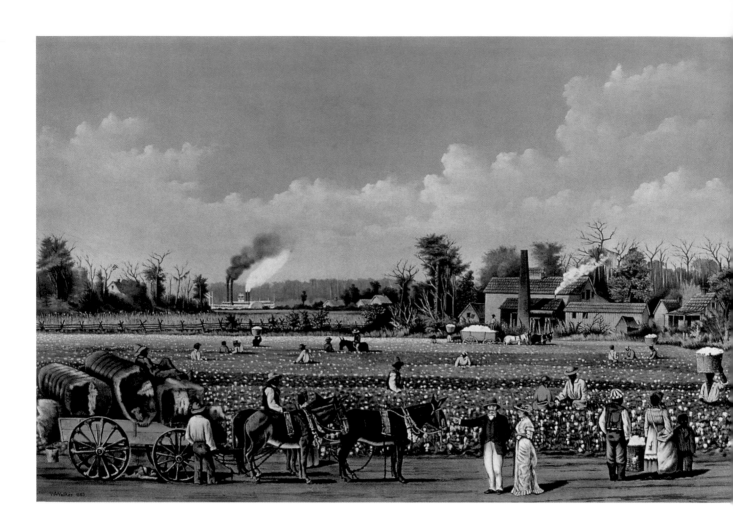

PLATE 10.
William Aiken Walker, A Cotton Plantation on the Mississippi *(1884). Chromolithograph.*
Currier & Ives, New York. Library of Congress, Prints and Photographs Division.
(Also appears as Figure 6.3.)

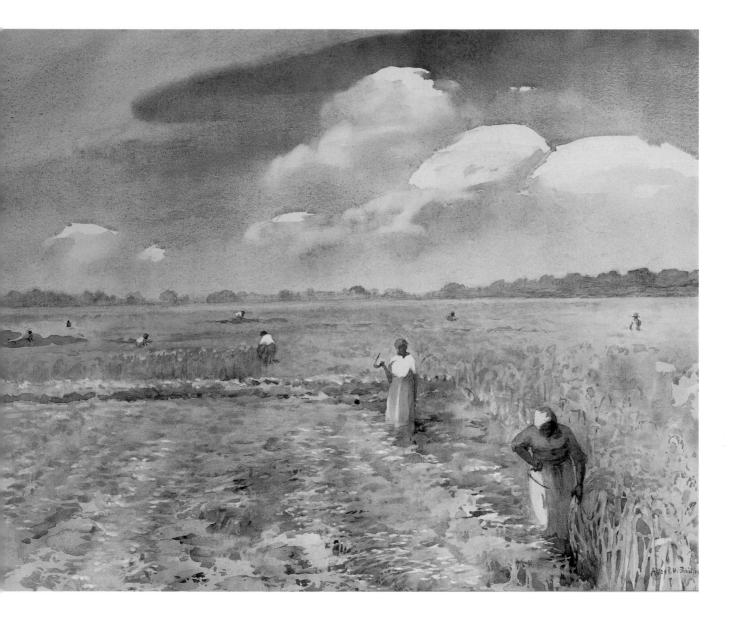

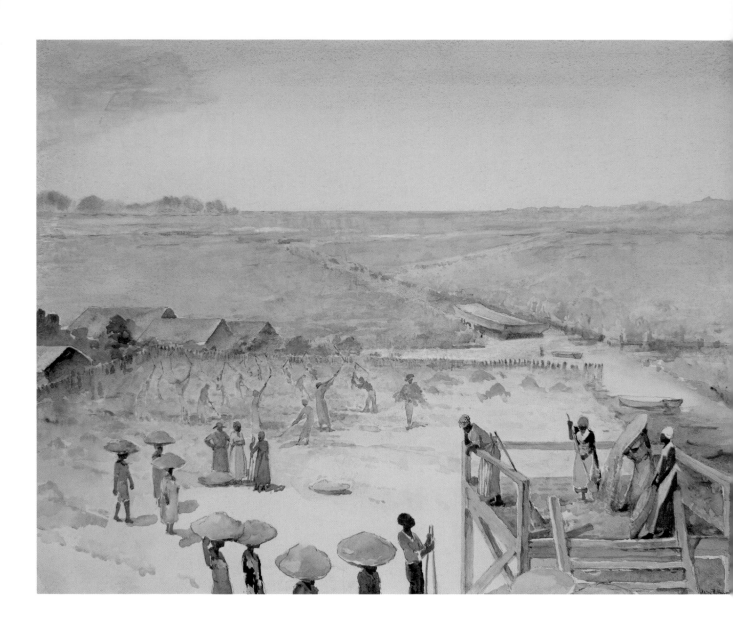

PLATE 12.
Alice Ravenel Huger Smith, The Threshing Floor with a Winnowing-House.
Watercolor on paper. Gibbes Museum of Art/Carolina Art Association, Charleston, South Carolina.
Gift of the artist. (Also appears as Figure 7.17.)

utilize the nuances of light and atmosphere to develop a dramatic, compelling sense of narrative was a possibility that he generally overlooked. Content to compose a thorough inventory, Persac seems to have had only a passing concern for the possibilities of symbolism. His ensembles of houses, outbuildings, fences, plants, trees, and streams are finally too neat to be believed, too good to be true. What he managed to create were overly optimistic scenes rendered in lovely watercolor tints, flattering portraits of planters' properties meant to honor their dreams of success.

Persac's images constituted a pleasant propaganda that covered plantation life with a sweet veneer of tranquility. The brutality of the plantation system, however, was evident to anyone who cared to notice. Plantations operated under a rule of violence. Vicious beatings were universally sanctioned as the standard managerial tactic; the whip served as the planter's chief emblem. It would, of course, be someone like Mary Reynolds, a former slave on a Louisiana sugar cane plantation, who might comment on the horrors of the plantation regime. Interviewed in 1937, when she was past 100 years old, she could still vividly recall the years of slavery:

> Slavery was the worst days was ever seed in the world. They was things past telling, but I got scars on my body to show to this day. I seed worse than what happened to me. I seed them put men and women in the stock with they hands screwed down through the holes in the board and they feets tied together and they naked behinds to the world. Solomon the overseer beat them with a big whip and Massa look on. The niggers better not stop in the fields when they hear them yelling. They cut the flesh 'most to the bones, and some of them when they taken them out of stock and put them on the beds, they never got up again.[45]

Sadistic acts were commonplace. Hunton Love, who lived on a Bayou La Fourche plantation, witnessed "a woman . . . throwed on a bed of ants which they had caused to 'semble. She was tied down with heavy weights so she couldn't budge. She was tortured awful."[46] Others testified that they saw pregnant women who were about to give birth savagely whipped when they did not work fast enough to make their assigned quota during the harvest season.[47] Slaveholders hoped that such outrageous punishments would make their captive workers so compliant that they would think of nothing other than their task. Solomon Northup, a free black who was kidnapped in New York and sold to a Louisiana planter in 1841, knew firsthand how daily floggings could make a slave fearful, anxious, and constantly worried about his owner's next unpredictable tirade. But he noted as well that such behavior also had a debilitating effect on white people: "Daily witnesses

of human suffering—listening to the agonizing screeches of the slave—beholding him writhing beneath the merciless lash—bitten and torn by dogs—dying without attention, and buried without shroud or coffin—it cannot otherwise be expected, than that they should become brutified and reckless of human life.[48]

That slaveholding could transform otherwise decent men and women into inhumane brutes may never have occurred to Persac's clients, but if they sensed, even for a moment, that the plantation system was morally suspect, they could have turned to his paintings to find an attractive counter-argument. How, they might have mused, could a place as nice as this be connected in any way to evil deeds? Given that planters certainly wanted to think well of themselves, Persac provided a valuable service. He rendered comforting visions of slavery by reassuringly presenting the plantation as a civilized and civilizing place.

After completing his last paintings of the Teche plantations in 1861, Persac remained in New Orleans for the duration of the Civil War, finding work painting posters that advertised houses for sale.[49] After the war there were no further requests for his portrayals of plantations. The majority of Louisiana's plantations, having been vandalized and looted by invading Union troops, were in ruins. The fate of Joseph Tucker's plantation was typical; in 1863 the recorder of deeds for La Fourche Parish wrote: "No horses, mules, cattles, or other animals to be found. Implements of husbandry are not generally in good order and are so scattered about in such a manner as not to be found in lots for appraisal. No household furniture is to be found in any buildings on the premises."[50] Of course, the slaves were gone too, and without them, the planters no longer had the means to generate the fantastic profits they had enjoyed during the prewar decades. The days of antebellum grandeur were gone forever, and so was the prospect of commissions for future plantation landscapes.

Persac's prudent response was to turn to new artistic enterprises. In 1865 he opened a photography studio, and four years later he advertised himself as the director of an "Academy of Drawing and Painting." At this academy he listed his specializations as "Portraits and Landscapes in oil and water color." While no portraits or any works in oil by Persac are known today, by 1870 he was looking to establish himself as a member of the expanding community of New Orleans artists.[51] But his growth as an artist did not diminish his long-standing interest in engineering; the same judges at the "Grand State Fair" that awarded him high artistic honors in 1870 also presented him with a certificate for the "best safeguard for city railroad cars." Like the fabled multitalented figures of the Renaissance, Persac tried to do many things well, and to some extent he succeeded.

His last known artwork was allegedly a portrait of presidential candidate Horace Greeley, done in 1872 in collaboration with Paul Poincy. As he honed his cre-

ative skills and developed new interests, Persac seems to have abandoned plantation landscapes. Realizing that there was little glory and no profit to be gained in creating pictures of sites that had been reduced to tattered memories, he apparently never painted another plantation scene. The end of slavery also proved to be the end of Persac's plantation landscapes.

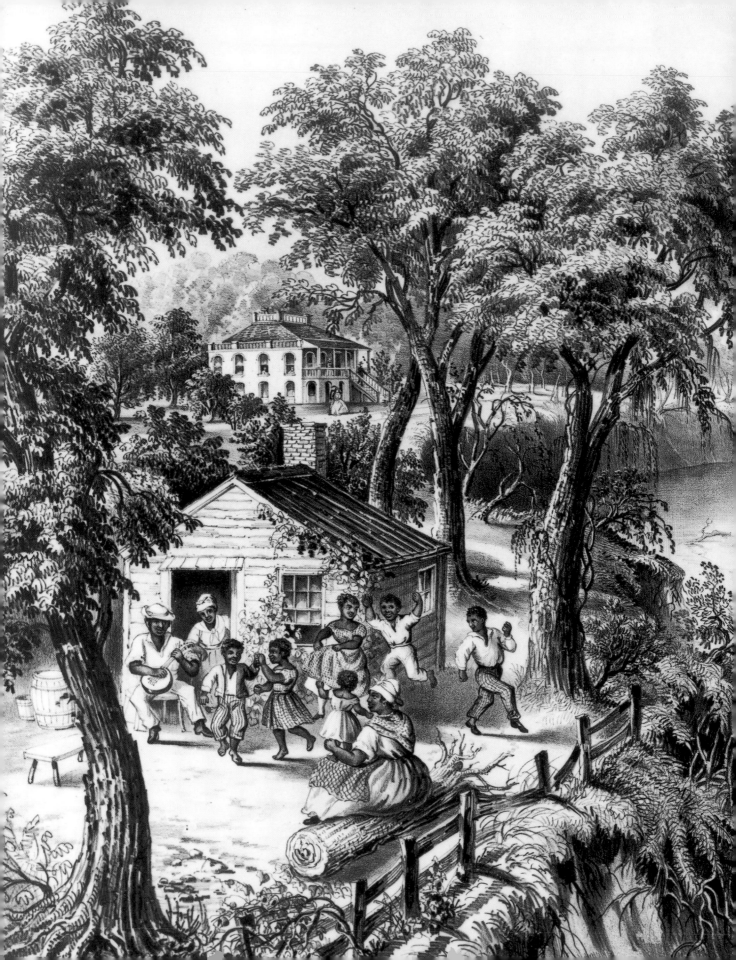

For most of the nineteenth century the lithography company of Currier & Ives provided middle-class Americans with a steady supply of pleasant and reassuring images with which to decorate the walls of their homes. Shrewdly assessing the nation's taste in art, Currier & Ives identified itself as "The Grand Central Depot for Cheap and Popular Pictures."[1] Eventually the firm's catalogue would include almost 7,500 prints, most of them produced in runs of several thousand each. True to the company's claim that its pictures would be affordable by the average person, prints were priced at twenty cents a piece or six for a dollar.[2]

Given its high sales volume, it is not surprising that the Currier & Ives workshop was known as "the factory." Located in a five-story building in downtown Manhattan, the firm carried out the various stages of production on the upper three floors. After the inked outlines of the images came off the lithographic stones, they were carried to the fifth floor, where they were colored by hand in an assembly-line fashion by teams of women workers. According to print historian Roy King, "each woman worked in a different color: the first might wash in a blue sky, the next a green background of trees, another added the chestnut coat of a horse."[3] At the end of the line, the final details were added by a specialist known as the "finisher." Although the identities of these female colorists remain cloaked in anonymity, it was a woman, Frances Flora Bond Palmer, who became the most prominent artist on the Currier & Ives staff (Figure 5.1). Better known as Fanny Palmer, she has had approximately 200 prints attributed to her, and she surely added her personal touches to many more. Given the widespread enthusiasm for Currier & Ives images, one is inclined to agree with Ewell L. Newman, who concluded, "It is likely that during the latter half of the nineteenth century more pictures by Mrs. Fanny Palmer decorated the homes of ordinary Americans than those of any other artist, dead or alive."[4]

Surprisingly, despite her evident ability to satisfy the demands of American popular taste, Palmer was not an American. Born in Leicester, England, in 1812, she received her artistic training at Miss Linwood's School, a girl's seminary in London. She would eventually teach some art classes and, under her husband's name, establish a lithography business. An 1842 advertisement for E. S. Palmer,

Lithographic Printer, which appeared in the *Trade Directory of Leicester*, announced the availability of images "executed in the highest Parisian and London taste, and in the first style of art."[5] Although her renderings of the Leicesterhire countryside were well received—the local newspaper reported that they had a "boldness and freedom not often exhibited by the female pencil"—the Palmers' print business failed, and so they decided to emigrate to the United States.[6] Landing in New York in 1843, they quickly opened a new shop.

Palmer recognized that there was a strong demand for images, and she was shrewd enough to realize that what the American public wanted most were American scenes. Her new images included views of cities, renderings of military victories, pictures of the homes of patriots, and depictions of recently constructed bridges, viaducts, and public buildings. These images all appealed to nativist feelings of pride in the achievements of a growing nation; her images apparently wore well in the era of Manifest Destiny. Noting that Palmer's prints sold quite well, Nathaniel Currier acquired the rights to several of her works, including *View of New York from Brooklyn Heights*, *New York from Wehawken*, and *High Bridge at Harlem*, all of which he republished in 1849. Two years later when the Palmers' business went into bankruptcy, Currier not only bought up their remaining stock of prints but also hired Fanny Palmer as a full-time artist-delineator.

Palmer's talents, first honed on the subject of rural English landscape, were soon harnessed to the ideological project of Currier & Ives. According to art historian Stephen Daniels, the firm sought to provide the American populace with a "respectably Protestant, progressive image" via repeated scenes of domestic bliss, weekend sportsmen, moral and religious subjects, and representations of new forms of speedy travel, represented by modern steam-powered ships and locomotives.[7] One of Palmer's earliest contributions to Currier & Ives's vision of the American way of life was a set of four large folio prints in 1853 entitled *American Farm Scenes*. While these scenes bear some resemblance to her earlier prints of Leicester, they were intended as presentations of calm and peaceful settings that displayed the success and contentment available to all who might choose to pursue an American brand

FIGURE 5.1.
Portrait of Frances Flora Bond Palmer, ca. 1865. *Photograph. Harriet Endicott Waite research material concerning Currier & Ives, 1923–1956, Archives of American Art, Smithsonian Institution.*

of happiness. Not only was Palmer's English style easily assimilated into the Currier & Ives canon, but she quickly became the quintessential Currier & Ives artist. Art historian Charlotte Rubinstein points out that Palmer became "an excellent team member because of her willingness to work with other artists."[8] Given the task of providing backgrounds for many prints, it was her duty chiefly to supply the appropriate reassuring atmosphere for the millions of prints that were to hang in parlors and living rooms throughout the United States.

The consistency of Palmer's work owed not only to her personal way of handling content and perspective but also to the limited focus in the sources of her inspiration. While she generally created her sketches from nature, she never traveled beyond the suburbs of New York City. Currier would arrange for her to ride out into the nearby countryside in his carriage so she might render whatever was needed by way of sky, clouds, foliage, or rural and riverside views. She was thus at a disadvantage when tasked with producing convincing scenes for the rest of the continent. While she could turn to paintings, lithographs, and photographs for some inspiration, in a picture like *The Rocky Mountains—Emigrants Crossing the Plains* (1866) she has the heroic pioneers trudging past sizable trees more typical of a northeastern forest, the likes of which were never seen on the western prairies. In one of her most celebrated works, *Across the Continent—"Westward the Course of Empire Takes Its Way"* (1868) (Figure 5.2), she creates an alluring parable of conquest with an invented vista of the Far West representing no place in particular. But the print offers an appealing prospect, and that was all that mattered both to the public and her employers. Currier & Ives had found in Fanny Palmer a most useful instrument for drawing America as most Americans wanted it to be.

While Currier & Ives came to be regarded as "printmakers to the American people," the America they printed was generally confined to the nation's northern segment. Only forty-four of their images, considerably less than one percent, depict southern states. And seven of these prints are renderings of places explicitly connected to celebrated individuals, rather than images meant to convey a regional vista. Preferring to situate most of their renderings of American domesticity in upstate New York or New England, the firm avoided the South as a source either for scenery or for sentimental imagery.

To understand their regional bias, it is important to know that Nathaniel Currier and James Ives were both members of New York state militia units during the Civil War and that Ives, a captain in the Twenty-third Regiment of Brooklyn, saw battle in Pennsylvania. That their sentiments were pro-northern, if not patently anti-southern, is indicated not only by the dearth of southern pictures in their catalogue but also by their renderings of Civil War battle scenes. *The Battle of Spotsylvania, Va. May 12, 1864*, for example, bears a legend proclaiming it "the greatest

victory of the war" when, in fact, Grant had lost almost 60,000 men in this particular campaign.[9] The main purpose of these images was to instill faith in the Union cause rather than present to the public the bitter truth about Grant's brutal tactics, which might have caused them to question his pursuit of a crushing, absolute victory.

In the aftermath of the Civil War there was a great curiosity in the North to know what the defeated southern region looked like. As journalists toured the region, offering their observations in publications like *Harper's Weekly* and *Frank Leslie's Illustrated Newspaper*, Currier & Ives also sought to capitalize on this new popular interest. Toward this end, they offered a number of images that focused on the drama and excitement of river travel. Fanny Palmer was directed to execute a set of steamboat pictures, which included *The Champions of the Mississippi* (1866), *Rounding a Bend on the Mississippi* (1866), and possibly *Through the Bayou by Torchlight* (undated). These works use the format that she developed in two of her earlier renderings, *A Midnight Race on the Mississippi* (1860) and *"Wooding Up" on the Mississippi* (1863) (Figure 5.3), both of which highlight the marvelous architectural decorations of the vessels often referred to as "floating palaces." These prints anticipated by twenty years rousing tales that Mark Twain would provide in

FIGURE 5.2.
Frances Flora Bond Palmer, Across the Continent — "Westward the Course of Empire Takes Its Way" *(1868). Hand-colored lithograph, Currier & Ives, New York. Library of Congress, Prints and Photographs Division.*

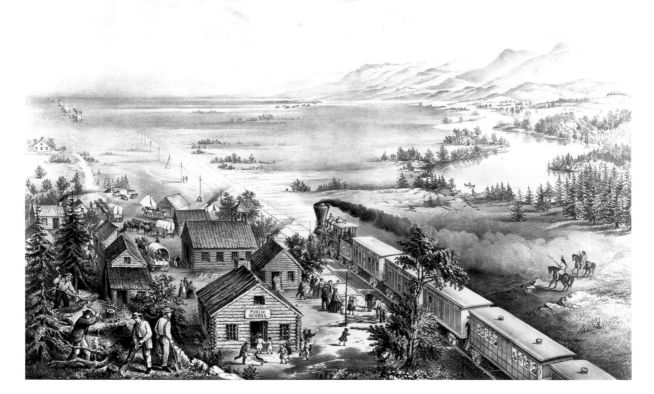

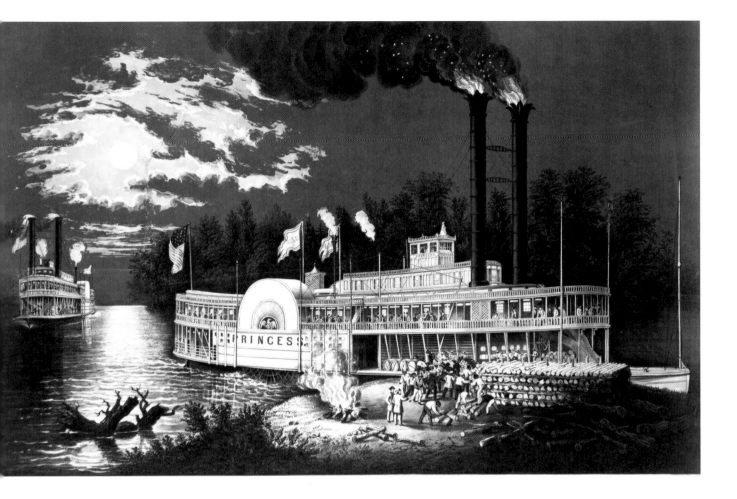

his book *Life on the Mississippi*.[10] In all of Palmer's scenes, glorious vessels, ablaze with light and spewing flames from their smokestacks, churn their way toward some undeclared destination. In fact, the river settings seen in these prints were so generic that they could have been imagined as being anywhere between Iowa and Louisiana. Except for their titles, there is no way of knowing that these are even southern images. But the great Mississippi River, the "father of all waters," was certainly understood to be an emblem of the South, and Currier & Ives deliberately seized its symbolic power as they sought to put their vision of the formerly rebellious region before the public.

After Lee's surrender at Appomattox in 1865, Palmer was directed to create *The Mississippi in Time of Peace* and *The Mississippi in Time of War*, a pair of river scenes that reiterated the moral lesson of the Civil War. The peacetime image presented a scene of energetic commerce by showing the mighty Mississippi River full of vessels (Figure 5.4). Five steamboats (both side-wheelers and stern-wheelers), a sail-

FIGURE 5.3.
Frances Flora Bond Palmer, "Wooding Up" on the Mississippi (1863). Hand-colored lithograph, Currier & Ives, New York. Library of Congress, Prints and Photographs Division.

powered ferry, and a flatboat ply the muddy waters. Palmer has her flatboat, a vessel along with its crew that was appropriated from George Caleb Bingham's celebrated painting *The Jolly Flatboatmen* (1846), glide right up to the front of the image.[11] Most of the crew relaxes as one of them dances to a fiddle tune played by another oarsman. Traffic in agricultural commodities fills the middle ground of the image. Off to the left a steamboat has run its bow up against the bank to take on its cargo, and an army of slaves tasked with loading the vessel swings into action. Some of them roll large barrels across the gangplank, while others wait their turn on the shore. In the middle of the image two riverboats, their lower decks jammed with bales of cotton, race for home. On the opposite shore stands a substantial plantation house, a physical proof of its owner's agricultural successes. In the background a setting sun paints the sky with an orange hue, a glowing golden arch that links the loading scene on the left bank to the planter's house on the right. From lively dance steps on the flatboat to the overloaded vessels to the radiant hue of success that fills the sky, the image presents an appealing message tied to images of abundance, efficiency, and prosperity. Palmer's picture suggests not only an idealized vision of the South but a vision of American perfection.

In the companion image the South is presented at war (Figure 5.5). The scene is now dark and ominous, a vista lit by the moon. Union ironclads on patrol blast away at the cotton empire. As the plantation on the distant shore goes up in flames, several steamboats—evidently the same vessels depicted in *The Mississippi in Time of Peace*—are on fire and sinking. Even the old flatboat, bearing its cargo of frontier goods, is about to go under. Off to the right a side-wheeler lists heavily, ablaze from its waterline to its pilot house. The flames are so intense that even the trees along the shore begin to burn as well. The crew of this vessel leaps overboard; some of them seen in the water cling to pieces of wreckage. Cotton bales now serve as their life rafts. Palmer's rendering shows how the promise of the Old South was smashed by the superior military power of the Union forces.

In this pair of images Currier & Ives summarize the four years of the Civil War. One senses here that both the "terrible swift sword" of northern justice has been wielded and that the nation has been restored to wholeness by means of a great struggle. Palmer's talent for imbuing landscape with sentiment was used here to narrate the war in moral terms and to show how the great sectional conflict had ended with a satisfying victory, at least from the northern perspective.

The destruction of the southern way of life was also the theme of *Low Water in the Mississippi* and *"High Water" in the Mississippi*, landscapes that Currier & Ives issued as a paired set in 1867. These prints may have been inspired in part by an article by Thomas Bangs Thorpe entitled "Remembrances of the Mississippi," which appeared in *Harper's New Monthly Magazine* in 1855. The article was accompanied

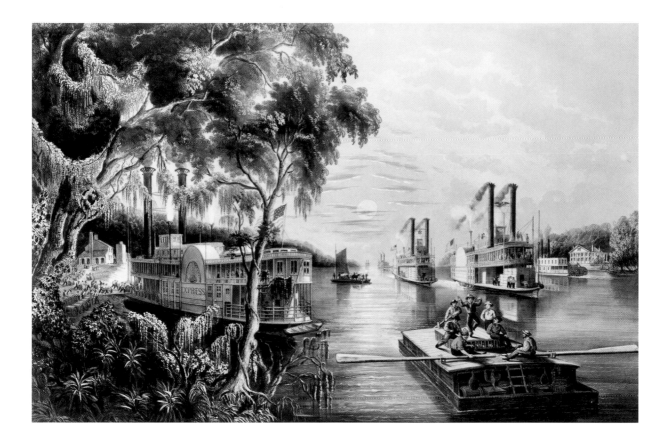

by a number of lithographic drawings, two of which—*The Mississippi at Low Water*
and *Same Scene at High Water*—bear a general similarity to the Currier & Ives
prints.[12] Showing the extraordinary seasonal variation in the depth of the river,
the images accompanying Thorpe's article were sketched from a vantage point on
the river itself. In *Low Water* a plantation house is shown perched on a high bluff,
while in *High Water* the river level reaches right up to the top of the bank (Figures
5.6 and 5.7). Even though there are features of content and perspective in the Cur-
rier & Ives prints that do not appear in these magazine illustrations, the similari-
ties of subject matter and titles at least suggest the seed of an idea to which Palmer
may have turned when tasked with creating her images. Since she clearly devel-
oped her scenes of the western landscape with the aid of published sources, one
may safely assume that her plantation views probably benefited from newspaper
sketches as well.[13]

 Low Water in the Mississippi, like *The Mississippi in Time of Peace*, presents an ap-
pealingly blissful moment (Figure 5.8). Contrary to its title, the image does not
focus on the Mississippi, even though the river does occupy half of the scene.
Rather, the viewer's attention is directed to a plantation located on the left side of

FIGURE 5.4.
*Frances Flora
Bond Palmer,* The
Mississippi in Time
of Peace *(1865).
Hand-colored litho-
graph, Currier & Ives,
New York. Museum of
the City of New York,
The Harry T. Peters
Collection.*

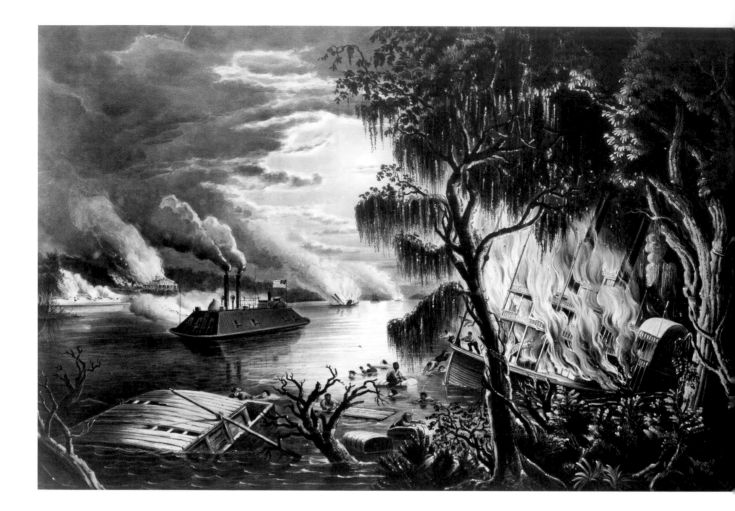

FIGURE 5.5.
Frances Flora
Bond Palmer, The
Mississippi in Time
of War *(1865).*
Hand-colored litho-
graph, Currier & Ives,
New York. Museum of
the City of New York,
The Harry T. Peters
Collection.

the picture. In the foreground stands a slave cabin. Drawing upon a body of im-
ages derived most likely from the performances of blackface minstrels, the picture
shows a throng of African Americans singing and dancing to tunes played on a
banjo. A man, two women, and six children of various ages, a group meant to be
interpreted as a slave family, are shown enjoying a moment of leisure in front of
their small but sturdy cabin. The fact that their quarters are embowered with a
clinging vine full of blossoms encourages the viewer to consider their captivity as
a relatively pleasant fate. The shoreline is shaded by tall trees, but through a con-
veniently placed gap the planter's mansion can be glimpsed in the distance. Here
too the members of the household seem to be taking their ease, as men dressed in
suits and their hoop-skirted consorts promenade on the lawn. The plantation
overlooks the river where two steamboats, one of them tellingly labeled "Robert
E. Lee," glide serenely past each other. Consistent with the print's title, the river
level is down, exposing much of its steeply eroded banks so that the plantation ap-

FIGURE 5.6.
Anonymous,
The Mississippi
at Low Water.
*Wood engraving
in* Harper's New
Monthly Magazine
*(1855). Library of
Congress.*

FIGURE 5.7.
Anonymous,
At High Water.
*Wood engraving
in* Harper's New
Monthly Magazine
*(1855). Library of
Congress.*

pears to stand well above the river on what might be assumed to be the safe high ground.

In the companion print, the security of this plantation has literally been swept away by the flooding Mississippi (Figure 5.9). The river is now up to the treetops and the plantation's buildings are imperiled, the slave houses most of all. The slave family clings to the roof of a cabin as the little building floats away with the current. Huddled together with some of their neighbors, they struggle to snare some of their belongings that drift by in the swift current. The planter's "big house" has also proved vulnerable, although it remains anchored to its foundation. Two figures call for help from its rooftop platform as two men in a small boat paddle to their rescue. In the background, a side-wheeler named after Confederate hero Stonewall Jackson cruises full-speed ahead, apparently oblivious to the plight of the flood victims who command so much of our attention.

By printing these images of a prosperous plantation ruined by a catastrophe, Currier & Ives continued to celebrate the northern victory over the South. While

FIGURE 5.8.
Frances Flora Bond Palmer, Low Water in the Mississippi *(1867). Lithograph, Currier & Ives, New York. Library of Congress, Prints and Photographs Division.*

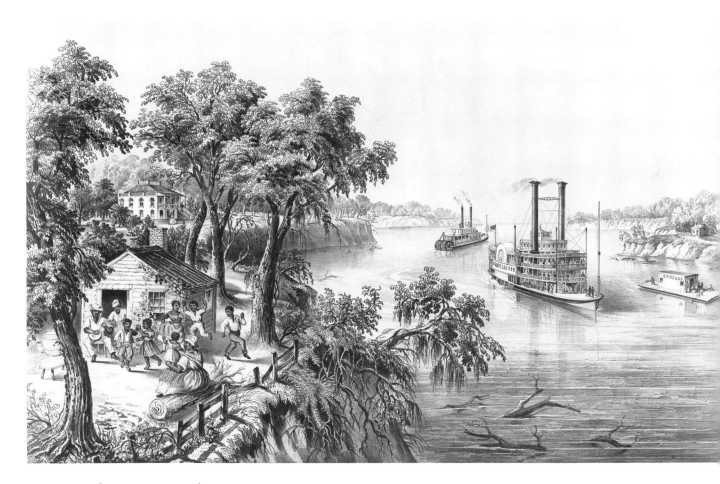

neither of these prints contain any obvious military elements, it is significant that the riverboats bear the names of prominent Confederate generals. In the company's earlier pair of Mississippi River scenes, the partners had directed Palmer to show how the economic foundations of the rebel cause were destroyed by force of arms; in *Low Water* and *High Water* it is a flood, an act of God, that delivers the crucial blow. Divine Providence is thus represented as taking the Union side, by visiting destruction on the region that had opposed the sovereign American government. Currier & Ives seem to be making common cause with the Radical Republicans, who were bent on punishing the South for what they viewed as a treacherous rebellion. Toward that end, they provided the public with visual images consistent with Republican plans for keeping the region under prolonged military rule. Where God could raise a mighty flood, the Republicans could and did order up an army of occupation, a veritable deluge of soldiers.[14]

That Nathaniel Currier and James Ives were pro-North did not mean that they were also pro-black. In fact, they assiduously declined to print abolitionist images,

FIGURE 5.9.
Frances Flora Bond Palmer, "High Water" in the Mississippi *(1867). Lithograph, Currier & Ives, New York. Museum of the City of New York. The Harry T. Peters Collection.*

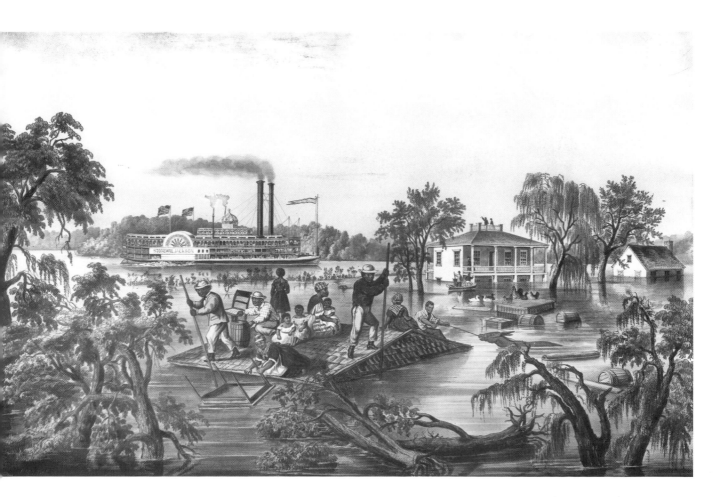

even though the antislavery question was hotly debated in New York. When they printed an honorific image of John Brown as he was led to the gallows, it was only after the Emancipation Proclamation of 1863 had made the abolition of slavery a chief aim of the war and thus as much a military objective as a moral cause. Between 1884 and 1896 Currier & Ives published over 170 racist caricatures, crude attempts at comedy that mocked the social aspirations of black people. These images consistently portrayed African Americans as failing in their every attempt at making a better life. Called the *Dark Town Series*, these print versions of racist slurs sold extremely well. Representative of this series of prints was a blackface version of the Statue of Liberty. The well-known colossus of New York harbor, originally titled *The Great Bartholdi Statue, Liberty Enlightening the World*, was redrawn as a grotesque black woman holding aloft a burning stick and described in a pseudo-black dialect as *Brer Thuldy's Statue, Liberty Frightenin de World. To be stuck up on Bedbug's Island, Jarsey Flats, opposit de United States* (1884).[15]

When compared to the *Dark Town Series*, Palmer's two sets of plantation scenes seem like benign, if not actually positive, images. In both *The Mississippi in Time of Peace* and *Low Water in the Mississippi* she arranges a line of sight that cuts off any view of the fields, where the arduous tasks of cultivation would be carried out. The viewer sees in the first image only the results of harvest on the way to market; and in the second scene the slaves are portrayed in a pleasant domestic moment, apparently celebrating after their work is done. Neither print gives any evidence of the coercion, force, and brutality that epitomized chattel slavery. Art historian Estill Curtis Pennington describes these works as "fantasy images of Southern life," an appropriate description given Palmer's avoidance of the misery that enslaved African Americans were forced to endure.[16] Her congenial portraits of the "peculiar institution" supported belief in long-standing myths regarding the beneficence of plantation life. She provided just the sort of setting in which one could imagine that slave masters were compassionate and their appreciative slaves were deeply loyal.

Not only did Palmer fail to render slavery as it was, she also failed to render the South. Never having visited the region, she was compelled to create her vision of a plantation based on what she knew about the scenery and buildings of New York. The trees with which she lines the Mississippi River, even though they are festooned with strands of Spanish moss, appear to be of the same species that she used in her 1853 series *American Farm Scenes*, which portrays ideal farmsteads situated in northeastern locales. They may even be compared with the trees she first rendered in her scenes of the English countryside near Leicester.

The temple-form plantation house that appears on the distant bank of *The Mississippi in Time of Peace*, a building type often seen as emblematic of southern plan-

FIGURE 5.10.
Ithiel Town and A. J. Davis, Residence of S. Russell, Middletown, Conn. *(ca. 1831).* Library of Congress.

tations, is also almost certainly derived from a northern source. The building features an impressive portico supported by six columns. The use of six columns was the distinctive signature of renowned New York architect Ithiel Town. Establishing his practice in 1826, his work provided inspiration for many architects and contractors during the second quarter of the nineteenth century.[17] Because images of his buildings were widely circulated in print form, Palmer, who was herself a prominent delineator of architectural drawings before she joined the staff at Currier & Ives, certainly would have been familiar with his work. In fact, her Mississippi plantation house bears some resemblance to an 1831 image of the house that Town designed for Samuel Russell of Middletown, Connecticut (Figure 5.10).[18] Like Town or his delineator, she also presented the house turned slightly to the left so that two chimneys rising above the roof are visible on the right-hand side of the building.

Her plantation house in *Low Water* is also a northern building. This two-story frame structure, square in plan and crowned with a pyramidal roof, is outfitted with a distinctive viewing platform. The house is one that Palmer had rendered twelve years earlier in her image *American Country Life. October Afternoon* (1855), an idealized depiction of an unmistakably New York setting. Her Mississippi mansion resembles this New York dwelling in almost all respects except that the porch on the southern house is two stories high. The pattern for this house traces back to a set of plans and views of an "Italian Bracketed Villa" designed by William H. Ranlett for a client living in Oswego, New York (Figure 5.11). Palmer knew this

house very well because she was commissioned by Ranlett to do a rendering of it for his book of architectural drawings published in 1851.[19]

Equally telling of Palmer's dependence on northern inspiration is her slave cabin. Drawn as a small, clapboard-covered frame house, its front door is placed in its gable end. Representative slave cabins, however, were typically designed with their doors located on the front rather than at the gable ends of the house.[20] Palmer's unusual slave cabin was certainly derived from A. J. Davis's plan for "a small cottage for a working man" published in 1850 in A. J. Downing's *The Architecture of Country Houses* (Figure 5.12).[21] Comparison of Palmer's image with Davis's drawing reveals that both are small framed houses with gable-end doors and, more tellingly, both have the same small pent roofs over their doorways and the same multipane windows. Not knowing how slaves were housed, Palmer must have reasoned that all agricultural laborers would be treated in an equivalent manner. While a worker's cottage in the North might be the functional equivalent of a slave quarter, the two structures were visually quite different. Even a casual observer of southern ways would readily have realized that Palmer had invented a novel slave cabin for her imagined plantation.

Given the extent of Palmer's efforts to create a plantation scene by relocating northern buildings to a southern locale, it seems certain that the black figures that appear in her landscapes were also based on northern sources, most likely on illustrations that appeared first in books of minstrel songs. Since Palmer had little

FIGURE 5.11.
William H. Ranlett, Italian Bracketed Villa *(1851). From William H. Ranlett,* The Architect, *Vol. 2 (New York: W. H. Graham, 1851). Library of Congress, Rare Books.*

FIGURE 5.12.
Alexander Jackson Davis,
A Laborer's Cottage *(1850).*
From A. J. Downing, The
Architecture of Country
Houses. *Library of Congress.*

talent for drawing the human figure, that task was often delegated to another artist on the Currier & Ives staff, most probably to James Ives.[22] Had Ives looked to the frontispiece of the popular songbook *Christy's Plantation Melodies* (1851), he would have found an image of a banjo player sitting in front of a slave cabin, a figure that would readily have been accepted as the natural occupant for Palmer's cabin. Various models for the figures who dance to the banjo's tune could easily have been discovered in *White's New Book of Plantation Melodies* (1845), where capering figures abound.[23] In fact, images of black people dancing to banjo music were commonplace in northern publications during the middle decades of the nineteenth century.[24] It is instructive to recall that blackface minstrels, while they performed all over the nation, were most enthusiastically supported in New York City and that most of its performers were in fact northerners, who offered their audiences an imitation of the speech and song style of southern blacks.[25]

Palmer's fabricated plantation scene from *Low Water*, replete with northern elements and inspiration, proved so popular that by 1872 Currier & Ives saw fit to issue a second version, four years after Palmer had left their employ. Now entitled *The Old Plantation Home*, the image depicts only the slave cabin with the planter's house in the background (Figure 5.13). Although no artist is listed for this print, there can be no doubt that Palmer's *Low Water* served as its model. Except for the absence of a few trees and the deletion of one of the dancing figures, all the elements of her earlier scene were carefully repeated.

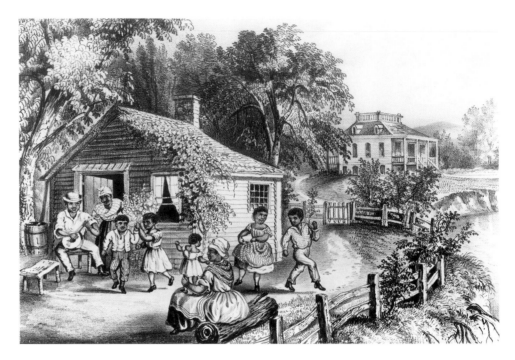

Although Palmer died in 1876, even as late as 1883 elements of *Low Water* appeared again as decorations for two more prints: *Distinguished Colored Men*, issued by Muller & Company; and *From the Plantation to the Senate*, by E. E. Murray & Company. Apparently marketed to newly enfranchised blacks, both of these works offered selections of portrait likenesses of well-known African American leaders. *Distinguished Colored Men* displayed eleven cameo-shaped portraits flanked by familiar elements from the experience of bondage; a cotton plant and a stalk of sugar cane, two prime plantation commodities (Figure 5.14). Placed along the bottom of the print were two vignettes that featured plantation cabins based on Palmer's images. One of them showed an African American family at rest in front of their house as three other blacks steer a barge loaded with farm produce to market.[26] The other scene was a copy of *The Old Plantation Home*, except that the positions of the house and the figures are arranged in reverse order from the original. Paired at the bottom of the print, these two plantation scenes were intended to represent conditions before and after slavery. In the right-hand corner the depiction of enslaved blacks reminded the viewer that African Americans once labored exclusively for the benefit of their owners, while on the left side these same people were shown as free men and women who, at long last, can enjoy the fruits of their labors.

In *From the Plantation to the Senate*, Gaylord Watson seems to have followed *Distinguished Colored Men* very carefully. He also contrasted a selection of formal

FIGURE 5.14.
George F. Cram,
Distinguished
Colored Men *(1883).*
Chromolithograph,
A. Muller and
Company. Library
of Congress, Prints
and Photographs
Division.

portraits of black heroes with scenes of servitude, but he chose to make a cotton field the central element in his poster-sized print (Figure 5.15). Although only four of the seven men that he depicted actually served in the Senate, they were all significant African American leaders. Further, there can be no doubt that Frederick Douglass, whose image is larger than the others and centrally positioned, was the

most respected black man of his era. Along the bottom of the print are the same plantation views seen in *Distinguished Colored Men*. Although these scenes are poorly drawn, there is no question that Watson depended either on the print by Muller & Company or the Currier & Ives originals.

It is certain, as well, that Palmer's benign imagery was being progressively en-

folded into the narration of an idealized freedom saga. While she probably would never have expected it, her invented cabin was gradually transformed into an essential icon of the enslaved past. Reprinted thousands of times, her genteel image was embraced as a useful representation of the experience of slavery by blacks and whites alike. White viewers of *The Old Plantation Home* or *Low Water in the Mississippi*, most of them northerners eager to learn something about distant parts of the nation, would no doubt have been reassured by the "good old days" nostalgia encountered in these cheerful bucolic scenes. These images might have even persuaded them that the reported evils of slavery were only so much rumor. If they were at all interested in healing the profound regional divisions caused by the Civil War, they could have found in the happy frolics depicted in these images reason to forgive and forget and encouragement to put the past behind them. Former slaves certainly would have known better. But if by the 1880s they had made their way up a rung or two on the social ladder to the point where they might be able to purchase prints for the walls of their homes, they too might have accepted Palmer's softened images simply because a more accurate rendering was just too painful to consider. Even twenty years after the publication of *Distinguished Colored Men* and *From the Plantation to the Senate*, signs of the slave system were still plainly visible all across the South. In 1903, W. E. B. Du Bois published the results of his survey of Dougherty County in southwest Georgia, a report that offered a depressing portrait:

> All over the face of the land is the one-room cabin,—now standing in the shadow of the Big House, now staring at the dusty road, now rising dark and sombre amid the green of the cotton fields. It is nearly always old and bare, built of rough boards, and neither plastered or ceiled. Light and ventilation are supplied by a single door and by the square hole in the wall. There is no glass, porch, or ornamentation without. . . . the majority are dirty and dilapidated, smelling of eating and sleeping, poorly ventilated, and anything but homes.[27]

Clearly Palmer's renderings of plantation life, a projection of her inadequate knowledge of the South, had next to nothing in common with the actual experiences of African Americans. That her depiction of slavery would eventually be included in images intended to promote black pride and social empowerment is highly ironic. Perhaps it was enough for black viewers just to have a plantation represented, even if it was shorn of all of its oppressive dimensions. By the 1880s the ongoing African American struggle for liberation had moved past slavery to confront the more enduring problem of racism, a deeply embedded ideology for which there was no readily identifiable icon.[28]

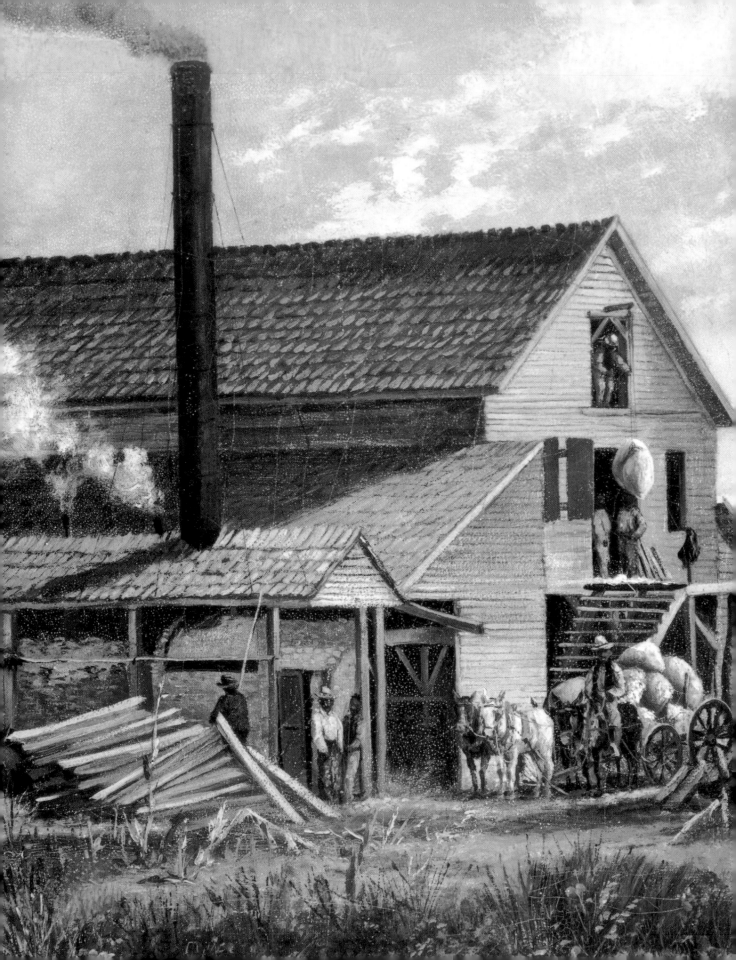

6 A Not So Sunny South
William Aiken Walker's Plantation Paintings

William Aiken Walker (1838–1921) was a true son of the South. Born and raised, for the most part, in Charleston, South Carolina, he served in the Confederate Army and was wounded in the defense of Richmond in 1861. After the war he pursued a long and pleasantly itinerant career as a professional painter. Constantly in search of commissions, he visited cities and resorts throughout the region, hoping to connect with potential patrons. Except for brief stints of travel in Europe and the Caribbean in 1870, Walker lived and worked for extended periods in Baltimore, Asheville, Augusta, St. Augustine, and Galveston, returning frequently to Charleston for brief visits. He was particularly attracted to New Orleans, and he used the "Crescent City" as his regular winter base from 1876 until 1897.[1]

He was a most arresting figure, even for a city like New Orleans (Figure 6.1). Often attired in a long coat and beret and sporting a dramatic, at times almost outlandish, mustache, Walker generally could be found in the French Quarter at the corner of Royal and Dumaine Streets. Working at an easel that he set up on the sidewalk, he dashed off numerous paintings, some as small as a postcard, primarily for the tourists. These works were generic sketches of African Americans, posed either in cotton fields or in their living quarters. If he worked quickly, he could turn out as many as twenty of these pictures on a good day. While we have no firm statistics to measure his total artistic output, to say that Walker painted more than a thousand of these pictures would not be an exaggeration. It is important to recognize that Walker's preoccupation with African American subjects was as much an expression of his own choice as customer preference. His earliest known work, painted when he was only twelve, was a painting of a black man standing on the docks of Charleston while lighting his pipe. Black subjects were the essential leitmotif of his career.[2]

Soon after his arrival in New Orleans, Walker—who has been characterized as the "perfect weekend guest"—used his polished manner and gregarious nature to develop useful alliances with members of the local art scene.[3] In fact, he joined with other New Orleans artists to establish the Southern Art Union. This new association provided a forum for the city's expanding population of painters so they

could more easily share ideas about their work.[4] One member of this group, Richard Clague, owned a home outside of the city on Bayou St. John, which served as a popular weekend retreat for the artists. Here Walker—along with Andres Molinary, Marshall Smith, William Buck, and others—enjoyed rural outings during which they would sketch and photograph the local scenery. These friendly and diverting excursions no doubt encouraged Walker to experiment with the landscape genre. An undated painting by him of a steamboat taking on a supply of fuel at a bayou landing was probably inspired during one of these jaunts into the Louisiana countryside.

Walker became fascinated by the vessels that clustered thickly along the levee at New Orleans, and he painted a number of panoramic scenes of the riverfront action. Prominent in these paintings are the ranks of side-wheelers lined up along the levee. These palatial vessels, decorated in a rich filigree of Gothic ornamentation, held great appeal for Walker, and he often traveled by steamboat whenever he undertook commissions from newfound clients who lived upriver from New Orleans. It was on these trips, some as far north as Greenville, Mississippi (a distance of more than 500 miles along the river), that he became familiar with the rural vistas along the shores of the Mississippi. Two paintings, *Deer Creek* and *Rattle Snake Bayou, Mississippi*, now lost but known to have been put on display in 1883, were completed as the results of river voyages undertaken to complete portrait commissions. *Deer Creek* was almost certainly a view of Ditchley Plantation, home of Samuel Ferguson in Washington County, Mississippi.

FIGURE 6.1.
William Aiken Walker,
Self-Portrait *(1913).*
Oil on panel. Gibbes
Museum of Art/
Carolina Art Association, Charleston,
South Carolina.
Bequest of Mrs. Lucia
Walker Cogswell.

Walker painted a portrait of Ferguson's daughter in 1882.[5]

Among Walker's most ambitious plantation scenes were a sequence of relatively large views painted between 1881 and 1885. Numbering ten in all, eight of them present cotton-producing estates, while the remaining two illustrate rice plantations. Two of these images, *Big "B" Cotton Plantation* (Figure 6.2) and *A Cotton Plantation on the Mississippi* (Figure 6.3 [Plate 10]) present vistas of Mississippi River estates. In both works, the Mississippi River and an iconic steamboat can be seen in the background; visual links, perhaps, to the way that Walker came

to know these places. Walker indicated the specific locations for only three of his ten plantation scenes, but *The Rice Harvest* (Figure 6.4) contains visual clues that suggest it may be a depiction of a Louisiana estate.[6] That Walker completed three additional plantation scenes in 1881, during a period when he is known to have been painting Mississippi plantations, suggests that those three are most likely views inspired by Mississippi estates. However, their titles—*The Sunny South*, *Plantation Economy in the Old South* (Figure 6.5), and *The Cotton Plantation* (Figure 6.6)—indicate that Aiken was aiming to create generic images evocative of the entire region rather than visual documents of specific places.

The best known of Walker's plantation views is *A Cotton Plantation on the Mississippi* (1883) (Figure 6.3), which was distributed nationally in print form in 1884 by Currier & Ives. Walker's pleasant scene fit in well with the other scenes in the extensive Currier & Ives catalogue, the bulk of which were blissful domestic and pastoral images intended to inspire reflection on the value of work, family, and home. Because only a handful of Currier & Ives prints represented southern images, sales of Walker's image were quite brisk. *A Cotton Plantation on the Mississippi* presents a wide cotton field under a pleasant cloud-filled sky. Three separate groups of figures stand on a dirt road in the foreground. The plantation owner and his wife are not only centermost, but they also stand slightly forward of the two groups of black workers, three cotton pickers who gather to their right and three men to their left who are attending to a mule-drawn wagon. The cotton field spreads across the middle of the picture from edge to edge. Painted so that the rows of plants run across the picture plane, the field is rendered as a wide sea of green plants flecked with white bits of cotton. Here sixteen diminutive figures, waist deep in their task, are shown either gathering the bolls of fiber into large baskets or carrying loads of harvested cotton on their heads to a wagon in the distance. A man on a horse at the back of the field, presumably the overseer, supervises their work. Behind the field stand the plantation's buildings. The steam-powered cotton gin with its large brick chimney is particularly prominent, while the other structures—most of them apparently houses for the overseer, field hands, and possibly the owner—blend with the trees. Through a gap in the vegetation, Aiken provides a glimpse of a passing steamboat. The three parallel settings seen here—detailed figures in the foreground, cotton field in the middle ground, and a background of buildings—constitute the organizing formula that Walker employed in all of his known plantation landscapes.

Comparing *Big "B" Cotton Plantation* with *A Cotton Plantation on the Mississippi* reveals that Walker made only slight variations in the details of certain elements while retaining a consistent overall compositional strategy. In *Big "B" Cotton Plantation*, a wagon again appears in the lower left corner, but in this instance Walker

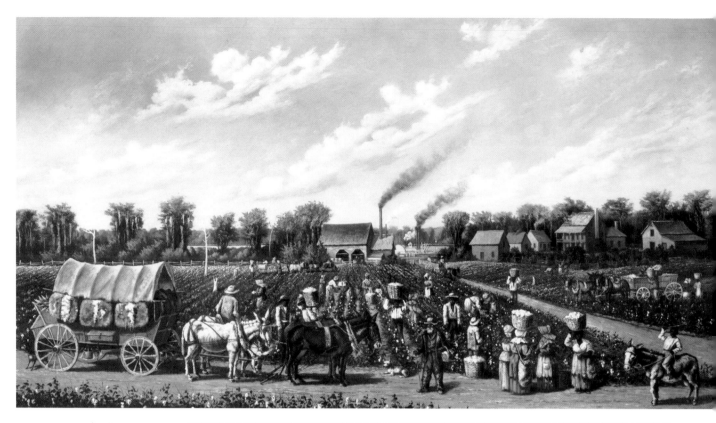

FIGURE 6.2.
William Aiken Walker,
Big "B" Cotton
Plantation *(1881).*
Oil on canvas. The
Collection of Jay P.
Altmayer.

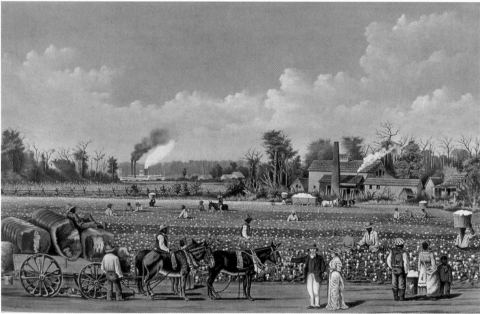

FIGURE 6.3.
William Aiken Walker, A Cotton Plantation on the Mississippi *(1884). Chromolithograph. Currier &*
Ives, New York. Library of Congress, Prints and Photographs Division. (Reproduced in color as Plate 10.)

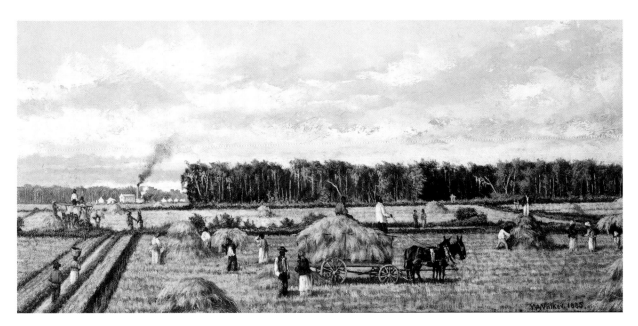

FIGURE 6.4.

William Aiken Walker, The Rice Harvest *(1885). Oil on canvas.*
The Ogden Museum of Southern Art, University of New Orleans, New Orleans, Louisiana.

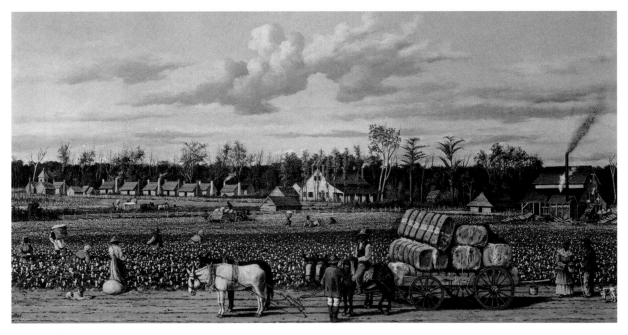

FIGURE 6.5.

William Aiken Walker, Plantation Economy in the Old South *(ca. 1881).*
The Warner Collection of the Gulf States Paper Corporation, Tuscaloosa, Alabama.

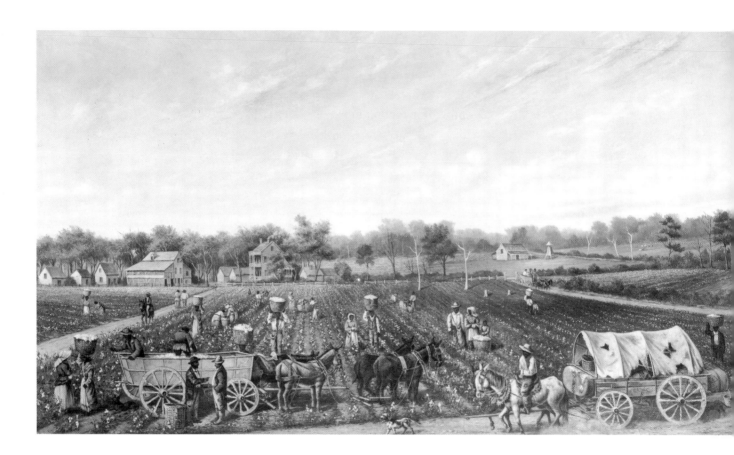

has provided a canvas canopy to cover its load. Once again the background is occupied by a row of plantation buildings, except more of them are visible, particularly the planter's residence. The field is still at the center of the painting, but it is being worked by more field hands. The middle ground differs as well, because the rows of cotton plants run away from the viewer, enhancing the sense of perspectival depth in the picture. But it is clear that the same format was used for both paintings. The *Big "B"* scene also compares closely with *The Sunny South*, *Plantation Economy in the Old South* (Figure 6.5), and *The Cotton Plantation* (Figure 6.6), largely because these four works all present a full inventory of representative plantation buildings, including planter's houses, barns, sheds, quarters, kitchens, and cotton gins and presses. Two of Walker's other smaller plantation landscapes, *Cotton Plantation with Cotton Gin* and *Cotton Plantation in South Carolina*, are almost duplicates; the only outstanding difference seen in these two images is the direction in which Walker arranges the rows of cotton.[7] Even though he had first-hand knowledge of many different plantation estates, it is clear that Aiken painted more by formula than from actual experience.[8]

That Walker painted relatively few landscapes may indicate that he was not

completely comfortable with works that required him to assemble many figures across a large expanse of canvas. Measuring as large as twenty-five by forty inches, his plantation scenes could be as much as four times the size of his more typical works. When painting smaller scenes of African Americans, Walker worked quickly and confidently, using an assembly-line technique. He first coated a wide piece of academy board with a ground of sienna. Next he painted the upper third of his board in blue, for the sky, and then spread green across the center for a cotton field. Black figures in various poses and other details were then painted serially across this tricolored background, and when his row of images was completed, the board was cut up into smaller sections and sold as so many individual paintings.[9] Since the figures that inhabit his plantation landscapes assume the same poses found in his numerous souvenir-sized images, it would appear that for Walker a landscape was simply a collection of discrete images. Under more typical circumstances they might have been cut apart into separate pictures, but in these larger works they remained connected as a single ensemble. In some plantation-inspired works Walker did "cut" into his landscapes by moving in closer to render one element in detail. He would, for example, create a wagon scene, a close-up view of a cotton gin, or a group of blacks hoeing or picking cotton. It is clear that the panorama was not his forte. He preferred instead to specialize in stock images executed on an intimate scale. Walker's chief aim was to confirm a prevalent social stereotype about black people, namely that they were essentially destined for nothing more than agricultural labor.[10]

Walker's plantation landscapes were, above all, scenes of production. We see in them abundant acreage bursting with cotton fiber as diligent laborers bend to their tasks, moving the crop from the fields onward toward some distant, unseen textile mill. One senses here less an artist's attraction to the land and something more like an ode to industry. In fact, *Big "B" Cotton Plantation* was a work commissioned by Boston textile mill owner Stephen Weld, and it hung in his company offices until 1938. Weld presumably used this image to illustrate his source of raw materials. The painting narrates the first stage of his textile production, and from a northern perspective, it describes the most intriguing dimension of the story by describing an exotic, faraway place, the fabled "land of cotton." Walker's *The Cotton Plantation* (Figure 6.6) was apparently solicited for a similar commercial purpose, but in this case by a Charleston cotton broker. Edward L. Wells paid $100 for the scene, alleged to represent a plantation near Augusta, Georgia, and he too placed it his office, where one imagines that it offered visual confirmation of his ability to deliver ample supplies of fiber upon request. These commercial uses of Walker's images were closely paralleled by advertising strategies seen in manufacturer's trade cards and posters during this period. In 1885, J. & P. Coats of Stam-

ford, Connecticut, major producers of cotton thread, issued a poster featuring a spool of thread at its center with a scene of plantation fields above and a depiction of bales of cotton arriving at the factory below (Figure 6.7). Presenting a sequence of actions that progresses from field to ship to factory to finished product, the poster offers a clear statement of industrial propaganda. While Walker's plantation scenes were not meant to function explicitly as advertisements, they certainly display an enthusiasm for the cotton industry. In fact, Walker's *Cotton Plantation on the Mississippi* (Figure 6.3) may have inspired an 1894 poster by the Johnson & Johnson Company. Entitled *Red Cross Cotton from Start to Finish*, this image shows a roll of gauze bandages unfurled above a scene of a cotton harvest very similar to the one depicted in Walker's print.[11]

In all of Walker's plantation landscapes the point of view is consistently from the fields looking back toward the planter's residence, that is, toward the public entrance to the estate. The perspective is clearly that of an insider looking out.

But the focus does not confirm the social hierarchy of the plantation layout. Even though the planter's "big house" is occasionally evident, Walker directs the viewer to look beyond the hypothetical fence lines of the owner's domain. In *Big "B" Cotton Plantation*, Walker carefully draws attention down a road to a wharf where a steamboat waits to receive its cargo. In *A Cotton Plantation on the Mississippi*, one's eye is drawn not only to the river in the background but to the trees on the opposite shore. In other scenes the land rolls on well beyond the apparent boundary of the estate. In every instance the viewer senses that the cotton field is a confined space that is isolated from the wider world. Cotton, spreading horizontally across the picture, becomes the dominant subject of these paintings. The viewer's encounter with the environment is overtaken by a concern for a commodity.

No doubt Walker found encourage-

ment for his particular focus in a major spectacle that was held in New Orleans in 1884, the World's Industrial and Cotton Centennial Exposition. This fair, staged in the vast expanse of what is today Audubon Park, featured many pavilions, but the grounds were dominated by a special building reserved solely for the display of factories and mills. This large cast-iron structure, which measured 350 by 120 feet, was devoted principally to displays of cotton in all of its phases, from the boll to the bale. One guidebook announced, "Cotton pickers, openers, and lappers as well as the various and complex machinery for ginning, cleaning, baling, and compressing will be in constant operation." But more impressive was a 25-acre cotton field planted next to the pavilion that enabled visitors "to see the cotton growing in all of its stages, from the bloom to the bursted pod."[12] This prominent display, like Walker's plantation landscapes, affirmed the importance of cotton to the South. It also must have assured Walker that his approach to painting the landscape was not only appropriate but truly in tune with the times. If tens of thousands of visitors could be entertained by a patch of cotton, then plantations could certainly be considered a most appropriate subject. And further he must have felt reassured that cotton should be the central focus for his paintings. While the exposition also included an art gallery, none of Walker's paintings were on display. Instead he roamed the grounds offering souvenirs to the visitors, scenes of cotton being harvested or of cotton bales standing along the levee. Consistent with the industrial themes of the exposition, these images presented two of the crucial phases in the business of cotton.[13]

Walker's large plantation landscapes were painted during a period that witnessed a resurgence of confidence among white southerners. Following what were considered the dark, punishing days of Reconstruction, new leaders—usually newspaper editors—from all across the region trumpeted their advocacy for a New South. Statements appearing in the *Charleston News and Courier*, the *Louisville Courier-Journal*, and the *Manufacturer's Record* of Baltimore offered repeated justifications for optimism, keyed to the region's potential for industrial growth. Foremost among these spokesmen was Henry W. Grady, editor of the *Atlanta Constitution*.[14] In a much celebrated and reprinted address entitled "The New South," first delivered in 1886, Grady distilled the key tenants of his plan for an era of prosperity. Noting that the South of slavery and secession was now dead, he claimed that the region could be rebuilt by turning to a pattern of diversified industry. However, he did not completely turn his back on the region's long-standing agrarian tradition. He reasoned that if locally raised cotton could be transformed into locally manufactured textiles, then the region as a whole would surely prosper. He offered assurance to postbellum planters when he claimed: "The cotton field is the new Comstock Lode. And for years the farmers fought in destitution, as

miners fight, while bales of cotton, as of silver, went to enrich the cities beyond their horizon. At last they have learned how to catch the ebbing sea at the edge of the patch, and throw its enriching flood back on their own fields."[15] The theme of progress resounded throughout the region, particularly among those who had come of age just after the Civil War.

The linkage between cotton and the promise of new wealth can certainly be recognized in Walker's plantation images. With precise strokes, he carefully delineated every feature, indeed almost every plant, in an effort to present a worthy scene. While *Big "B" Cotton Plantation* served to illustrate a New England entrepreneur's source of wealth, there can be no question that his other plantation landscapes were painted to suggest a source of new wealth for the South as well. That Walker meant to align his vision with the enthusiasm for the expanding New South creed is indicated by his inclusion of a steam-powered cotton gin in almost all of his plantation paintings, both in the full landscapes and in the smaller vignettes of wagoneers and cotton pickers. The earliest cotton gins were driven by hand-turned cranks and later by a system of gears powered by teams of mules.[16] While steam-powered engines were first used on plantations as early as the 1830s as an alternative to mule-powered gins, only the wealthier planters could afford them, and they were not a common feature of the plantation landscape until the early twentieth century. Planters who were able to install steam gins not only cleaned their own cotton but also processed the harvests of their neighbors' farms. Consequently, a steam-powered gin was seen not only as a sign of wealth but also as an indicator of modernity.[17] The gin house was, in effect, a small factory serving much of the community, and it enhanced the reputation of its owner as a man of stature. Walker's 1883 *Cotton Gin, Adams County, Mississippi* (Figure 6.8) is a detailed rendering of one of these new gin houses, and it matches closely the sorts of machines that New South advocate and cotton mill manufacturer Daniel Augustus Tompkins was promoting in his various pamphlets and articles.[18] Trails of black smoke rise from cotton gins into the skies above all of Walker's plantations, signs of a resurgence linked to the new faith in industrial means and methods. In line with various promoters of southern optimism, Walker's images signaled that the restoration of the region was at hand. A modern steam-powered gin is included even in his *Plantation Economy in the Old South* (Figure 6.5), an image that, based on its title, was meant to present an agricultural narrative from an earlier age. Sensing the growing fervor for New South ideals during the 1880s, Walker painted links between the Old South and the New even if it resulted in the inclusion of an anachronistic detail.

Walker also displayed his belief in the promise of a resurgent South by his treatment of atmosphere in his plantation landscapes. In every case they are well-

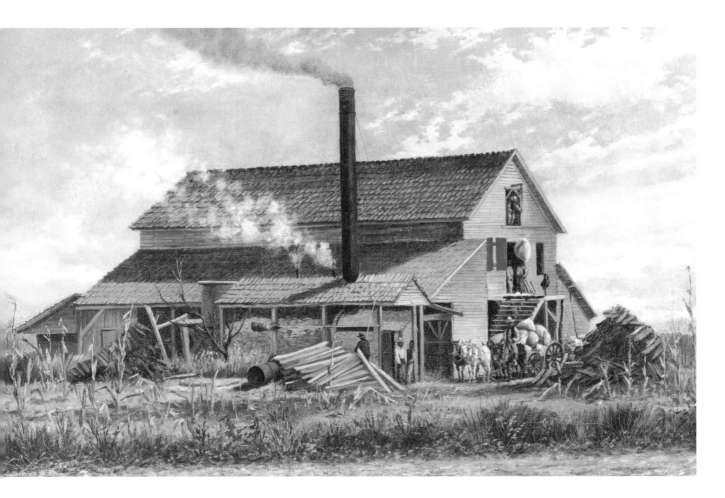

lighted places; the sun shines brightly everywhere, suggesting imminent possibility. Given the size and the placement of shadows on the ground, it is always noon in Walker's images, with the sun directly overhead and thus at the moment of its full illuminating power. The clear implication here is that conditions could not be better. These beneficial feelings are projected as well by the way Walker renders his skies, which occupy at least half of any canvas. In them, high, thin clouds are pushed along by light breezes. Occasionally a puffy cumulus ambles past. The weather, usually an uncooperative and often a destructive force in the business of agriculture, here facilitates the work of the plantation. While his New Orleans painting colleagues preferred shadowy landscapes rendered in a somber range of colors, scenes thick with the weight of humid air, in Walker's paintings the air is crisp and filled with optimism.[19] Although art historian Cynthia Seibels is correct in her observation that for Walker "the landscape background is incidental," he nevertheless used his backgrounds to support his personal vision of the land of cotton as a region of promise.[20]

That Walker's optimistic message was understood by the viewing public is indicated by a review published in the *New Orleans Times-Democrat* in 1883. Reporting on a recent exhibition at the shop of art dealer Samuel T. Blessing, the writer provides a detailed description of Walker's *Rattle Snake Bayou, Mississippi*. Praising the painting as "full of freshness and force," he contrasts the virtues of Walker's efforts with the failures of other painters: "It represents plantation life, not coarse and vulgar, as some in attempting to portray it have made signal failures and debased their artistic talent, but a real spirited picture of life, industry and progress."[21] These approving words suggest that Walker was in touch with popular sentiments regarding the promise of the much discussed economic upturn.

Even though Walker occasionally rendered large portraits of African American field hands—his *Old Jeb* (Figure 6.9), for example, stands almost four feet tall— all of the black people in his landscapes are small, at times no bigger than a flyspeck. That they are drawn in a diminutive scale was no doubt determined by the requirements of depicting a broad panoramic vista, but the impact of their small stature tends to emphasize the cotton more than the people who produce it. Their only apparent purpose is to harvest fiber, and they are shown, for the most part, in one of three necessary tasks: picking cotton, carrying baskets loaded with cotton on their heads or shoulders, or depositing their burdens into a wagon before they return to gather up another load. A few figures may be shown in conversation, but they are always carrying a basket full of cotton. Only the occasional child seems to be excused from the regimen of the fields. While Walker spreads these figures around the plantation scene as if they were individual figures or separate, small groups, one certainly senses that they are all performing a single, collective task. Thus they are more than workers, they are a gang. As such, they conformed to a readily available white stereotype of African Americans. A newspaper reviewer quickly recognized in one of Walker's landscapes the cotton pickers, the men on a wagon, the little pickaninnies, and the old mammy, all of them, he noted, were "veritable types of the plantation negroes."[22]

By illustrating black people working as members of a gang, Walker reveals his nostalgia for past times, a longing for the Old South that was finally at odds with his promotion of an improving New South. By the 1880s, plantation gangs had been largely replaced by tenants or sharecroppers. Most plantation tracts were now worked by single families, each contracted to cultivate an assigned 20- to 40-acre plot. At the end of the year, they were either paid wages or given a share of the profits from the sale of the harvest, minus the landowner's reported expenses for their food, housing, seed, fertilizer, and implements. Under these conditions, large antebellum plantation estates were reconfigured as clusters of smaller holdings.[23] A plantation's overall boundaries remained in place, but the land was thor-

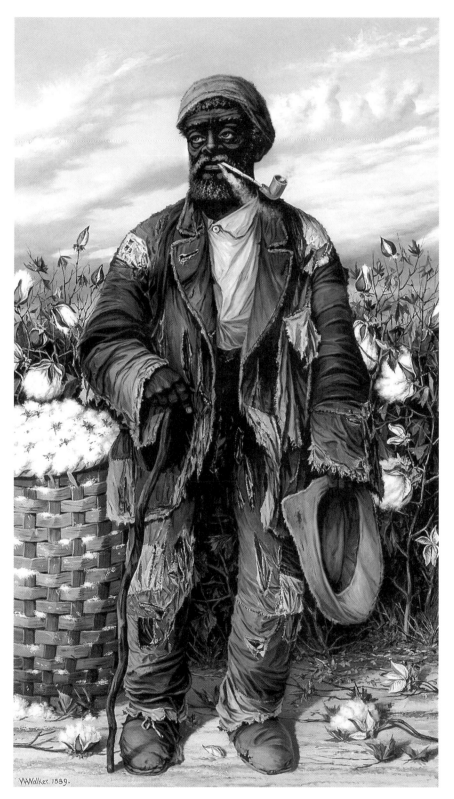

FIGURE 6.9.
William Aiken Walker,
Old Jeb *(1889). Oil on canvas.*
Photograph courtesy of The
Charleston Renaissance Gallery,
Robert M. Hicklin Jr., Inc.,
Charleston, South Carolina.

oughly rearranged into a patchwork of small farms. That Walker knew this is indicated in a number of his field hand sketches, in which a small group of black workers is posed in front of a solitary cabin (Figure 6.10). Also two undated works, *Tenant Farmers in Cotton Field* and *Sharecroppers in the Deep South*, reveal by their titles that Walker was keenly aware that southern agriculture had undergone a profound transformation. Nevertheless, he rendered his New South plantations as if they were still being operated by the rules of the antebellum period. In so doing he painted his preferred South, where black people were nothing more than docile laborers who dutifully urged profit from the land as they always had.

The black plantation workers that Walker must have observed on his voyages

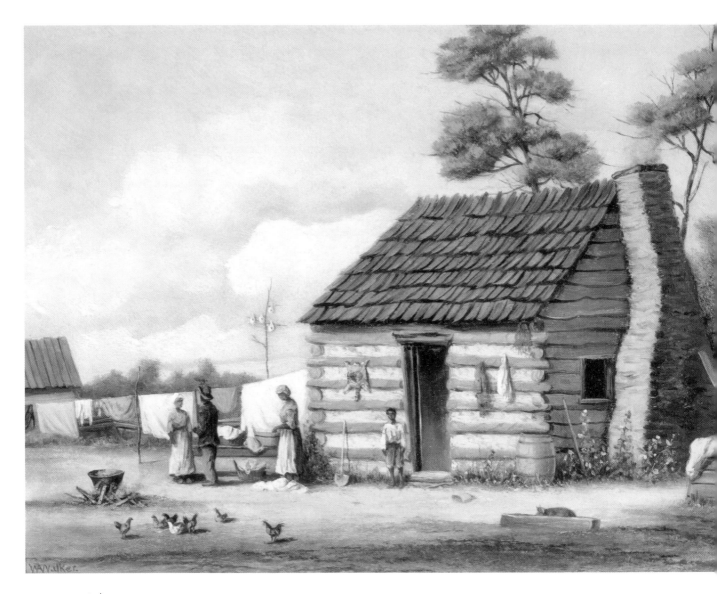

up and down the Mississippi were not as tied to the land as he showed them to be. At the start of the 1880s, black people were leaving Mississippi as fast as they could; thousands of them flocked to Kansas, where new, all-black towns were being formed. Planters from the Delta region of Mississippi, the northwestern portion of the state between Memphis and Vicksburg, found it necessary then to recruit black laborers from other parts of the state and threatened to "shoot on the spot" or "tar and feather" any person caught trying to "decoy away" their workers. In an effort to recruit new field hands, labor agents traveled as far away as North Carolina.[24]

During the late nineteenth century, Mississippi blacks had become a decidedly transient population. In addition to those who were moving out of the state and their replacements who were moving in, still others were moving from plantation to plantation in search of the best deal with respect to wages and housing. The competition for field hands caused one planter from Hinds County to complain: "I have a good hand; my neighbor offers him a higher price, and also tells him I will cheat him out of his wages. I have had this done by the richest men in the neighborhood."[25] Underlying this pattern of transience was the tendency of white landlords to resort to violence in order to maintain what they considered to be "good order." In 1890, planter Clive Metcalfe matter-of-factly described in his diary the whippings he routinely gave his black tenants when they had offended him in some way.[26] It is not difficult, then, to understand why planters more often than not were faced with stiff managerial challenges; they had thousands of acres under cultivation but barely enough workers to produce a crop. And what workers they did have were constantly looking for a chance to leave. In 1882, Mississippi planter George Collins had 100 bales of cotton in his fields and not nearly enough hands to pick it. His anxiety was multiplied by the prospect that his entire crop of corn might be lost. The crisis, he reported, was enough "to make me tremble."[27] None of this anxiety, however, is signaled in Walker's plantation images. He offers instead a rosy view, one shaped by the belief that after the Civil War legions of loyal former slaves had stayed on to render faithful service to their benevolent and caring masters. It was pure fantasy to project such a benign scenario for almost 4 million black southerners.

During the period when Walker was creating his cotton scenes of splendid potential, the fortunes of cotton planters in Mississippi proved to be rather bleak. In 1869, Natchez-area planter William H. Ker wrote to his sister to complain about his ruinous finances: "I feel like giving up entirely, for the more I struggle and just when I have cause to feel a little relief, something occurs to bring everything before me. I had rather have a man shoot at me than ask me for money that I owe him and can't pay him, and I never go on the streets, that I don't feel like dodging

men, lest they should dun me."[28] Ker's circumstances were not unique. Many planters were wiped out in 1873, when the market price for cotton hit an all-time low of fourteen cents a pound. By 1893 the price would fall even further, to five cents.[29] But according to economist James L. Watkins, during the 1880s, the period when Walker was painting his cotton landscapes, conditions were particularly disastrous: "[In 1881] the crops suffered from a severe midsummer drought; great damage resulted from overflows in the Mississippi river districts, and the cotton worm was unusually destructive, resulting in the loss of over a million bales. In the spring of 1883 excessive and continuous rains interfered with the planting and the season was so backward that, with other misfortunes to the crop, the yield fell short of the previous year by a million and a quarter bales."[30] Faced with these conditions, the common wisdom among white landowners held that it was best simply to abandon their plantations for jobs in town. The confident predictions of rising fortunes linked to a "new Comstock Lode of cotton" had failed to materialize, at least in Mississippi. We find, then, that Walker was editing the landscape with his brush, that he was painting the South as he wanted it to be. Ironically, in his scenes he described the promise of success by offering his viewers a memory of the Old South, when captive black people did all the onerous labor.

Walker's general distaste for the modern era was expressed in a letter he wrote to Katie Diehl in 1905. Upon returning to New Orleans for the first time after an absence of eight years, he was disturbed by what he found, observing that "people walk fast now." And what was worse, he wrote, "It is no longer the quiet, easy going city of a few years ago, but one of progress, and it is destined to be a great city, it is now a big one. It is all fine and progressive, but alas, pleasanter to me in the olden time."[31] Something of this same reluctance was present in his plantation landscapes as well. Art historians August Trovaioli and Roulhac Toledano note that because these paintings lack a certain focal point, they also lack the reality of a specific place. Describing the visual effect as "iconographical," they note that Walker's technique "conveys a special mood of permanence and endurance."[32] Walker's paintings express his desire to stop time in order to hold on to an Old South that he saw slipping inevitably away.

Walker's landscapes offer what finally has to be seen as a mixed message, combining the promise of improved production with a desire to turn back the clock. The fact that his landscapes are so thoroughly populated by African American figures suggests a longing for the antebellum order, when black people seemingly just did as they were told. While there is nothing to indicate that Walker ever advocated that African Americans be returned to bondage, he is certainly consistent in the way he always presents them as subservient, even slavelike, laborers. Trovaioli and Toledano see in Walker's meticulous attention to the details of black

dress—the ragged clothes, worn-out shoes, and beat-up hats—an indication that he was "sincerely interested in and fascinated by Negroes."[33] To come to this assessment, however, there is much that they must excuse and overlook. Seibels argues that Walker, as well as many other white southerners of his period, found images of poorly dressed blacks and scenes of their crude cabins to be "comforting." Even if they had been "broke by the war," whites could find in the poverty of African Americans a reason to remain optimistic; they may have fallen, but there was still a class of people even worse off. It was for this reason, she alleges, that Walker consistently gave his black figures "extremely servile attitudes."[34] She notes further than even though Walker lived for years in New Orleans, which had a sizable black professional class, he always painted black men and women as struggling agricultural laborers. He was apparently not interested in instances of African American success.

Estill Curtis Pennington senses an exploitive agenda in Walker's paintings, describing them as "mean and hard."[35] He particularly finds Walker's racism unmasked in a series of portraits done at the time of the Cotton Exposition of 1883. Given dialect titles such as *Whar Am Dat Expersision?* or *Gwine Ter Der Expersision?* (Figure 6.11), they were offered as deliberate farcical grotesques, the painted equivalents of a blackface minstrel show. "Nothing in the presentation of blacks in these works," writes Pennington, "in any way reflects their basic humanity, potential for growth, or status as free men and women."[36] Interestingly, one of these burlesque characters even appears in the foreground of *Big "B" Cotton Plantation*, where he stares directly out at the viewer. Though diminutive in scale, there can be no question that this figure is an alternate version of the same satirical image that Walker sold to tourists at the Cotton Exposition. Its presence in a plantation scene confirms that Walker held a thoroughly stereotyped view of black people as weak-minded creatures suited only to work the land as directed by their white overlords.

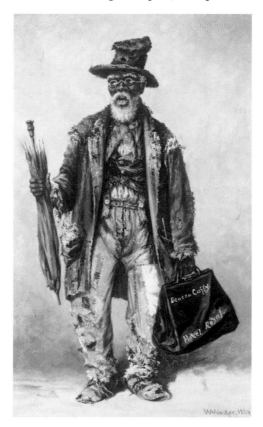

FIGURE 6.11.
William Aiken Walker, Gwine Ter Der Expersision *(1884). Oil on board. The Collection of Jay P. Altmayer.*

Walker's view of the plantation was optimistically idyllic. In his fields, all seems pleasant and reassuring. A newspaper reporter, upon viewing one of landscapes, apparently felt these same sentiments. In his lyrical response, he notes how effectively Walker has rendered the setting, revealing it to be "mild and luxuriant with the splendors of our Southern clime, made all the more brilliant with the gorgeous dress that nature assumes when the year is dying."[37] Aspects of general well-being also characterize the black people who are spread about the fields. As Seibels notes, "All smile, happy to be working, as they bend to pick the fleecy white staple."[38] It mattered not that these men and women might have wished for a different fate or that, under their breath, they may have cursed the planters who continued to exploit them. Walker's use of bright light and an appealing palette of warm colors disguised the fact that a new form of involuntary servitude was now in place, one based on illiteracy, abusive laws, the prison contract system, and the threat and reality of routine violence.[39] The sunny South that Walker promoted in his plantation landscapes was, in social terms, not so sunny after all.

I n 1937 Alice Ravenel Huger Smith (Figure 7.1), a woman who rarely traveled very far from her native Charleston, South Carolina, found herself in South Hadley, Massachusetts, sitting on a stage at Mt. Holyoke College. It was the one hundredth anniversary of the founding of that distinguished college, and its administrators thought it fitting that they mark the event by conferring doctorates on outstanding women in various fields. Smith, then sixty-one years old, was honored that evening for her talent as a painter of ethereal landscapes. Delighted to be recognized in this way, she would later reflect on how unlikely that event had seemed to her. To be awarded a doctorate of letters by such a prestigious institution, and a northern one at that, was a delightful surprise. Smith marveled that the august Mt. Holyoke had selected her, a person "who had never been to college, never even to a boarding school, never to a big public school—only to a small private school of thirty or forty girls."[1] But in many ways, it was because Smith was able to develop her artistic abilities without the usual sorts of direction (and limitations) offered by lessons and instructors that she was being recognized.

Born in 1876 to a family with deep historical roots in South Carolina, Smith attended the Misses Sass's School, where she was tutored in the basic subjects. To her curriculum she later added some lessons in art by attending classes offered by the Carolina Art Association, which were taught by a French woman she identified as Mademoiselle Louise Fery. Smith described her training in art as not particularly venturesome.[2] Guided through a series of still-life and figure exercises, she learned to render accurately. Having been told by her grandmother that she would become an artist, she had no doubts about her future as a painter, but she searched for almost twenty years for the genre, technique, and style that best suited her. She said of this period: "When I began my painting career I stumbled through the usual experiments that all young artists must make, portrait painting, miniatures, bookbinding with the idea of fine-tooling, block prints, flowers, a little etching, and pencil drawings to illustrate various books. Oils, pastels, watercolors." Eventually she committed to watercolor landscapes, realizing, as she put it, "that my own lovely, flat country of rice-fields, of pine woods, of cypress

FIGURE 7.I.
*Miss Alice Ravenel
Huger Smith (1876–
1958). Photograph.
Gibbes Museum of
Art/Carolina Art
Association, Charles-
ton, South Carolina.*

swamps, of oaks, and lotus, and all their attendant feathered folk would yield me a full harvest."[3]

To create even a single painting Smith would undertake numerous trips into the countryside around Charleston, where she might sketch various settings, some of them in exacting detail. She employed this regimen to fix a scene in her mind, for she did her painting in her studio. This technique was suggested to her by Birge Harrison, a New York artist who had rented rooms in the former slave quarters of her Charleston home during the summers of 1908 and 1909. Smith felt that deep study of a place allowed her to capture it with confidence. In fact, she so transcended the task of representation that her paintings were readily seen as symbolic works, even as icons of the low country.

Smith developed an impressionistic style without referring back either to its European originators or to any of its American enthusiasts. She learned to produce marvelous visual effects by skillfully harnessing the random meanderings of flowing color. According to Louis Lawson, one of her associates from the Pink House art gallery in Charleston:

> When she painted she wet the entire surface of the board first—very wet—and literally rolled the board around with her hands as she added the colors of the sky, water, etc. When she had the colors where she wanted them, she would "stop" the remaining water with one of her large, blunt or pointed Japanese brushes. . . . You will note that a relatively small part of any painting is conventionally painted with a wet brush—only grass, birds, etc. in the foregrounds.[4]

While antecedents for Smith's style have been sought in the array of influences to which she was introduced while still a neophyte—tonalism, Japanese prints, the Charleston Renaissance—her approach to painting was finally her own. Henry S. Canby, writing for the *Saturday Review*, congratulated her for this achievement when he observed of her work: "The result is a landscape where imagination has

been free to compose and the brush free to state a beauty that is both real and symbolic."[5]

Over a span of thirty years, from 1921 to 1951, Smith exhibited her works in museums and galleries all across the United States and contributed as well to shows that traveled to European venues. But in her view, one of her more significant achievements was the publication in 1936 of *A Carolina Rice Plantation of the Fifties*, a book that was notable mainly for her watercolors. With this volume she fulfilled a lifelong ambition, which she stated very clearly in the book's preface:

> [T]hroughout my life I have been trying to paint the rice-planting section of South Carolina—that long strip of flat lowlands lying within the influence of the tides which extended to about forty or fifty miles from the sea. The marshes, the fields and forests, the canals, "the settlements," and the many other marks of a great industry, have been noted down by me for many years. I have seen much of it disappear and the remnants are vanishing year by year. Therefore I have brought into a sequence some of my notes and sketches for those who may be interested.[6]

While the book also contained a wide-ranging essay on the plantation era by her cousin Herbert Ravenel Sass and excerpts from the as yet unpublished recollections of her father Daniel Elliot Huger Smith (who had grown up on a rice plantation), it was her paintings that formed the heart of the volume. Gathered together at beginning of the work, her thirty images clearly overshadowed the book's written portions.

In a somewhat disjointed sequence Smith provided an account of the annual cycle of rice production. She swung back and forth between scenes of a rice-growing estate and portrayals of the natural beauties of the low country. She began logically enough with four images that illustrated the presumed social hierarchies of a plantation. The environments of master and slave were contrasted by pairing images of a planter's mansion with a slave "settlement" and a white church with a black one (Figures 7.2–7.5). Then Smith shifted abruptly to paintings of oak groves and pine trees, both of them romantic images enveloped in hazy purple shadows. These works, when combined with subsequent scenes of fields and gardens in the fall and winter, suggested that a plantation should be understood as a site of unrivaled natural beauty. Smith then turned to images that documented how rice was grown. In a sequence of sixteen paintings, the core of her portfolio, she summarized the key steps. Beginning with the planting of the seed, she moved incrementally through the stages of cultivation, harvest, and threshing, and concluded with a shipload of rice being sent to market (Figures 7.6–7.19).

After scenes showing a stubble-filled field after the harvest and the mending of a storm-damaged levee (Figure 7.20), Smith concluded her portfolio by returning again to images of regional vistas.

Art historian Martha R. Severens speculates that the four concluding images may have existed before Smith undertook her plantation project and that they might have been added to the portfolio as an afterthought.[7] What is clear, however, is that while creating this ensemble of paintings, Smith drew upon her family's history. Her relationships with her father and grandmother provide us with a valuable key to understanding why the plantation became her primary subject.

Smith was drawn to the South Carolina landscape not only by its inherent beauty but by feelings of obligation that required her to honor the achievements of her ancestors. Members of her family had authoritatively stamped their personalities on the Carolina low country. Her grandmother, Eliza Carolina Middleton Huger Smith (1824–1919), a formidable matriarch who always demanded and received "*prompt* obedience," had managed the family's two plantations after her husband's death in 1851. It was her effort "to build from the wreckage of the past a platform for the next generation to stand on" that inspired Alice Smith to valorize the antebellum rice plantation.[8] Smith also sensed that her grandmother's charisma had flowed on to her father. Together, they were for Smith, as she said, "the rocks upon which others rested."[9] Daniel Elliot Huger Smith (1845–1932) was raised on a plantation, had gone off to fight in the Civil War at the age of sixteen, and later had established a successful business as a cotton exporter in Charleston, despite the challenges of the Reconstruction period. A confident man, well-armed with firm opinions, he also proved to be a diligent student of local history. His memoirs, covering his experiences from 1846 up to 1913, had a profound impact on his daughter. Paging through his stories of Smithfield, the family's rice estate, during a period when she was still searching for a truly satisfying art form, Alice Smith found herself enthralled by his recollections.

Beginning in 1914, Alice and D. E. Huger Smith would coauthor three books. Their first volume, *Twenty Drawings of the Pringle House on King Street, Charleston, S.C.*, offered a portfolio of Alice's atmospheric pencil sketches along with a brief text by her father.[10] The dwelling that they described, better known as the Miles Brewton house, was among the most celebrated of Charleston's old homes, for it had the dubious distinction of having served as headquarters of the British army during the American Revolution and of the Union army after the Civil War. During the 1920s, the so-called "grand old aristocrat on King Street" would also become one of the prime icons in the city's celebrated campaign for historic preservation.[11] The partnership of Alice Smith's illustrations and D. E. Huger Smith's words was

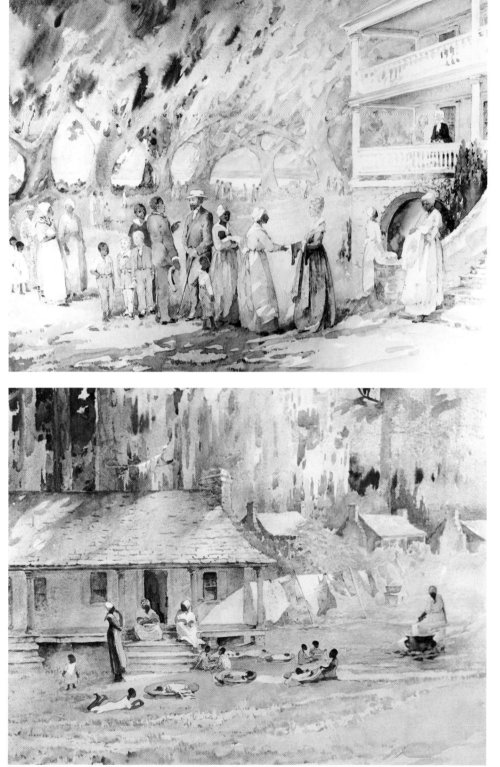

FIGURE 7.4.
Alice Ravenel Huger Smith, The Parish Church. *Watercolor on paper. Gibbes Museum of Art/Carolina Art Association, Charleston, South Carolina. Gift of the artist.*

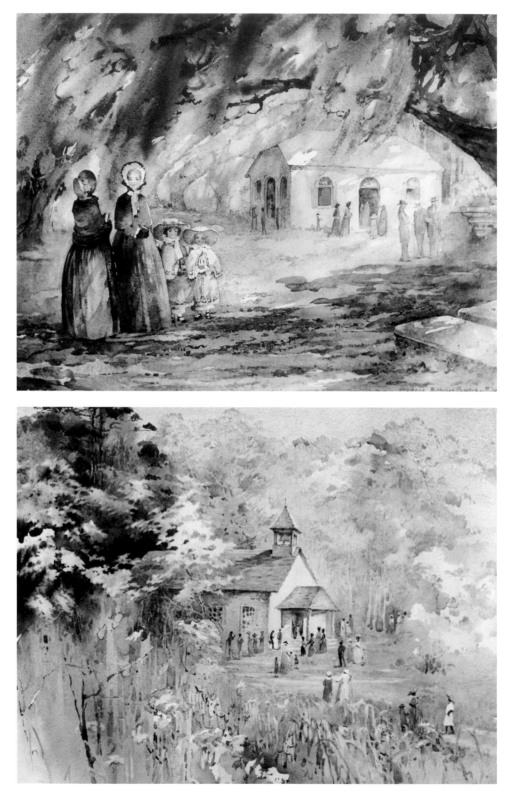

FIGURE 7.5.
Alice Ravenel Huger Smith, The Plantation Church. *Watercolor on paper. Gibbes Museum of Art/Carolina Art Association, Charleston, South Carolina. Gift of the artist.*

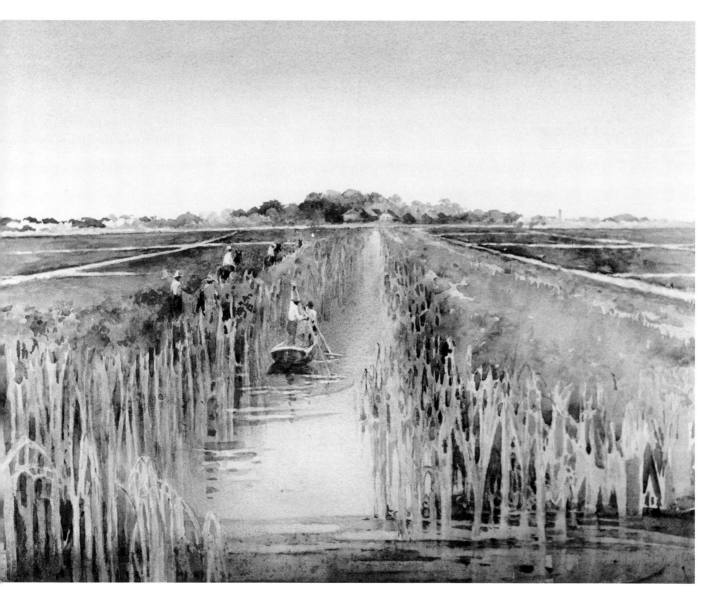

FIGURE 7.6.
Alice Ravenel Huger Smith, Field Prepared for Planting. *Watercolor on paper.*
Gibbes Museum of Art/Carolina Art Association, Charleston, South Carolina.
Gift of the artist.

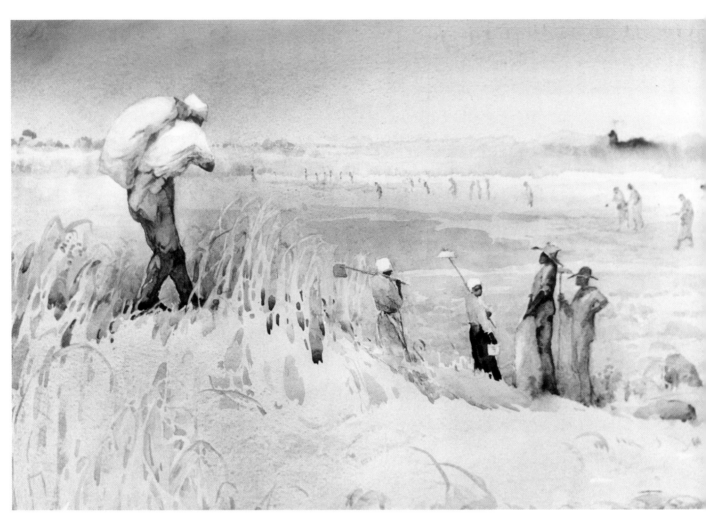

FIGURE 7.7.
Alice Ravenel Huger Smith, Taking Seed-Rice Down to the Fields. *Watercolor on paper.*
Gibbes Museum of Art/Carolina Art Association, Charleston, South Carolina. Gift of the artist.

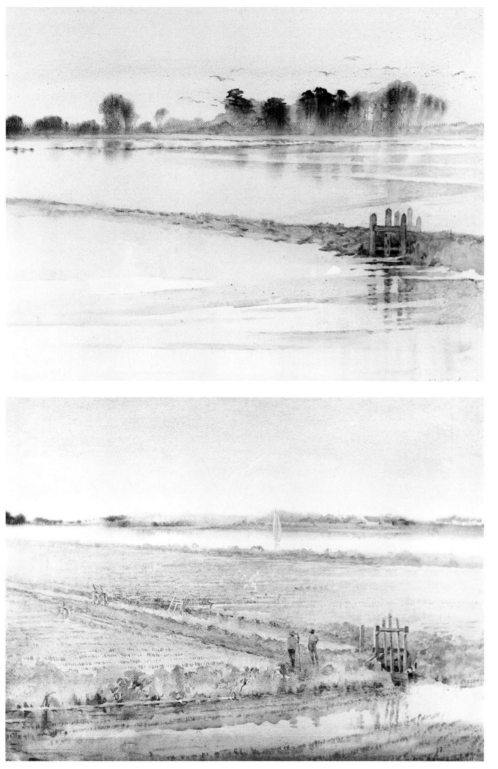

FIGURE 7.8.
*Alice Ravenel
Huger Smith,*
The Sprout Flow—
The First Three to Six
Days After Planting.
*Watercolor on paper.
Gibbes Museum of
Art/Carolina Art
Association, Charles-
ton, South Carolina.
Gift of the artist.*

FIGURE 7.9.
*Alice Ravenel
Huger Smith,*
The Point-Flow, or
"Stretch Water."
*Watercolor on paper.
Gibbes Museum of
Art/Carolina Art
Association, Charles-
ton, South Carolina.
Gift of the artist.*

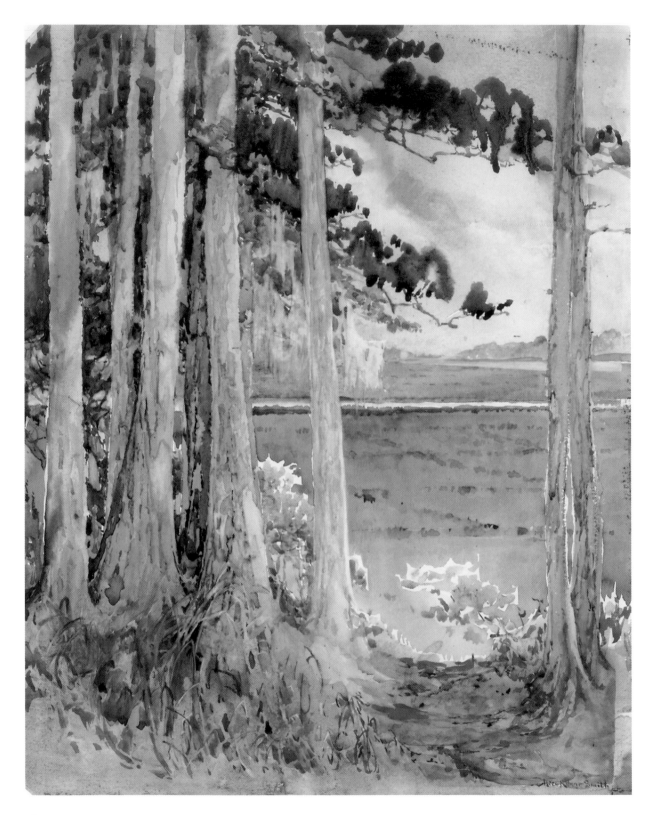

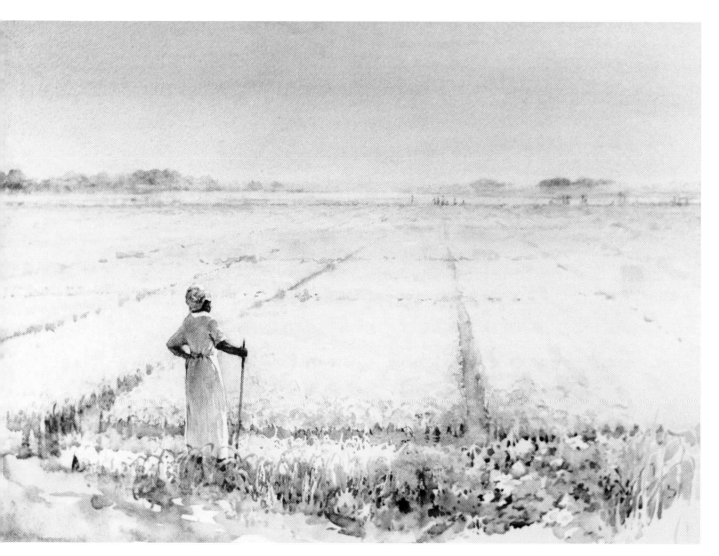

FIGURE 7.11.
Alice Ravenel Huger Smith, Ready for the Harvest. *Watercolor on paper.*
Gibbes Museum of Art/Carolina Art Association, Charleston, South Carolina.
Gift of the artist.

opposite:
FIGURE 7.10.
Alice Ravenel Huger Smith, The Harvest Flow, When the Rice Is Barreling. *Watercolor on paper.*
Gibbes Museum of Art/Carolina Art Association, Charleston, South Carolina. Gift of the artist.

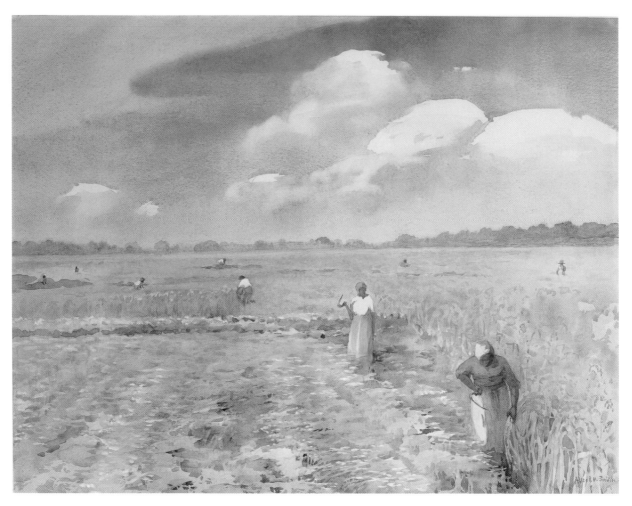

FIGURE 7.12.

Alice Ravenel Huger Smith, Cutting the Rice. *Watercolor on paper. Gibbes Museum of Art/Carolina Art Association, Charleston, South Carolina. Gift of the artist. (Reproduced in color as Plate 11.)*

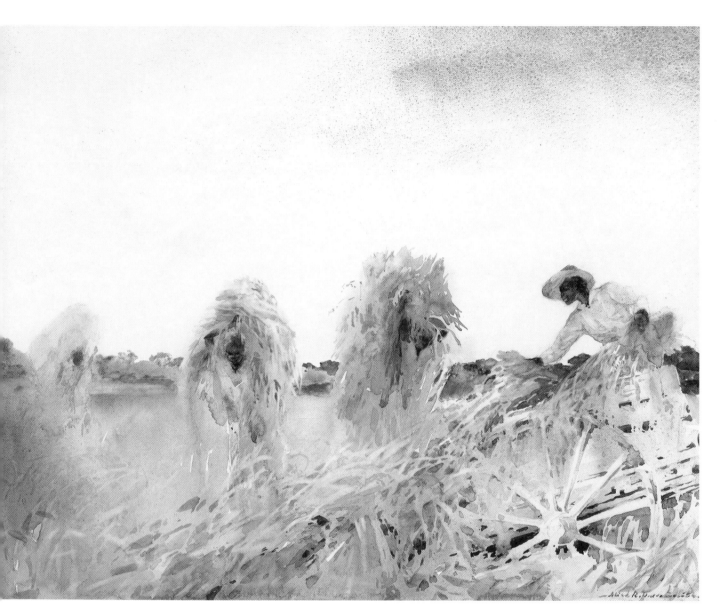

FIGURE 7.13.
Alice Ravenel Huger Smith, Carting Rice from a Small Field. *Watercolor on paper. Gibbes Museum of Art/Carolina Art Association, Charleston, South Carolina. Gift of the artist.*

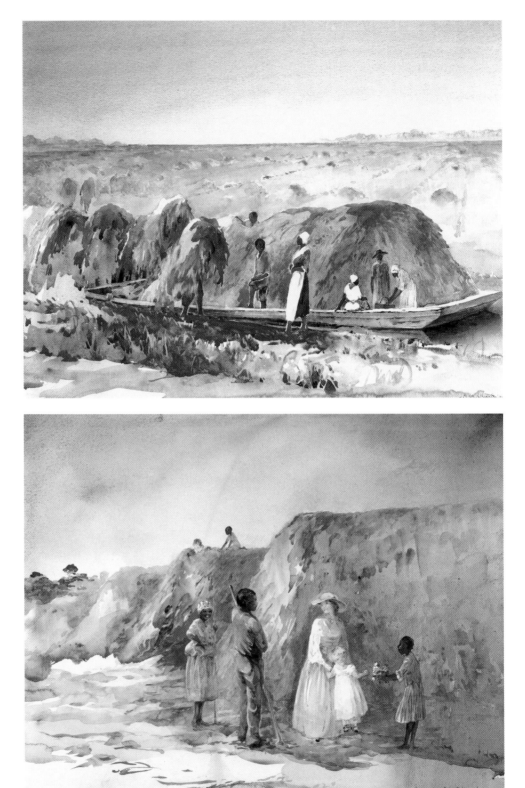

FIGURE 7.14.
Alice Ravenel
Huger Smith,
A Rice Flat in One
of the Canals.
Watercolor on paper.
Gibbes Museum of
Art/Carolina Art
Association, Charles-
ton, South Carolina.
Gift of the artist.

FIGURE 7.15.
Alice Ravenel
Huger Smith,
The Stack-Yard.
Watercolor on paper.
Gibbes Museum of
Art/Carolina Art
Association, Charles-
ton, South Carolina.
Gift of the artist.

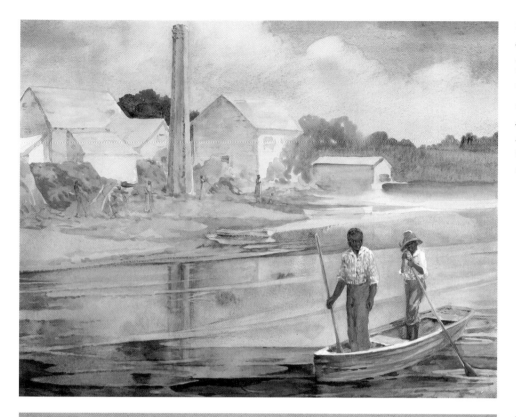

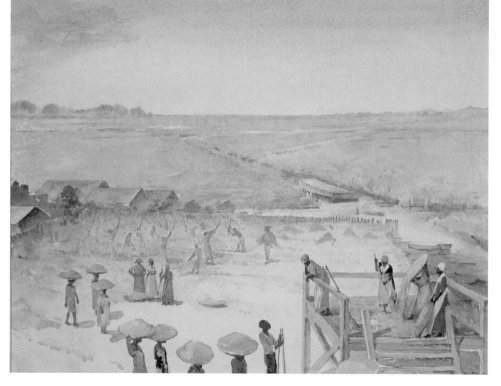

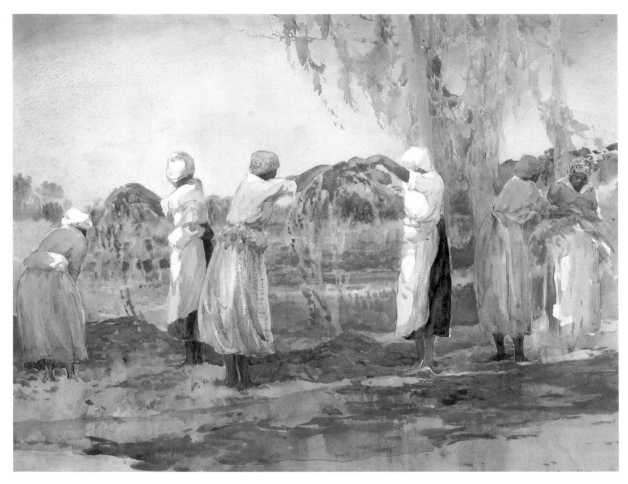

FIGURE 7.18.
*Alice Ravenel
Huger Smith,*
Shaking the Rice
for the Straw
after Thrashing.
*Watercolor on paper.
Gibbes Museum of
Art/Carolina Art
Association, Charles-
ton, South Carolina.
Gift of the artist.*

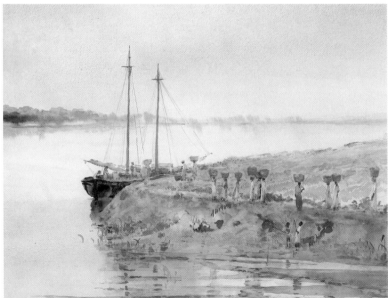

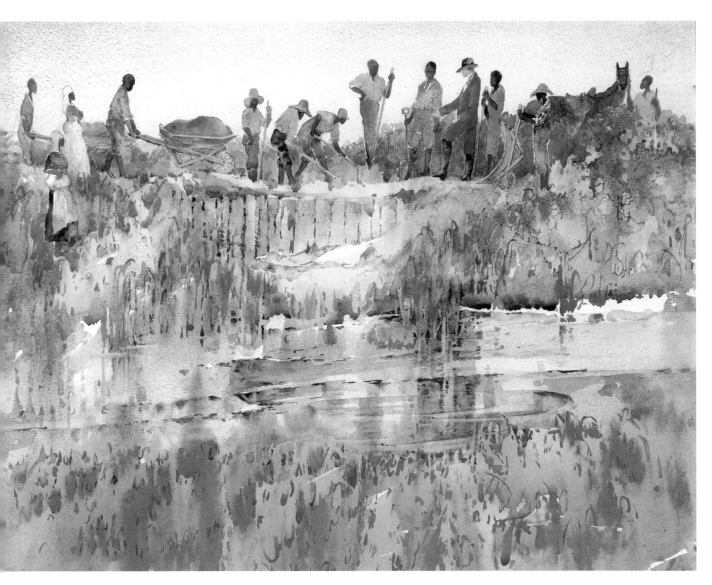

FIGURE 7.20.
Alice Ravenel Huger Smith, Mending a Break in a Rice-Field Bank. *Watercolor on paper.*
Gibbes Museum of Art/Carolina Art Association, Charleston, South Carolina. Gift of the artist.

opposite:
FIGURE 7.19.
Alice Ravenel Huger Smith, Loading a Rice Schooner. *Watercolor on paper.*
Gibbes Museum of Art/Carolina Art Association, Charleston, South Carolina.
Gift of the artist.

more fully developed in their next volume, *The Dwelling Houses of Charleston, South Carolina* (1917), a wide-ranging assessment of the city's old buildings and neighborhoods.[12] The book sounded an alarm, warning local authorities and aficionados of historic houses of what would soon be lost if the city failed to develop a comprehensive plan for intervention and restoration. While it is difficult to know exactly what impact the book's message may have had on preservation policy, just three years after its appearance the Society for the Preservation of Old Dwellings was formed. In 1924 the Smiths coauthored a brief biography of Charles Fraser, Charleston's best known nineteenth-century artist.[13] Although Fraser specialized principally in portrait miniatures, he also produced a notebook of appealing landscape sketches, most of them depictions of plantations located on the nearby Ashley and Cooper Rivers.[14] Thus, for a span of seven years Alice Smith's thoughts were fully occupied with images of built form, the historical record, and images of plantation estates, the places considered to be most emblematic of the region. She also had before her the two examples of mastery and competence offered by her grandmother and her father. Consequently, while trying to develop her own "true" talent as an artist—her own mastery—the tug of parental influence exercised a strong determinative influence.

After her father died in 1932, Smith found a degree of solace in his unpublished memoirs, and she resolved to finish a proposed project that would again match her images with his words. Not only did her plantation series suggest that growing rice was an adventurous enterprise, the very point of view held by her father, but several of her paintings were visual transcripts (some close, others less so) of his descriptions of Smithfield.

Her opening image, entitled *Sunday Morning at the Great House* (Figure 7.2), shows the planter along with his wife and children as they exchange greetings with the slave workforce on the Lord's guaranteed day of rest. The line of slaves stretches well around the edge of the lawn as they wait in the shade of the oak trees for their turn to shake hands with their master. D. E. Huger Smith described just such a scene at the family's plantation: "The residence was called by the negroes 'the Great House,' although by no means large. . . . The big gate was about a quarter of a mile from the house, and thence a road led by a somewhat imperfect avenue through the lawn to the garden-gate. This lawn was in fact a small park dotted with some fine oaks."[15]

When Alice Smith set out to paint slave quarters, she again relied on her father's account, which focused less on the condition of their houses and more on the health care that his mother provided for the slaves who lived out in the so-called settlement (Figure 7.3). Smith showed the nurse's house, where slave infants, each in its own basket, were set out on the grass under the watchful gaze of

several women and older children. Her father's recollections furnished all the details that she would need to create this image:

> The settlement of negro-houses was built in long rows with what were called streets between the rows, running north and south with a small square, in middle of which stood the sick-house fronting south. In one end of this dwelt the sick-nurse. There were rarely any sick in this house, and it was chiefly used as a day-nursery for the babies and children. On fine days there might be seen on the open ground before this house a large number of "fanner-baskets," and on each basket a folded blanket, and on each blanket a baby. Near each baby sat or played a small boy or girl detailed to care for that especial baby, and at the door sat Maum Judy, or later Kate, the Nurse, who when not dozing, kept a watchful eye, lest perchance a baby might be neglected.[16]

D. E. Huger Smith also wrote of the pleasure he felt as he watched a long line of slaves carry baskets of threshed rice on their heads along the levee to a schooner that was waiting to carry the harvest on to Charleston or Savannah. A precise routine was followed to insure that the precious grain known as "Carolina gold" was carefully measured into a ten-bushel tub before it was poured into the ship's hold. His daughter, hanging on his every word, would paint a shimmering scene she called *Loading a Rice Schooner*, which captured the event just as her father had described it (Figure 7.19).[17] Elements that appear in several other paintings — *The Plantation Church* (Figure 7.4), *Cattle in the Broom-Grass — An Autumn Evening*, and *The Threshing Floor with a Winnowing-House* (Figure 7.17 [Plate 12]) — can also be found in D. E. Smith's account, but his commentary on these matters was less explicit, and hence those paintings were more generic in both their content and character.

Alice Smith also turned to other authorities for advice in order to complete her visual survey of rice production. Her uncle, Robert Tilghman Smith, was enlisted to serve as one of her primary consultants. His knowledge was more current than her father's, since he had continued to direct rice-growing operations on three different plantations up to the beginning of the twentieth century.[18] In fact, she decided that in the absence of her father's authoritative guidance it would be prudent to solicit suggestions from as many old planters as she could find who were willing to give advice. While she may have begun her plantation portfolio with the goal of recapturing the old family estate up on the Combahee River, she eventually realized that she would have to be content with a more generic portrait assembled from various comments, recommendations, and bits of advice.[19] Smith also relied on her visits to various estates that were close to Charleston, principally Mepkin, Mulberry, Wappaoola, and Dean Hall up the Cooper River, and Middle-

ton on the Ashley. In fact, her painting of rice in its final stage of growth, *The Harvest-Flow, When the Rice Is Barreling*, depicts the fields at Middleton (Figure 7.10). When she visited her friend Marie Heyward at Wappaoola, it was their custom to attend Sunday services at the nearby historic Strawberry Chapel, the church that provided her with the basis for the painting called *The Parish Church* (Figure 7.4).[20] Because all of South Carolina's rice plantations ceased operations well before the time that she was compiling her portfolio, there was no place where Smith could sketch black people working in any rice fields. However, her friends Mr. and Mrs. Benjamin Kittredge, the owners of Dean Hall plantation, were transforming their old rice estate into a "water garden." There Smith found gangs of black men toiling in the marshes, and she used them as models for her renderings of plantation field hands, even though the comparison was only approximate.[21]

That Smith felt compelled to search out a contemporary equivalent to plantation labor is surprising, given that in 1913 she had spent a considerable period of time at Chicora Wood, the rice estate belonging to Elizabeth Allston Pringle up on the Pee Dee River. Pringle had written a number of stories detailing her experiences of plantation life that were serialized from 1904 to 1907 in the *New York Sun*. She later gathered these stories into a single volume entitled *A Woman Rice Planter* (1914), and to make her book more compelling, Pringle, writing under the pen name Patience Pennington, solicited Smith to prepare eighty-six drawings to accompany her text.[22] These vivid sketches presented numerous agricultural as well as domestic tasks. At least eleven of these images were recycled, in whole or in part, in Smith's rice plantation series: the views of the rice fields, scenes of harvesting and threshing, and images of particular buildings, including the plantation "big house," the rice mill and winnowing house, and the slaves' church.[23] It would appear that some of the seeds for *A Carolina Rice Plantation of the Fifties* were sown in Pringle's account.

To make her depiction of a South Carolina rice plantation credible, Smith was obligated to include images of African Americans. Thus, black figures occur in more than half the images contained in her plantation series. Rendering black people was for Smith a very familiar task. When interviewed by Marietta Neff in 1926 for an article in the *American Magazine of Art*, Smith reported that she had painted some 800 "negro sketches" which she sold as souvenirs to tourists.[24] These works were very similar in style and demeanor to the works of fellow Charlestonian William Aiken Walker, who knocked off quick sketches of blacks when he was between major commissions and in need of cash. Like Walker, Smith also rendered her subjects as generic types rather than as individuals. While her pictures were not the demeaning caricatures that were so common at the turn of the century, they were still limited to the formulas and stereotypes that satisfied a

visitor's need for a bit of local color. But these renderings were still much more detailed than those she did for her rice plantation paintings, where African Americans appear mainly as brown silhouettes. Because she opted to give very few of her African American subjects any facial features, they appear mainly as dark bodily presences who silently tend to their assigned tasks. Historian Stephanie Yuhl observes that in Smith's paintings her black subjects "melt into the landscape."[25] While Smith was attempting to present black field hands as universal, even archetypal, figures who were intimately connected to the land, they were reduced finally to anonymous laborers.[26] As revealed by her early portrait work, Smith was certainly capable of capturing facets of an individual's personality. The illustrations that she produced for *A Woman Rice Planter* had already demonstrated that she was capable of rendering sensitive likenesses of black people (see, for example, Figure 7.21).[27] One might conclude that the featureless black faces were intended to reduce the visual prominence of the work force. As anonymous figures, they blended more easily into the plantation setting.

Smith reacted to African Americans with a marked ambivalence, behavior that perhaps reflected the apprehension she felt regarding matters of race. She seems to have absorbed some her father's attitudes, although in a milder form. D. E. Huger Smith was certain that African Americans were an inferior people. Although he admitted that they had many good and lovable qualities, he thought that blacks had been spoiled by Emancipation. Embittered at the passing of the old southern order and angered by the loss of the privileges he had once enjoyed simply by virtue of being a white man, he fumed over the changes in southern society. At the conclusion of his personal reminiscences he raged against the Fourteenth and Fifteenth Amendments, which insured the protection of civil and voting rights for all citizens but particularly for newly enfranchised southern blacks. He argued that those two amendments had "given birth to an amount of usurpation, injustice, fraud, and misrule that would stagger a Mexican."[28]

Alice Smith was far less vitupera-

FIGURE 7.21. *Alice Ravenel Huger Smith,* Bonaparte *(1913). Illustration for Patience Pennington [Elizabeth Allston Pringle],* A Woman Rice Planter *(New York: Macmillan, 1913). Library of Congress.*

tive on issues related to the color line. Her position was characterized by alternate gestures of approach and avoidance, appreciation and aversion. During her early years as an artist, she had depended on the regular sales of her small images of black people in order to pay the rent for her painting studio, but she complained that she found the task fatiguing.[29] She was thoroughly enamored of the black nurse whom she called "Dah." Of this woman, who had raised her along with her four siblings, Smith wrote: "We loved Dah much the best. She had a way of giving us lumps of brown sugar and letting us wear our best sashes and telling us lovely tales of the lizards and rabbits and brother deer, and the other wild folks that everyone loves, young and old." Yet she was miffed to find out that her "Dah" preferred to be called by her proper name, Mrs. Elizabeth West.[30] For some years Smith had carefully collected folktales from blacks working at Wappaoola plantation and had taken pains to capture the sounds of their Gullah-inflected speech. She planned a manuscript entitled "Coloured Conversations" for publication in *Harper's*.[31] But even though she had extensive firsthand knowledge of the people who had lived and worked on rice plantations in the late nineteenth and early twentieth centuries, when she undertook her plantation series, she consciously chose to bypass their testimony. Instead, she "threw the book *back* to the Golden Age before the Confederate War so as to give the right atmosphere." To her, the "right atmosphere" clearly meant that she should concentrate on the period when her family's fortunes flourished from the uncompensated labor of captive blacks. She preferred this era of reputed glory to her own day, when, she recalled, "times were hard, and rice planters had to use some makeshifts."[32] In her plantation watercolors she rendered a benign view of slavery that suggested that African Americans had benefited from their bondage. She clung to the reassuring fantasy that denied slavery's brutality. No doubt she agreed with Herbert Sass, who wrote in one of the essays for her plantation book that centuries of captivity "had worked wonders for the negro race, lifting millions of negroes out of barbarism in a far shorter time than any other barbarous people had been so lifted in the history of mankind."[33]

Taking a stance regarding plantation slavery that would be difficult to support today, Smith veneered plantation experiences with beautiful surfaces. She did this by focusing on the atmospheric features of the setting, particularly on color, light, and the glistening sheen of water. Under her trademark impressionist techniques, human actors dissolved into the fields, becoming themselves almost like natural features of the landscape. In this way, black people were shown in what Smith took to be their proper role, that is, they were shown as compliant workers devoted to making a good crop for a benevolent master. This pleasant view of plantation life was an idealized perspective that, at bottom, was intended to flat-

ter the Smith family. By filtering out any stories that might challenge received legends of diligent endeavor and well-mannered elegance on the part of the planter class, Smith rendered a reassuring, nostalgic vision, one calculated to shield her viewers from one of the most inhumane episodes in American history.

When Smith gazed out upon the remnants of the rice empire, she suppressed historical truths in order to concentrate on the pictorial potential of the setting. With the colors of her paint tray foremost on her mind, she rhapsodized about the rice lands. During the years when she regularly visited Wappaoola, for example, she observed, "[The fields were] beautiful alike when green, or tawny in the fall, or silver when the grasses were in their last glory. Others were orange when the broom-grass has its November coloring. The rice-fields were golden with ripe rice in summer."[34] This was the very palette that she employed in her plantation portfolio: green for *The Harvest Flow* (Figure 7.10), tawny for *A Winter Field Still in Stubble*, silver for *The Reserve in Winter*, orange for *Cattle in the Broom-Grass*, gold for *Ready for the Harvest* (Figure 7.11). Indeed, flashes of gold appear in two-thirds of her paintings, warming each one with a reassuring glow. Since Smith aimed to recapture what she called a "Golden Age," she seems to have reasoned that it was fitting to fill the air with a lustrous yellow haze. This tactic made her pictures seem dreamlike, a quality that one reviewer seemed to recognize when he commented, "None of her pictures is actually a picture of any particular place."[35]

This absence of specificity helped Smith to idealize plantations as pleasant places that had once been occupied by noble owners and reliable workers. Since she provided only the vague outlines of no place in particular, she could easily project the scenario of a conflict-free past onto her beloved Carolina low country. One former planter, whom she had consulted for information about rice-growing methods, generally approved of her portfolio but felt she had "left out the last picture," telling her, "You should have a poor planter standing on a bank, holding on to a tree, and watching a crop swirling away down the river in a storm."[36] But Smith declined his recommendation. She meant for her pictorial narrative to be a salute to achievement. She was not interested in any admissions of loss, failure, or inadequacy. Negative memories, and negative images, were banished from her plantation series.

Smith aimed to show what white people had made of the Carolina low country. Given this purpose, she must have found herself somewhat stymied at first. It was, after all, armies of enslaved black laborers who had actually created the plantations, by transforming the swamps and marshes into complex systems of fields and canals. It was the slaves who built what rice planter David Doar called "a huge hydraulic machine."[37] Because slaves were a necessary element that Smith absolutely could not leave out of her paintings, she took care to render them in a

manner that suggested they had no reason to object to their captivity. No over-seers' whips appear in her paintings, even though her father was quite explicit about their presence in his recollections.[38] In her painting *Mending a Break in the Rice-Field Bank* (Figure 7.20) she implies an egalitarian feeling between owner and slave, as the planter stands together with several field hands while they casually watch other members of the crew push a load of fill into the gap in the levee.[39] Her image of the slave quarters is particularly revealing of her attempt to rehabilitate slavery (Figure 7.3). In this picture she rendered a row of cabins in the background, partially hidden behind a clothes line and some shrubbery. Rather than showing the expected scene of the slaves' domestic routines, she provided a view of their newborns being tended by nurses at the "sick house," an image suggestive principally of the planter's beneficence. Since Smith produced clear, detailed renderings of slave buildings for her other book projects, it is quite apparent that she could approach slavery and African American domestic life when she was interested in creating accurate documentation.[40] But her self-declared purpose for *A Carolina Rice Plantation of the Fifties* was to project an image that would honor the recollections of her father and grandmother. To achieve this goal, she carefully revised the record to suit her purpose.

Smith's plantation series satisfied a deeply sensed familial obligation. Her branch of the Smiths traced themselves back to Robert Smith, the first Episcopal bishop in South Carolina, founder of the College of Charleston, and owner of Brabants, a 3,000-acre plantation on the Cooper River. The other family names that she carried, both of them Huguenot in origin, were equally distinguished. Smith believed that personal honor was firmly linked to one's ancestral pedigree and the reputation of one's family name.[41] Ever the dutiful daughter, Smith took pains to carry out what she understood to be her filial-pietistic obligations. She willingly submitted to those unwritten codes of veneration. Even when she was well past seventy years old, and finally an exalted elder herself, she still assumed the subordinate position, writing that she was grateful that it was given to her "to grow up in the shadow of the shade of the great civilization that had produced the generations of the past."[42] In 1950 she completed a task that had nagged at her conscience for years when she saw both her father's memoirs and a collection of her grandmother's letters successfully published in book form.[43]

Given the awe with which she regarded them, Smith could never admit that her grandmother or her father were ever associated in any way with an ignoble enterprise. The bonds of affection thus presented her with a vexing problem, since both her relatives obviously had owned many slaves and been absolutely dependent upon them for their livelihood. The solution to her dilemma was to render chattel slavery not merely as a tolerable system but finally to present it as a benign insti-

tution. In taking this stance, she made common cause with U. B. Phillips, arguably the most influential historian of slavery during the first half of the twentieth century. Phillips held that plantations were virtuous institutions that had served basically as schools, providing blacks the training they needed in order to adapt successfully to American civilization.[44] Herbert Sass applied Phillips's assessment expressly to South Carolina, writing, "Nowhere in America was slavery a gentler, kindlier thing than in the Carolina Low Country."[45] He could offer such a sugarcoated characterization in large part because Smith had created a set of pleasant images in which the cruelty and violence that undergirded so much of the plantation system were visually neutralized.

While it is tempting to suggest that Smith's rendering of slavery shows her to be nothing more than a product of her times, such an assessment would be inadequate. That it was possible for a woman of her background and position to reject the comforting assumptions with which Alice Smith protected her family's honor is illustrated by the example of Julia Peterkin (1880–1961), a noted South Carolina novelist who was nearly Smith's exact contemporary. She too was descended from plantation owners and had even spent a portion of her childhood living at the family estate. Like Smith, she was intimately familiar with black people; she was reputed to have learned to speak Gullah before she learned English. But when Peterkin created her portrayals of African Americans, unlike Smith, she emphasized their heroic struggle and took pains to avoid commonplace racist stereotypes. The great African American scholar W. E. B. Du Bois, astonished that a white woman could write so insightfully about his people, praised her, saying that she had "the eye and the ear to see beauty and to know truth."[46] At almost the same moment that Smith was producing her plantation paintings, Peterkin was writing *Roll, Jordan, Roll* (1933), a nonfiction account of black life in the low country. Her clear-eyed and sympathetic descriptions offered an alternate way to think about the same landscape that Smith had chosen to cloak with a hazy mist, both visually and intellectually. Peterkin proved that one could set aside the rosy lenses of romantic projection that Smith preferred. Her example suggests that Smith could have produced something other than saccharin portrayals of rice field workers had she so desired. But it is clear that she chose to do otherwise. The paintings in *A Carolina Rice Plantation of the Fifties* should be understood, then, as the results of her decisions rather than merely as symptoms of the social climate of Charleston.

Smith's efforts at glorifying the slave regime became even more ironic with the launching by the Federal Writer's Project of a massive project to interview exslaves, which was initiated in 1936, the very year that *A Carolina Rice Plantation of the Fifties* was published. Thousands of elderly African Americans who had expe-

rienced slavery firsthand were visited, and their recollections were recorded. Not surprisingly, those from the low country remembered the rice plantation experience much differently than did the members of the planter class who had supplied Smith with various details. The former slaves who had worked on rice-growing estates recalled all sorts of experiences, but they repeatedly came back to the violent beatings that were the standard technique of plantation discipline. Hagar Brown testified: "Don't done your task, driver wave that whip. Put over a barrel, beat you so blood run down." Margaret Bryant remembered how slaves were confined in the "bull pen," a dark small box, where, she told her interviewer, "you can't see you hand before you. Can't turn round good in there. Left you in there till morning. Give you fifty lash and send you to work." Probably the most horrifying account came from Ben Horry, who witnessed how his mother was punished for not finishing her assigned task. She was taken to the barn, he said, "and strapped down on a thing called the Pony. Hands spread like this and strapped to the floor and all two . . . both she feet been tie like this. And she been given twenty-five to fifty lashes till the blood flow. . . . I stay there look with THESE HERE!" [pointing to his eyes].[47] While Smith may never have heard tales like these, it is hard to accept that she was completely unaware of the brutalities of plantation life or of the lasting scars, physical and mental, caused by such vicious acts. Given that she often visited for prolonged periods the same sorts of communities as the Federal Writers Project interviewers, it would appear that not only did she decide to see the plantation in a beneficent light but she also chose to turn a deaf ear to any stories that might have disparaged the plantation enterprise.

According to James C. Kelly, at the beginning of the twentieth century southern artists tended to glorify the region with images that emphasized its traditional values. Alice Smith's work was particularly representative of this trend. She was, suggests Kelly, filled with nostalgia for a way of life that was vanishing before her eyes.[48] In what was finally a vain attempt to reverse the profound changes that signaled the rise of a new social order in the region, Smith threw herself into landscape painting. Elizabeth O'Neill Verner, a fellow Charleston painter, marveled at the trancelike focus Smith maintained as she painted: "The paint flows, glides, dances or is suddenly checked as she desires. She is in complete control. What she is painting is all that matters."[49] Smith claimed that her decision to claim landscape as her artistic specialty grew out of her reading of works on Japanese art. She wrote that she was profoundly moved by the observations of the eleventh-century artist Kakki, whose discourse on the value of landscape suggested that paintings of scenery could turn one's thoughts toward mildness, kindness, and magnanimity. Believing that the modern world had little use for these feelings, she created idealized renderings of swamps, trees, and "feathered folk" as images

that might inspire a return to the serenity of a former age. Smith would eventually extend her search for emotional calm to contemplation of the lost world of the plantation.

An especially significant insight had come to Smith while she was visiting Elizabeth Pringle at her Chicora Wood estate. It was then that Smith realized how she might forge a connection between Asian spiritual philosophy and Carolina rice fields.

> While I was staying with her [Pringle] a neighbor died and was buried at All Saints, Waccamaw. We went to the funeral in a boat rowed by two negro men. It was a long trip down the Pee Dee and through a canal or creek across an island of rice-fields, which was very beautiful edged with grasses and flowers, and out into the Waccamaw, a broad bold river. There we met a flat on which were the coffin and the family, which we followed up the Creek to the Church.
>
> The loveliness and simplicity came back to my memory in confirmation of my belief that today's inventions have cut us off from intimacy with mother earth. We hurry too fast to feel her, and know her. We see her, but with interest and admiration, not with that slow deep feeling I seem to remember of those days.[50]

Smith's plantation series drew together what she felt were two key sources of enduring value—nature and history. She was in full agreement with the members the South States Art League, who published a manifesto in 1928 that called for the creation of works that would reveal "those hidden qualities of the heart, those traditions of neighborly life, those relations to the soil, which have made us what we are."[51] An active member of the League, Smith had already been painting what she considered to be the core elements of southern identity for almost two decades.

Motivated by the melancholy feelings of loss and longing, Smith took full advantage of the expectations of impressionist painting as she focused more on the projection of feeling rather than on the specific content of any setting. Because the impressionist painters considered the appearance of reflected light at a particular moment as their true subject matter, the features of a landscape held only passing interest. Outlines were suppressed and forms dissolved into areas of color whose juxtaposition produced the desired optical effect. Smith too suppressed detail in her landscapes while heightening the impact of color, tone, and light. But instead of aiming to capture the immediacy of a particular moment, she tried to forge a connection with a universal sentiment. In her plantation paintings the murky light, the hazy mist, the glistening sheen on the water—all constituted a filmy screen that suggested a separation of the viewer from a lost heroic world. Over the course of her long career as an artist, Smith produced approximately 560 water-

color paintings, and slightly more than 100 of them were renderings of the remnants of old plantation fields.[52] That she concentrated so much on what was left of rice-field landscapes reveals the depth of her connection to such places. She often visited these sites to commune with nature, but in the series of images created for *A Carolina Rice Plantation* she aimed to tell a story of energetic enterprise and gallant courage, the story of the Smith family. In this task she went beyond the limits of one family's story to recount the mythic tale of a former golden age. Unlike the impressionists, who celebrated a fleeting insight about the present moment, Smith retreated to a more reassuring past. She inverted the strategies of impressionism to reach back through the veil of memory.

When Samuel Dyssli arrived in South Carolina in 1737, he was surprised to see huge gangs of captive Africans transforming the freshwater marshes into profitable rice lands. With considerable astonishment he wrote, "Carolina looks more like a negro country than a country settled by white people."[1] The demographic prominence of black people would remain an indicative characteristic of the South for the next two centuries. Up through the middle decades of the nineteenth century the number of blacks on rice plantations remained quite high; in 1860, twenty estates held between 300 and 500 slaves and eight others owned between 500 and 1,000.[2] Although cotton, tobacco, and other commodities could be grown successfully with smaller numbers of field hands, in 1860 some 2,292 southern planters held at least 100 slaves. Their estates, like the plantations of the so-called rice kingdom, also would have looked like "negro countries." In fact, because the South was a rather thinly populated region with only a few large towns and even fewer cities, any clustering of buildings was destined to attract a traveler's attention. Even a group of five to ten cabins erected to house slaves on a plantation might be referred to as a "little town."[3]

By 1860 some 46,000 estates were operated with at least twenty slaves, enough to qualify them as plantations. Spread across the region from Maryland to Texas, these agricultural holdings were all places where a substantial black presence was readily noticed. While African Americans would influence many aspects of southern culture, one of the more important impacts they had was the way they affected how white southerners saw themselves.[4] Letitia M. Burwell, a planter's daughter from Virginia, offered important testimony regarding the extent to which the presence of a large black community could determine one's sense of place. In her memoir of growing up before the Civil War, she wrote, "Confined exclusively to a Virginia plantation during my earliest childhood, I believed the world one vast plantation bounded by negro quarters."[5] Confronting a large black community day after day had an impact on the self-perceptions of the master class that was both profound and inescapable. They were, after all, living in a black world.

Given that there were 4 million African Americans in the South at the start of

the Civil War, it is surprising that paintings of plantations created in the antebellum period contain so few black figures. In many images they are entirely absent; in others one or two may appear, usually affecting a pose of casual nonchalance. It was only well after the war's conclusion that black people were regularly included in plantation scenes and in numbers indicative of their certifiable prominence. To be sure, some images (most often found in personal sketchbooks and magazine illustrations) did include black field hands, but slave gangs were not commonly depicted until well after Emancipation.

The general absence of slaves, and therefore of slavery itself, in renderings of plantations up to the end of the Civil War can be explained in part by the aesthetic conventions of the landscape genre. However, to understand why black people were so thoroughly excluded from representations of the places where they were numerically dominant requires that other factors be considered. The prolonged arguments over the merits of chattel slavery, which made the status of black people a topic of daily conversation during the antebellum period, certainly shaped how blacks were perceived.[6] The shrill comments offered by slavery's advocates in newspaper editorials and various manifestos suggested that black people were, at best, contemptible beings who would be rehabilitated only through their owners' considerable efforts. This position was enhanced by a series of popular novels set on picturesque plantation estates, books that confirmed the social eminence of the planter class with streams of flattering imagery. These verbal treatments, both political and literary, valorized slavery and the plantation while endeavoring to present enslaved blacks as little more than a coarse population in need of considerable guidance. When planters commissioned paintings, not too surprisingly, they opted for pictures that confirmed their own centrality and their slaves' marginality, works of art that by and large managed to conceal the presence of the black majority. Artists who were aiming to capture the scenic beauties of an agricultural setting found that they could simply ignore the armies of enslaved laborers that lived and worked on plantations.[7] Slaves were basically painted out of the picture. What, these artists might have argued, could such a lowly, even barbaric, element contribute? Out in the fields, blacks were controlled with the lash; inside the picture frame, they could be controlled with a paintbrush.

ANTEBELLUM IMAGES

Because the first plantation paintings were commissioned by men who were still, at heart, Englishmen, the images that they commissioned understandably followed English precedents, and their American-born heirs closely followed their example. In 1774 Harry Dorsey Gough of Baltimore County, Maryland, even went so far as to rename his recently acquired estate "Perry Hall" in honor of his ances-

tral home in Staffordshire, England—a considerably more tepid title than the large holding's previous one, "The Adventure."[8] Well into the nineteenth century, American taste in landscape art remained firmly linked to the formulas taught at the Royal Academy in England. A typical estate painting usually featured an open foreground framed by trees with a path leading to a fine house on a far hill (see, for example, Figure 2.8). During the first decade of the nineteenth century, Baltimore artist Francis Guy provided Gough and his other clients with precisely this sort of image. Human figures might be scattered about here and there to enliven the composition, but in these paintings Guy aimed chiefly at showing a grand mansion in a gardenesque setting (as, for example, in Figure 2.5). Since the old English landlords cared little for pictures that showed menial laborers cultivating crops or looking after the livestock, neither did southern planters. Paintings that offered a retreat into nature also provided these men with a way to see themselves as above and beyond the abolitionist critique of slavery. When houses were surrounded by gardens rather than fields, the oft-proclaimed evils of bondage were hidden under the unsullied cloak of natural beauty.

During the first two decades of the nineteenth century the merits of English-derived landscapes were confirmed by novels set on plantation estates. The authors of these books, according to Francis Gaines Pendleton, generally followed a fixed pattern: "The setting reveals the conventional mansion, a large white house with commodious grounds, the latter lovely with prodigal growth of flowers and shrubbery considered southern. The background is usually the cotton field; if a moon-light scene can be introduced, so much the better."[9]

Many of the attributes of this formula appear in one the earliest of these works, Isaac E. Holmes's *Recreations of George Taletell, F.Y.C.* (1822). The protagonist of this novella, after traveling through the English countryside, next pays a visit to a plantation located in the hinterland of Charleston, South Carolina. Taletell's recollection of his first encounter with this estate focuses on the decorative features of the foliage and gardens:

> I turned with very little regret, from the broad road into my uncle's avenue, which running between two rows of cedar trees, led up to a spacious mansion on a brick ground, built in the comfortable style of Carolina hospitality, with its huge Dutch roof and convenient suit of shed rooms. . . . There was a snugness and comfortable air settled on every object, from the stable to the kitchen, and from the yard to the garden, which spoke a fullness and satisfaction generally to be met with on a well settled plantation.[10]

After a prolonged round of greetings, a sumptuous meal, and a good night's rest, Taletell ventures out the next morning to inspect his uncle's estate in greater de-

tail. He discovers first that the brook that crosses the front yard is actually a man-made feature, laid out along a winding course, its excavated banks attractively planted with overhanging willows. He proceeds next to climb a small hill, where his guide shows him "a little chapel ingeniously constructed with lathes and twisted moss; it resembled the holy retreat of some pious hermit, who leaving the world his blessing, sought some quiet spot—some sacred wood to make his piece with Heaven." Looking out from this primitive structure, which commands the "finest prospect" of the plantation, Taletell rhapsodizes about the rice fields and meadows. But he focuses mainly on the "strong interest" of the scene, that is, he looks over the land as if it were a painting. Consequently, he reads an irrigation canal as a decorative feature because it "inlayed the fields with a narrow line of fluid silver." Before his tour is finished, Taletell passes by what appears to be a fragment of an ancient tower. Puzzled by the presence of this structure, he is informed that such picturesque ruins are a standard feature of proper English gardens and that it was "put up at the suggestion of a gentleman who had travelled, and come home to reform his neighbor's ideas in the matters of taste."[11]

Holmes's account describes a style of English gardening that was well established in the Carolina low country, although his inventory of landscaping features included elements, particularly the contrived ruins and primitive garden chapel, that were too extravagant even for the most unrestrained South Carolina planter.[12] But his central point was clear: men of impeccable taste should actively engage the project of improving the landscape and not sully their lives with such matters as crops, livestock, and field hands. Although planters' diaries and letters do, in fact, reveal that these latter concerns were precisely what occupied almost all of their waking moments, works of literature and their painted counterparts suggest to the contrary that their imaginations were occupied by other more pleasant and diverting ideals.[13] Between 1796 and 1806 Charleston artist Charles Fraser painted a number of plantation landscapes in which he aimed to capture the beauties of the low country. Following the suggestions of William Gilpin, English author of numerous guidebooks that offered specific recommendations on how one should "see" a landscape, Fraser replaced the facts of agriculture with decorative imagery (Figure 3.18). Emphasizing pastoral charm over the drudgery of rice cultivation, his watercolors were closely aligned with the descriptions that would be offered two decades later by Holmes.

Nineteenth-century novelists writing about the South repeatedly emphasized its picturesque qualities; substantial houses invariably nestle into tranquil settings. In *The Valley of the Shenandoah* (1824) George Tucker described several estates; one of them was "situated near the banks of the river, having a small rivulet meandering on one side of the house and discharging itself into the Shenandoah,

in a gentle current, through a rich black loam." Identifying the house as simply an "irregular mansion," he concentrated on its surroundings, writing that the building was "encircled by grass of the brightest verdure" and that "the grounds above it were decorated with clumps or rows of weeping willows, poplar, aspen, and such shrubs and vines as delight moist situations, all flourishing in unusual luxuriance." He capped this account by proclaiming that the scene "conveyed the agreeable ideas of fertility, abundance, and comfort."[14] Tucker devoted not a single sentence to the enslaved workers whose constant efforts insured that these appealing goals would be attained. When J. E. Heath described the mansion on the James River belonging to the Fitzroyal family in *Edge-Hill* (1828), he too focused intently on features of its surrounding vegetation: "Its front, or northern side, overlooked a spacious lawn, which was shadowed by some trees of lower Virginia; and in the rear, extending in terraces to the river bank, lay the garden, which abounded in delicious fruit and beautiful shrubbery, and was accommodated with summer houses and pavilions in various positions." All the features of the estate, wrote Heath, "announced the owner's opulence, and presented a refreshing picture of rural beauty."[15] In a similar fashion James Hall, author of *The Harpe's Head* (1833), provided the mansion house at Walnut Hill plantation with a beautiful lawn, one "set with fine forest trees, the venerable and gigantic aboriginals of the soil," and "a garden laid out with taste, and highly embellished with flowers and ornamental plants."[16] William Gilmore Simms, perhaps the South's most prolific writer during the antebellum period, set most of his fiction in the era of the American Revolution, where his characters regularly encounter plantation estates. In *Mellichampe* (1854), Simms has a squadron of British soldiers come upon the mansion of the Berkeley family, which then gives him the opportunity to describe the "peculiar design" of the plantation's avenue of pine trees: "A waving and double line, carried on in sweeping and curious windings for two thirds of a mile, described by these trim and tidy trees, enclosed the party, and formed a barrier on either hand, over which no obtrusive vine or misplaced scion of some foreign stock was ever permitted to gad or wander." He also points out the hedge of greenbriar, a "thousand various and beautiful flowers," and a "lovely park" that was "tastefully sprinkled, here and there, singly and in groups, with a fine collection of massive and commanding water-oaks."[17] Clearly Simms was "painting" with his pen some of the same elements that artist T. Addison Richards had recommended as potential features for a compelling landscape.

John Pendleton Kennedy's *Swallow Barn, or, A Sojourn in the Old Dominion* proved to be the most popular of all the plantation novels written during the antebellum period. First published in 1832, interest in the book remained strong enough to support a second printing in 1853. While Kennedy devoted more atten-

tion to his black characters than did other writers, he still began his account with the most conventional of openings: "Swallow Barn is an aristocratical old edifice which sits, like a brood hen, on the southern bank of the James River. It looks down upon a shady pocket or nook, formed by an indentation of the shore, from a gentle acclivity thinly sprinkled with oaks whose magnificent branches afford habitation to sundry friendly colonies of squirrels and woodpeckers."[18] Allowing his eye to roam about the plantation's grounds, Kennedy acted like a painter assessing a scene. Looking down on a gurgling brook that runs near the mansion down to the river, he follows its course, recording the mosses, the laurel and alder, and a gnarled sycamore. When he comes to a rough bridge, he confirms his desire to make common cause with landscape artists by proclaiming that this place "would delight a painter to see."[19]

While it is difficult to say exactly what novels landscape painters or their planter clients may have been reading, the consistent use of picturesque formulas that place the greatest emphasis on aspects of foliage suggests some awareness of the descriptions crafted by southern writers. According to Guy A. Cardwell, in plantation novels of the antebellum period an estate was much more than an agricultural unit: "It became a little world, a way of life, an epitomizing of cherished values that were to be defended at all costs."[20] Landscape painters created visual equivalents of these little worlds, seemingly matching their images to the pleasant prose descriptions. While the defenders of chattel slavery were quite explicit about what they saw as the advantages of the institution, painters of plantation landscapes generally seem, at first glance, to have stayed clear of this protracted debate. Fully in control of the elements that they might include in their scenes, they could simply "erase" any signs of slavery and thus avoid the controversy altogether. Yet their pleasant, seemingly conflict-free images could also serve as tacit propaganda on behalf of chattel slavery.

It was well known that just beyond the margins of any plantation picture captive blacks were toiling from dawn to dusk. While slave labor was labeled by some as "automatic, noiseless service," no planter could afford to overlook the importance of the work performed by his slave gangs.[21] James Henry Hammond, former governor of South Carolina and owner of several plantations, worked by a total of 333 slaves, was certainly among those who realized that enslaved blacks were central to the success of the southern economy.[22] In a celebrated speech given on the floor of the U.S. Senate in 1858, he acknowledged that slave labor was responsible for the great fortunes in the South. However, when he called blacks "the very mud-sill of society," it was clear that Hammond did not hold them in high regard. Rather, he argued that, as the occupants of the lowest social tier, they were naturally suited for only the most humble of tasks:

In all social systems there must be a class to do the menial duties, to perform the drudgery of life. That is, a class requiring but a low order of intellect and but little skill. Its requisites are vigor, docility, fidelity. Such a class you must have, or you would not have that other class which leads progress, civilization, and refinement. . . . Fortunately for the South, she found a race adapted to that purpose to her hand. A race inferior to her own, but eminently qualified in temper, in vigor, in docility, in ability to stand the climate, to answer all her purposes. We use them for our purpose, and call them slaves.[23]

Just two years earlier William J. Grayson had expressed identical sentiments in a long heroic poem entitled "The Hireling and the Slave." In one stanza, he critiques the African background of southern blacks, indicating that such a lowly, pagan people would only stand to benefit from a life of captivity among a superior white race:

> Hence is the Negro come, by God's command,
> For wiser teaching to a foreign land;
> If they who brought him were by Mammon driven,
> Still they have served, blind instruments of Heaven;
> And though the way be rough, the agent stern,
> No better mode can human wits discern,
> No happier system wealth or virtue find,
> To tame and elevate the Negro mind.[24]

If southern blacks were truly believed to be as debased as Hammond and Grayson suggested, then artists could easily leave them out of their paintings altogether. In the light of these proslavery arguments, slaves would easily have been deemed an unworthy subject for a work of art.

The tenor of proslavery rhetoric was exceedingly mean and vicious; black people were repeatedly described as nothing more than detestable, brutish animals. In an antiabolitionist harangue written in 1833, Richard H. Colfax wrote of blacks that "no alteration of their present condition would be productive of the least benefit to them."[25] When John Pendleton Kennedy described slaves in *Swallow Barn*, he abandoned his generally cheery tone to identify them as "essentially parasitical in nature."[26]

If the chief purpose of a plantation painting was to present a reassuring, tranquil scene, the presence of slaves would, if one followed the prevailing logic, only have spoiled the picture. Two bodies of evidence compelled painters to think in this manner: received academic formulas for paintings of scenery, reinforced by a host of literary treatments, suggested what features painters should include,

while venomous descriptions of blacks indicated what they should avoid. The end result was a standardized image of a plantation that included few signs of labor and even fewer signs of slavery. If slave quarters, work yards, fields, and mills were included—as was the case in the paintings by New Orleans artist Marie Adrien Persac—color, atmosphere, scale, and costume could be manipulated to convey a feeling of calm serenity. Persac's paintings offered his clients a pleasant prospect in which all controversy was hidden from view (see, e.g., Figure 4.3).

POSTBELLUM IMAGES

Plantation paintings created after the Civil War finally began to reveal something of the dominant African American presence, which, at least in landscape images, had been avoided and thus denied for more than a hundred years. Illustrations published in newspapers and magazines led the way; views of plantations encountered in various battles during the Civil War came first and were soon followed by a host of intriguing travel scenes meant to satisfy the northern public's curiosity about the Southland. Currier & Ives, the leading American producers of cheap prints, hoped to garner a significant portion of this new market with sedate views of plantation scenery. After 1865 they added to their catalogue such works as *A Home on the Mississippi*, *Low Water on the Mississippi* (Figure 5.8), and *The Old Plantation Home* (Figure 5.13). When slaves appeared in these images, they were shown engaged in joyous dancing and singing, acts that confirmed what many of slavery's defenders had claimed all along: that slaves were well cared for and quite contented with their fates. In *Cannibals All! or Slaves Without Masters* (1856), probably the most widely read of all the proslavery tracts, George Fitzhugh argued:

> The negro slaves of the South are the happiest, and in some sense, the freest people in the world. The children and the aged and infirm work not at all, and yet have all the comforts and necessaries of life provided for them. They enjoy liberty, because they are oppressed neither by care nor labor. The women do little hard work, and are protected from the despotism of their husbands by their masters. The negro men and stout boys work, on average, in good weather, not more than nine hours a day. The balance of their time is spent in perfect abandon. Besides, they have their Sabbaths and holidays.[27]

Currier & Ives's images of rose-covered slave houses, contented black family groups, and manifestations of holiday-like frivolity might easily have been regarded as proslavery propaganda had not the ratification of the Thirteenth Amendment already abolished all forms of involuntary servitude. Had such images appeared sooner, they might have bolstered the defenders of the slave system. But since these pictures were created after the Civil War, they functioned

only as nostalgic evocations. A longing for a world that was lost figured prominently in their appeal for southern audiences.

While some northern advocates for the project of Reconstruction assisted African Americans in their efforts to attain full citizenship, southern writers concentrated on rehabilitating the reputation of their native region. They focused once again on the key elements of the old plantation legend: fine houses, courtly white gentlemen, exquisitely gowned white ladies, bountiful harvests, and contented slaves. One finds, for example, Thomas Nelson Page offering in 1892 descriptions that could just as easily have been written in 1822. He describes the daily routine at Rosewell, one of the most celebrated estates in the tidewater region of Virginia, as manifesting "movement and life without bustle; whilst somehow, in the midst of it all, the house seemed to sit enthroned in perpetual tranquility, with outstretched wings under its spreading oaks, sheltering its children like a great gray dove."[28] But Page is best remembered for "Marse Chan" (1884), a short story rendered in Negro dialect that cast chattel slavery in a very favorable light. The narrator, an old black man named Sam, recounts to a passing traveler the history of the abandoned plantation at which he has chanced to stop. His account details the tragedy of a young man killed in the war and of Sam's efforts, as his loyal companion and personal servant, to return his body to his family for burial. A faithful slave, Sam has nothing but appreciative words when asked to describe how he and his fellow bondsmen were treated: "Dem wuz good ole times, marster—de bes' Sam ever see! Dey wuz in fac'! Niggers didn' hed nothin' 't all to do—jes' to 'ten' to de feedin' an' clean' de houses, an' don' what de marster tell 'em to do; an' when dey wuz sick, dey had things sont 'em out de house, an' de same doctor come to see 'em whar 'ten' to de white folks when dey wuz po'ly. Dyer warn' no trouble or nothin'."[29]

Page's Sam made a good companion for Joel Chandler Harris's Uncle Remus. This amiable black figure first appeared on the editorial page of the *Atlanta Constitution* during the late 1870s, where he offered droll comments on the events of the day, but after the appearance of *Uncle Remus: His Songs and Sayings* (1880), he was better known as the narrator of comic tales describing the antics of various animal characters. Harris also used Uncle Remus to voice his own unreconstructed views on race. In "A Story of the War," he has Uncle Remus shoot a Yankee soldier who was about to ambush his owner, "Mars Jeems." When asked later if he understood that the soldier was fighting for his freedom, Remus responds: "Co'se, I know all about dat . . . en it sorter made cole chills run up my back; but w'en I see dat man take aim, en Mars Jeems gwine home ter Ole Miss en Miss Sally, I des disremembered all 'bout freedom en lammed aloose."[30] Sam and Remus appealed to many white southerners who continued to believe that chattel

slavery had been a compassionate institution. Arguing that blacks were always well treated, they were exasperated by Yankee efforts to enfranchise them with the privileges of citizenship.

Those who enjoyed stories that extolled the loyalty of former slaves, also heard similar evocations of the old plantation days from the promoters of progressive economic reforms. In a speech he gave in 1887, Henry Grady, chief spokesman for the so-called New South creed, thoroughly romanticized the old patterns of interaction between blacks and whites. Suggesting that some African Americans might prove themselves useful partners in the resurgence of the region, he fell back on the image of the loyal slave: "I want no truer soul than that which moved the trusty slave, who for four years while my father fought with the armies that barred his freedom, slept every night at my mother's chamber door, holding her and her children as safe as if her husband stood guard, and ready to lay down his humble life on her threshold. History has no parallel to the faith kept by the negro in the South during the war." Even some northern commentators were convinced of the virtues of antebellum race relations. In *Bright Skies and Dark Shadows* (1890) Reverend Henry M. Field advocated a revival of paternalism to insure that blacks received the guidance they needed, so that "in time unfailing kindness will do its work, by bringing the old masters and their former slaves into a mutual understanding and good feeling that will be for the prosperity and happiness of both."[31]

The apparent fusion that occurred between literary imagery and calls for political action in the South during the final decades of the nineteenth century suggests the presence of optimistic feelings, at least among whites. Hoping to see themselves as at last absolved of any guilt as former slaveholders and looking forward to a restoration of their former social and political dominance, many landed white southerners viewed the future as quite promising. It is then not so surprising that during this period William Aiken Walker would paint hundreds of images of individual field hands. He also undertook commissions for a number of panoramic plantation vistas, large paintings that focused intently on gangs of black workers who busily gather the harvest (Figure 6.6). By shifting away from the standard format that emphasized the planter's magnificent house standing alone in a parklike setting, Walker signaled that black workers were no longer a taboo subject. While he could now fill his cotton fields with black people, his paintings were not meant to be accurate depictions of southern agriculture. These paintings held out the suggestion of a white social dominance that might soon be restored.

Plantation narratives remained a basic staple of southern literature throughout the first half of the twentieth century. Stark Young's best-seller *So Red the Rose*

(1934), an account of the experiences of a plantation family living in Natchez at the outbreak of the Civil War, was not only a widely acclaimed novel but was quickly transformed into a feature-length film. Similarly, Frank Yerby's *The Foxes of Harrow* sold millions of copies when it appeared in 1946 and was likewise adapted for the silver screen the following year. Cinematic translations of southern fiction proved to be an effective means for putting images of the plantation before a curious nation.[32] But no novel could rival Margaret Mitchell's *Gone with the Wind* (1936). Selling 21 million copies in its first fifty years, the book not only remains in print but has been translated into twenty-five languages.[33] The movie version, released in 1939, continues to rank high among the most watched films of all time.

According to cultural historian Richard H. King, novels like *Gone with the Wind* were manifestations of a form that he calls the "southern family romance."[34] More a mode of thinking than a plot outline, the family romance model was employed by many southern writers between 1930 and 1955 as they struggled to understand how best to cope with the powerful and lasting influences of patriarchal legacies. Alice Ravenel Huger Smith's book *A Carolina Rice Plantation of the Fifties* was published in 1935, right in between *So Red the Rose* and the even more celebrated *Gone with the Wind*. Obscured by the fame of these more prominent works, her volume, like other family romances, related the story of her ancestors. Retreating to the decade before the Civil War, she presented a glorious period of accomplishment as she carefully catalogued her ancestors' achievements in a portfolio of thirty watercolors. Unlike Allen Tate in *The Fathers* (1932) or William Faulkner in *Go Down, Moses* (1942), Smith was not inclined to challenge her forebears or to agonize over the dilemmas growing out their problematic birthright. Ever the dutiful and respectful daughter, she found it enough simply to present her father as a splendid figure from a bright, golden age. She even let his recollections function as the explanatory captions for her paintings.

While the structure of the family romance offered no role to blacks except that of social menace, Smith rendered them more positively, even heroically, as the necessary occupants of the rice landscape. Black people had a clear role to play in her family's story, and by acknowledging that they contributed their valuable labor, she took a position consistent with cultural and political trends that were then emerging in some places in the South. Decades of virulent race-baiting were giving way to a more moderate, though not particularly generous, position. The new thinking held that black people should be recognized, albeit in a permanently inferior social position. Held in check by the policies of segregation and systematic disenfranchisement, black Americans were subjected to a policy that historian George M. Fredrickson has identified as a form of "internal colonialism."[35]

Smith seems to support this position when she renders her black field hands as faceless figures who are beneficially directed to perform valuable tasks. She clearly assigned them to a subordinate and voiceless social position. In her social scenario, blacks provided the muscle while a white planter supplied the intelligent direction (Figure 7.20). Of course, Smith was painting a memory of slavery days, a period when such conditions had the official endorsement of the law. But she was also giving form to attitudes that swirled freely about the Jim Crow South, views that enjoyed the sanctions of convention, habit, and preference. In such circumstances, Smith, like Walker some fifty years earlier, could paint scenes of black labor without the slightest twinge of anxiety or embarrassment.

In the era before the Civil War three factors combined to influence planters' preferences in plantation imagery. First, prevailing aesthetic tastes promoted images of untamed nature over indications of agricultural labor, so that depictions of fields, pastures, or other sites of toil were suppressed. Secondly, since the advocates of slavery presented blacks as disreputable beings, they were not usually considered a worthy pictorial subject. And finally, given that works of art were supposed to flatter their patrons, estate paintings were obligated to refer to planters and the members of their immediate families. The appropriate subject of a painting was the client's house and its grounds, not his menial servants. This particular combination of aesthetics, racism, and class bias insured that paintings of plantations would include few, if any, black figures. The best image of a plantation was one that suggested that only white people lived there.

In the postbellum era the practice of chattel slavery had ended, but blacks still continued to dominate plantation estates, only now they were tenants or sharecroppers. Granted their freedom and the rights of citizenship, they aggressively negotiated for improvements in the conditions of their employment. When faced with this new, defiant response, many southerners longed for the old days when blacks were seemingly more subservient and, to a degree, artists satisfied their wishes with plantation scenes that showed compliant gangs of black laborers picking cotton or cultivating rice without any supervision. Pleasant idealizations of the antebellum period, like those produced by William Aiken Walker or Alice Ravenel Huger Smith, represent their efforts to depict an era of former success. Because plantation paintings in the postbellum period were basically attempts at recovering fading memories, artists filled their pictures with detailed portrayals of many of the necessary tasks that antebellum artists tended to overlook. Ironically, it was only with the abolition of slavery that artists found the motivation to paint the obvious truth about plantations—that they were landscapes dominated by black people.

NOTES

INTRODUCTION

1. Albert Boime, *The Magisterial Gaze: Manifest Destiny and American Landscape Painting c. 1830–1865* (Washington, D.C.: Smithsonian Institution Press, 1991), 1–2.

2. See Ira Berlin, *Many Thousands Gone: The First Two Centuries of Slavery in North America* (Cambridge: Harvard University Press, 1998), 17–92, for an appraisal of the fates of the first generation of African slaves in British North America.

3. Hugh Honour, *The Image of the Black in Western Art*, Vol. 4: *From the American Revolution to World War I*, Pt. 1, *Slaves and Liberators* (Cambridge: Harvard University Press, 1989), 20.

4. See Robert W. Brown, "Topography" in *Dictionary of Art*, 34 vols., ed. Jane Turner (New York: Macmillan, 1996), 31:154.

5. In addition to images reproduced in *The Image of the Black in Western Art*, a four-volume study sponsored by the De Menil Foundation of Houston (Fribourg: Office du Livre, 1976–89), see Sydney Kaplan, *The Portrayal of the Negro in American Painting* (Brunswick, Maine: Bowdoin College Museum of Art, 1964); Ellwood Parry, *The Image of the Indian and the Black Man in American Art, 1590–1900* (New York: G. Braziller, 1974); Karen M. Adams, "The Black Image in the Paintings of William Sidney Mount," *American Art Journal* 7 (Fall 1975): 42–59; Sarah Burns, "Images of Slavery: George Fuller's Depictions of the Ante-Bellum South," *American Art Journal* 15 (Summer 1983): 35–60; Guy C. McElroy, *Facing History: The Black Image in American Art, 1710–1940* (Washington, D.C.: Corcoran Gallery, 1990).

6. U. B. Phillips, "The Central Theme of Southern History," *American Historical Review* 34 (1928): 31.

CHAPTER ONE

1. Sam B. Hilliard, "Plantations and the Molding of the Southern Landscape," in *The Making of the American Landscape*, ed. Michael P. Conzen (Boston: Unwin Hyman, 1990), 104–26; Merle C. Prunty, "The Renaissance of the Southern Plantation," *Geographical Review* 53 (1963): 1–21. For the slave census of 1860, see Harold D. Woodman, *Slavery and the Southern Economy: Sources and Readings* (New York: Harcourt, Brace, & World, 1966), Table 3, pp. 14–15.

2. Francis Pendleton Gaines, *The Southern Plantation: A Study in the Development and the Accuracy of a Tradition* (New York: Columbia University Press, 1924).

3. On the centrality of plantations to the formation of the agrarian ideal in the South, see John R. Stilgoe, *Common Landscape of America, 1580 to 1845* (New Haven: Yale University Press, 1982), 65–72.

4. John Wilmerding, *American Art* (New York: Penguin, 1976), 76–82. See also James Thomas Flexner, *That Wilder Image: The Painting of America's Native School from Thomas Cole to Winslow Homer* (Boston: Little, Brown, 1962), chap. 1.

5. Peale's examples were preceded by the paintings of Justus Engelhardt Kuhn, a German artist who worked in Maryland in the first decades of the eighteenth century. However, Kuhn placed his sitters in front of European estates even though he included African American slaves as the attendants to his sitters. See Wayne Craven, *Colonial American Portraiture: The Economic, Religious, Cultural, Philosophical, Scientific, and Aesthetic Foundations* (Cambridge: Cambridge University Press, 1986), 237–43.

6. Edgar P. Richardson, *American Paintings and Related Pictures in The Henry Francis du Pont Winterthur Museum* (Winterthur, Del.: The Henry Francis du Pont Winterthur Museum, 1986), 54.

7. Mills B. Lane, *Architecture of the Old South: Maryland* (New York: Abbeville, 1991), 60–61.

8. Philip M. Hamer and George C. Rogers Jr., eds., *The Papers of Henry Laurens*, 15 vols. (Columbia: University of South Carolina Press, 1970), 2:335–36.

9. For a more detailed assessment of the career of Elias Ball, see Edward Ball, *Slaves in the Family* (New York: Ballantine, 1998). For examples of overmantel paintings depicting plantations, see Richardson, *American Paintings*, 16–17, for the image that once was on display at Morratico plantation in Virginia; and Michael Owen Bourne, *Historic Houses of Kent County* (Chestertown, Md.: Historical Society of Kent County, 1998), 30, for the painting of Stepney (ca. 1795), the estate of Simon Wilmer near Chestertown, Maryland. Note that the Morratico painting actually depicts an English estate rather than an American one.

10. See the exhibition catalogue by Roberta Kefalos, *The Poetry of Place: Landscapes of Thomas Coram and Charles Fraser* (Charleston, S.C.: Gibbes Museum of Art, 1997). Consult as well Anna Wells Rutledge, "Artists in the Life of Charleston," *Transactions of the American Philosophical Society* 39, pt. 2 (1949): 123. Coram's 4″ × 7″ sketch of Mulberry Plantation is one of the most widely reproduced plantation images. Most recently it appeared on the cover of Ira Berlin's book *Many Thousands Gone: The First Two Centuries of Slavery in North America* (Cambridge: Harvard University Press, 1998).

11. Duncan Clinch Heyward, a lineal descendant of Nathaniel, asserts that among the structures at Rose Hill was a steam-powered rice mill with a large square brick chimney, a typical feature of low-country rice plantations after 1830. D. C. Heyward, *Seed from Madagascar* (Chapel Hill: University of North Carolina Press, 1937), 102. However, since no mill of any sort is included in the picture, the painting had to have been executed sometime before the coming of steam power. A plausible date would then fall between 1810, when Nathaniel Heyward acquired the estate, and 1830, when his mill was constructed.

12. For a history of Rose Hill plantation, see Suzanne Cameron Linder, *Historical Atlas of the Rice Plantations of the ACE River Basin—1860* (Columbia: South Carolina Department of Archives and History, 1995), 521–25; and Heyward, *Seed from Madagascar*, 92–108.

13. On William Birch, see Edward J. Nygren, "From View to Vision" in *Views and Visions: American Landscape before 1830* (Washington, D.C.: Corcoran Gallery of Art, 1986), 22–25, 240–41.

14. Deborah Chotner, *American Naive Paintings* (Washington, D.C.: National Gallery of Art, 1992), 596.

15. For Stubbs's work, see Venetia Morrison, *The Art of George Stubbs* (Secaucus, N.J.: Wellfleet, 1989).

16. Susan Stein, *The Worlds of Thomas Jefferson* (New York: H. N. Abrams, 1993), 148–49.

17. Margaret Law Callcott, ed., *Mistress of Riversdale: The Plantation Letters of Rosalie Stier Calvert* (Baltimore: Johns Hopkins University Press, 1991), 359, provides some background on Baker, who was British consul stationed in Washington, D.C., in 1820.

18. Franklin Kelly, *Frederic Edwin Church and the National Landscape* (Washington, D.C.: Smithsonian Institution Press, 1988), ix, argues that Church meant to instruct the public through his paintings, not merely to entertain with appealing or exciting imagery. Thus his image of Shirley, produced in an unguarded moment, reveals how persuasive the standardized plantation or great house formula could be. For a history of the house, see Thomas Tileston Waterman, *The Mansions of Virginia, 1700–1776* (Chapel Hill: University of North Carolina Press, 1945), 346–58.

19. For a discussion of the building of the Mount Vernon piazza, see Robert F. Dalzell Jr. and Lee Baldwin Dalzell, *George Washington's Mount Vernon: At Home in Revolutionary America* (New York: Oxford University Press, 1998), 109, 121.

20. For Strickland's painting of Mount Vernon, see Richard Koke, *American Landscape and Genre Paintings in the New-York Historical Society*, 3 vols. (Boston: G. K. Hall, 1982) 3:158–65; for Robertson's, see *Kennedy Quarterly* 8 (February 1975): fig. 175; for Birch's, see *Mount Vernon: An Illustrated Handbook* (Mount Vernon, Va.: Mount Vernon Ladies Association, 1974), 16.

21. On George Ropes's painting, see the note provided by Julie Aronson in Chotner, *American Naive Paintings*, 326. James Thomas Flexner, *The History of American Painting*, Vol. 2: *The Light of Distant Skies (1760–1835)* (New York: Harcourt, Brace, 1954), 194, provides an example of a classroom exercise, painted by Susan Whitcomb of Brandon, Vermont, in 1842. She faithfully copied Jukes's

22. Dalzell and Dalzell, *George Washington's Mount Vernon*, 17.

23. Patricia Hills, "Painting Race: Eastman Johnson's Paintings of Slaves, Ex-slaves, and Freedmen," in Teresa A. Carbone and Patricia Hills, *Eastman Johnson: Painting America* (Brooklyn: Brooklyn Museum of Art, 1999), 122–26; see also John Davis, "Eastman Johnson's *Negro Life at the South* and Urban Slavery in Washington, D.C.," *Art Bulletin* 80 (1998): 67–92.

24. *The Louisiana Landscape, 1800–1969* (Baton Rouge, La.: Anglo-American Museum of Art, 1969), fig. 1.

25. John R. Todd and Francis M. Hutson, *Prince William's Parish and Plantations* (Richmond, Va.: Garrett & Massie, 1935), 214, 230.

26. For examples of plantation maps, see David Doar, *Rice and Rice Planting in the South Carolina Low Country* (Charleston, S.C.: Charleston Museum, 1936); Sam B. Hilliard, "Antebellum Tidewater Rice Culture in South Carolina," in *European Settlement and Development in North America: Essays in the Honour and Memory of Andrew Clark*, ed. J. R. Gibson (Toronto: University of Toronto, 1978), 91–115.

27. See Peter H. Wood, *Strange New Land: African-Americans, 1617–1776* (New York: Oxford University Press, 1996), 72.

28. For the history of indigo production, see Lewis Cecil Gray, *History of Agriculture in the Southern United States to 1860* (Washington, D.C.: Carnegie Institution, 1933), 290–97.

29. Edward C. Carter II, John C. Van Horne, and Charles E. Brownell, eds., *Latrobe's View of America, 1795–1820* (New Haven: Yale University Press, 1985), 84–85, 100–101, 92–93, 108–13.

30. That Latrobe was very interested in the condition and circumstances of enslaved blacks is indicated by some of the other sketches of African Americans included in his journal, which show them engaged in both work and leisure pursuits.

31. H. Parrott Bacot, Jay D. Edwards, Suzanne Turner, and Marcel Boyer, "Plantations by the River: The Paintings of Father Joseph Paret," *Louisiana Cultural Vistas* 6, no. 1 (1995): 18.

32. Bruce Robertson, "Venit, Vidit, Depinxit. The Military Artist in America," in Nygren, *Views and Visions*, 83–84.

33. On the history of the camera lucida, see *Encyclopedia of Photography* (New York: Greystone, 1963), 2:512. Hall's *Swamp Plantation on the Banks of the Alatamaha* is no. 25 in an unpaginated folio that accompanied Basil Hall, *Travels in North America in the Year 1827 and 1828*, 2 vols. (London: Simpkin and Marshall, 1829).

34. Letters of Margaret Hall, April 10, 1828, Collections of the Library of Congress, cited in Malcolm Bell Jr., *Major Butler's Legacy: Five Generations of a Slaveholding Family* (Athens: University of Georgia Press, 1987), 103. For more on the Halls' experiences in the South, see F. N. Boney, "A British 'Grand Tour' of Crackerland: Basil and Margaret Hall View Frontier Georgia in 1828," *Georgia Historical Quarterly* 74 (1990): 277–92.

35. John Taylor, *Arator: Being a Series of Agricultural Essays, Practical and Political*, cited in John R. Stilgoe, "Smiling Scenes," in Nygren, *Views and Visions*, 216.

36. Cited in Stilgoe, *Common Landscape of America*, 76.

37. Claims of colossal size for moving panoramas were unmasked as wild exaggerations by the discovery of a surviving panorama of the Mississippi painted by Montroville W. Dickeson and John J. Egan in 1850. When their painting was unfurled at a 1949 exhibition, it was found to measure only 7½ feet by 348 feet. See *Mississippi Panorama* (St. Louis: City Art Museum, 1949), 127.

38. On the history of the Mississippi panoramas, see John Francis McDermott, *The Lost Panoramas of the Mississippi* (Chicago: University of Chicago Press, 1958).

39. Lewis's book was originally published in German as *Das Illustrite Mississippithal*. For an English version, see Henry Lewis, *The Valley of the Mississippi Illustrated* (St. Paul: Minnesota Historical Society, 1968).

40. For a discussion of minstrel performance, see Robert C. Toll, *Blacking Up: The Minstrel Show in Nineteenth-Century America* (New York: Oxford University Press, 1974).

41. Mary Levin Koch, "The Romance of American Landscape: The Art of Thomas Addison Richards," *Georgia Museum of Art Bulletin* 8, no. 2 (1988): 4–6.

42. T. Addison Richards and William C. Richards, "Introduction," in *Georgia Illustrated in a Series of Views* (Penfield, Ga.: self-published, 1842), 1.

43. T. Addison Richards, "The Landscape of the South," *Harper's New Monthly Magazine* 6 (1853): 721, 730.

44. T. Addison Richards, "The Rice Lands of the South," *Harper's New Monthly Magazine* 19 (1859): 721–38.

45. Koch, "Romance of American Landscape," 28–29 n. 35, indicates that along with *A Water Oak in South Carolina*, Richards presented *Group of Palmettos—South Carolina, Bonaventure, Near Savannah, Geo.*, *The Edisto River, South Carolina*, *The Savannah River, South Carolina*, *Live Oaks in South Carolina*, and *The Keowee River, South Carolina*.

46. Letter written by Aaron Burr, excerpted in *The Plantation South*, ed. Katherine Jones (Indianapolis: Bobbs-Merrill, 1957), 88.

47. Jane Webb Smith, *Georgia's Legacy: History Charted through the Arts* (Athens: Georgia Museum of Art, 1985), 159–61.

48. Virginia E. Lewis, *Russell Smith, Romantic Realist* (Pittsburgh: University of Pittsburgh Press, 1956), 75–76. Precedent for Smith's view of Mount Vernon as seen across its front lawn can be found in G. I. Parkyns's engraving *Mount Vernon in Virginia, the Seat of the late Genl. Washington* (1795); see E. McSherry Fowble, *Two Centuries of Prints in America, 1680–1880* (Charlottesville: University Press of Virginia, 1987), 89.

49. Mark Thistlethwaite, "Picturing the Past: Junius Brutus Stearns's Paintings of George Washington," *Arts in Virginia* 25 (1985): 19, indicates that Stearns initially called the painting *Washington, The Farmer*, a title calculated to make Washington more approachable. Perhaps he intended the term to insulate Washington from any of stigma that nonsoutherners might have associated with the word "planter."

50. Estill Curtis Pennington, *Look Away: Reality and Sentiment in Southern Art* (Spartanburg, S.C.: Saraland, 1989), chap. 5.

51. Estill Curtis Pennington, *Downriver: Currents of Style in Louisiana Painting, 1800–1950* (Gretna, La.: Pelican, 1991), 88–90. It is also worth noting that Giroux's scenes are very similar in design to Banvard's plantation scene, which traveled so widely as an element in his moving panorama.

52. See *Frank Leslie's Illustrated Newspaper*, February 6, 1864, 311 (story), 316 (pictures).

53. See John B. Rehder, *Delta Sugar: Louisiana's Vanishing Plantation Landscape* (Baltimore: Johns Hopkins University Press, 1999), 226–41, for a summary of the formation, history, and current fate of Oaklawn plantation.

54. Ray E. Frederick, *Alfred R. Waud, Civil War Artist* (New York: Viking, 1974).

55. J. Carlyle Sitterson, *Sugar Country: The Cane Sugar Industry in the South, 1753–1950* (Lexington: University Press of Kentucky, 1953), 134.

56. Peter H. Wood and Karen C. C. Dalton, *Winslow Homer's Images of the Blacks: The Civil War and Reconstruction Years* (Austin: University of Texas Press, 1988), 95.

57. George Fuller was another artist who displayed an interest in and a compassion for black subjects as persons rather than as vehicles for stereotypes; see Sarah Burns, "Images of Slavery: George Fuller's Depictions of the Antebellum South," *American Art Journal* 15 (1983): 35–60.

58. Harry T. Peters, *Currier & Ives: Printmakers to the American People* (Garden City, N.Y.: Doubleday, Doran, 1942), plates 132–35.

59. That Walker's plantation image continues to have wide appeal as a representative scene, if not an accurate document, is indicated by its repeated use as an illustration in history textbooks. Most recently it appeared on the cover of John B. Boles, *The South through Time: A History of an American Region* (Englewood Cliffs, N.J.: Prentice Hall, 1995).

60. Pennington, *Look Away*, 97.

61. Estill Curtis Pennington, *A Southern Collection* (Augusta, Ga.: Morris Communications Corporation, 1992), 118–19; Pennington, *Downriver*, 174 (quote).

62. See Martha R. Severens, *The Charleston Renaissance* (Spartanburg, S.C.: Saraland, 1998) for a history of Charleston's artists during the first decades of the twentieth century.

63. For more on Hutty's work, see Boyd Sanders and Ann McAden, *Alfred Hutty and the Charleston Renaissance* (Orangeburg, S.C.: Sandlapper, 1990).

64. Lynn Robertson Myers, ed., *A Mirror of Time, Elizabeth O'Neil Verner's Charleston* (Columbia: McKissick Museum, University of South Carolina, 1983).

65. On Taylor's career, see Martha R. Severens, *Anna Heyward Taylor: Printmaker* (Greenville, S.C.: Greenville County Museum of Art, 1987); for her images of plantation labor, see Chalmers Murray, *This Our Land* (Charleston, S.C.: Carolina Art Association, 1949).

1. Stiles Tuttle Colwill, *Francis Guy, 1760–1820* (Baltimore: Maryland Historical Society, 1981), 18–19.

2. J. Hall Pleasants, "Four Late Eighteenth Century Anglo-American Landscape Painters," *Proceedings of the American Antiquarian Society* 52, pt. 2 (1942): 242.

3. Rembrandt Peale, "Reminiscences—Desultory," *The Crayon*, 3 (1856): 5. Guy's zigzag career path was typical of many men at the turn of eighteenth century who more or less fell into artistic careers; see David Jaffee, "'A Correct Likeness': Culture and Commerce in Nineteenth-Century Rural America," in *Folk Art and Art Worlds*, ed. John Michael Vlach and Simon J. Bronner (Ann Arbor: U.M.I. Research Press, 1986), 53–84.

4. After Guy left Baltimore in 1816, he returned to New York, where he painted what is today his best known work, a panoramic street scene entitled *Winter Scene in Brooklyn* (1816–17). In this painting Guy rendered a detailed view of the neighborhood across the street from his house. According to Henry R. Stiles, who published an anecdotal history of Brooklyn in 1869, "Guy, as he painted, would sometimes call out the window, to his subjects, as he caught sight of them on their customary ground, to stand still, while he put in the characteristic strokes." Cited in John Wilmerding, *American Art* (New York: Penguin, 1976), 74.

5. Peale, "Reminiscences—Desultory," 5–6.

6. See Jean Lipman, *Rufus Porter Rediscovered: Artist, Inventor, Journalist, 1792–1884* (New York: Clarkson N. Potter, 1968), 70–72.

7. Pleasants, "Four Late Eighteenth Century Anglo-American Landscape Painters," 193.

8. Peale, "Reminiscences—Desultory," 6. On the life of Stuart, see James Thomas Flexner, *America's Old Masters* (New York: McGraw-Hill, 1982), 247–312; for a discussion of his snuff habit, see esp. 249–50.

9. Pleasants, "Four Late Eighteenth Century Anglo-American Landscape Painters," 242–43.

10. Ibid., 246, 264, 266.

11. See John Harris, *The Artist and the Country House from the Fifteenth Century to the Present Day* (London: Sotheby's Institute, 1995) for the three views of Ledston Hall in Yorkshire produced by John Setterington in 1728 (54–55); the five views of Claremont in Surry executed by the so-called Master of Tumbled Chairs ca. 1740 (74–75); and the paired views of Copped Hall in Essex by George Lambert, done in 1746 (78–81).

12. Cited in Barbara Wells Sarudy, *Gardens and Gardening in the Chesapeake, 1700–1805* (Baltimore: Johns Hopkins University Press, 1998), 36.

13. Colwill, *Francis Guy*, 58–59; Pleasants, "Four Late Eighteenth Century Anglo-American Landscape Painters," 287–90.

14. See Colwill, Francis Guy, 58, for a reproduction of this painting.

15. James Thomas Flexner, *History of American Painting*, Vol. 2: *The Light of Distant Skies (1760–1835)* (New York: Harcourt, Brace, 1954), 121.

16. Quoted in Colwill, *Francis Guy*, 64–65.

17. See ibid., 63, for a reproduction of this painting.

18. Cited in ibid., 63–64.

19. For more on comparable urban plantations, see John Michael Vlach, "Evidence of Slave Housing in Washington," *Washington History* 5, no. 2 (1993–94): 64–74; and John Michael Vlach, "'Without Recourse to Owners': The Architecture of Urban Slavery in the Antebellum South," in *Shaping Communities*, ed. Carter L. Hudgins and Elizabeth Collins Cromley (Knoxville: University of Tennessee Press, 1997), 149–60. Bolton is very similar in its configuration to Duddington, the estate belonging to Daniel Carroll of Washington, D.C., who lived only six blocks from the site of the Capitol; see Junior League of Washington, eds., *An Illustrated History of the City of Washington* (New York: Knopf, 1977), 62–63.

20. Edith Rossiter Bevan, "Perry Hall: Country Seat of the Gough and Carroll Families," *Maryland Historical Magazine* 45 (1950): 36–37, 41.

21. See Colwill, *Francis Guy*, 62, for a reproduction of this painting.

22. Bevan, "Perry Hall," 37; Ezra Squier Tipple, *The Heart of Asbury's Journal* (New York: Eaton and Mains, 1904), 560–61.

23. The Perry Hall gardens show the clear impact of Lancelot "Capability" Brown, who as royal gardener, revolutionized garden design in England and America with his irregular designs meant to create the feeling of an untouched natural setting. See Tom Turner, *English Garden*

Design: History and Styles since 1650 (Woodbridge, England: Antique Collectors' Club, 1986), 38–42; and Dorothy Stroud, *Capability Brown* (London: Faber and Faber, 1975).

24. Perry Hall inventory, folder 401, Harry Dorsey Gough Papers, Maryland Historical Society, Baltimore, Md.

25. Tipple, *Heart of Asbury's Journal*, 526, provides an image of the slave jail at Perry Hall. Ironically, it was designed in the same ornamental fashion as the flanking elements of the main house, including even the pyramidal roof topped with a short steeple.

26. Colwill, *Francis Guy*, 61. The painting was retained by Hall's descendants and handed down through four subsequent generations, who regarded the work as a valuable genealogical heirloom. Recently the painting was acquired by the Maryland Historical Society.

27. Ibid., 110.

28. Edgar P. Richardson, *American Paintings and Related Pictures in the Henry Francis du Pont Winterthur Museum* (Charlottesville: University Press of Virginia, 1986), 90–91; Colwill, *Francis Guy*, 111.

29. Colwill, *Francis Guy*, 37.

30. For Lambert's painting, see Luke Herrmann, *British Landscape Painting of the Eighteenth Century* (London: Faber and Faber, 1973), plate 9; for William Hodges's painting, see Harris, *The Artist and the Country House*, 109.

31. Robert L. Alexander, "Nicholas Rogers, Gentleman-Architect of Baltimore," *Maryland Historical Magazine* 78 (1983): 85–105; Mills Lane, *Architecture of the Old South: Maryland* (New York: Abbeville, 1991), 103.

32. Edith Rossiter Bevan, "Druid Hill, Country Seat of the Rogers and Buchanan Families," *Maryland Historical Magazine* 44 (1949): 194. Sarudy, *Gardens and Gardening in the Chesapeake*, 54, provides a site plan of Druid Hill that includes the location of the work yard, slave quarter, and the slave garden or "huck patch."

33. Alexander, "Nicholas Rogers," 85.

34. Cited in Colwill, *Francis Guy*, 25.

35. Herrmann, *British Landscape Painting of the Eighteenth Century*, 22; see also chap. 2, "The Topographical Tradition."

36. Charles G. Steffen, *From Gentlemen to Townsmen: The Gentry of Baltimore County, Maryland* (Lexington: University Press of Kentucky, 1993), 147–62.

CHAPTER THREE

1. *Catalogue of Miniature Portraits, Landscapes, and Other Pieces Executed by Charles Fraser, Esq. and Exhibited in "The Fraser Gallery," at Charleston during the months of February and March, 1857* (Charleston, S.C.: James & Williams, 1857).

2. Anna Wells Rutledge, "Artists in the Life of Charleston," *Transactions of the American Philosophical Society* 39, pt. 2 (1949): 134; Beatrice St. Julien Ravenel, *Architects of Charleston* (Charleston, S.C.: Carolina Art Association, 1945), 157–60. Of Fraser's two cupolas, one was added to the Exchange Building (now replaced) and one to St. John's Lutheran Church (still standing).

3. See Edward Biddle and Mantle Fielding, *The Life and Works of Thomas Sully* (1921; reprint, New York: Kennedy Graphics, 1970).

4. Cited in Rutledge, "Artists in the Life of Charleston," 135; see also William Dunlap, *History of the Rise and Progress of the Arts of Design in the United States*, 3 vols. (1834; reprint, New York: Benjamin Blom, 1965), 2:294.

5. Julia Curtis, "Redating 'Sketches from Nature by A. Fraser and C. Fraser,'" *South Carolina History Magazine* 93 (1992): 60.

6. Dunlap, *Rise and Progress of the Arts of Design*, 2:294.

7. Rutledge, "Artists in the Life of Charleston," 101.

8. On the career of Morse, see Oliver W. Larkin, *Samuel F. B. Morse and American Democratic Art* (Boston: Little, Brown, 1954).

9. Neil Harris, *The Artist in American Society: The Formative Years, 1790–1860* (Chicago: University of Chicago Press, 1966), 84.

10. Martha R. Severens, *A Southern Collection: The Greenville Museum of Art* (New York: Hudson Hills, 1995), 40–41.

11. Martha R. Severens, "Charles Fraser: Sketches and Oil Paintings," in *Charles Fraser of Charleston*, ed. Martha R. Severens and Charles L. Wyrick (Charleston, S.C.: Gibbes Art Gallery, 1983), 75.

12. Caroline Moore, ed., *Abstracts of Wills of the Charleston District, South Carolina* (Columbia, S.C.: R. L. Bryan Co., 1974), 240–41.

13. John R. Todd and Francis M. Hutson, *Prince William's Parish and Plantations* (Richmond, Va.: Garrett & Massie, 1935), 221.

14. Lawrence S. Roland, Alexander Moore, and George C. Rogers Jr., *The History of Beaufort County, South Carolina*, Vol. 1: *1514–1861* (Columbia: University of South Carolina Press, 1996), 114.

15. A copy of this map can be seen in the collections of the South Carolina Historical Society, item no. 32/120/A097 (top). Timothy Ford, a traveler who visited South Carolina in 1785–86, left a description of the gardens at the plantation home of John Edwards, which matches the elegance of what Fraser saw at Wigton: "The garden is spacious, & animated by the taste & ingenuity of Mr. Edwards, exhibits its various walks, flowers, vegetables, trees, and springs in the most pleasing view." See "Diary of Timothy Ford, 1785–86," *South Carolina Historical and Genealogical Magazine* 13 (1912): 185–86.

16. Comparable examples of plantation houses can be found in Samuel Gaillard Stoney, *Plantations of the Carolina Low Country* (Charleston, S.C.: Carolina Art Association, 1938): the Brick House (114–15), Fenwick Hall (121), Fairfield (134), Lewisfield (186), and Belvidere (210–11). Another, The Hayes, appears in Michael Heitzler, *Historic Goose Creek, South Carolina, 1670–1980* (Easley, S.C.: Southern Historical Press, 1983), 146.

17. The inventory can be found at the South Carolina Historical Society, Charleston, within the Gibbes-Gilchrist Collection, item no. 11/151/10.

18. Henry A. M. Smith, "The Ashley River: Its Seats and Settlements," *South Carolina Historical and Genealogical Magazine* 20 (1919): 98.

19. That Fraser thought of houses as surrogates for their owners was confirmed late in his life in his book *My Reminiscences of Charleston* (Charleston, S.C.: John Russell, 1854), 118.

20. Fraser may have chosen to paint Steepbrook because it was conveniently located next door to Wigton, his brother James's estate.

21. Henry A. M. Smith, "Goose Creek," *South Carolina Historical and Genealogical Magazine* 19 (1928): 16; Heitzler, *Historic Goose Creek*, 101–2.

22. Henry DeSaussure Bull, "Ashley Hall Plantation," *South Carolina Historical Magazine* 53 (1952): 62, 65; Mills Lane, *Architecture of the Old South: Carolina* (Savannah, Ga.: Beehive, 1984), 15–16.

23. Standing on the grounds of Ashley Hall was a twenty-foot-tall obelisk erected in 1792 in memory of William Bull, a former colonial governor of South Carolina. So impressive was this stone marker that for years it was marked on maps, and navigators took their bearings from its position. Fraser included the obelisk in one of his views of the Ashley Hall mansion. See the right-hand edge of Fig. 3.10 and compare it with Henrietta Drayton's later painting of Ashley Hall (Fig. 1.14). See Rosina S. Kennerty, *Plantations on the South Side of the Ashley River* (Charleston, S.C.: Nelson Printing, 1983), 8.

24. For more detail on Laurens, see David Duncan Wallace, *The Life of Henry Laurens* (New York: G. P. Putnam's Sons, 1915).

25. John Rutledge, Edward's father, had married Eliza Fraser, Charles Fraser's aunt. See Charles Fraser, "Fraser Family Memoranda," *South Carolina Historical and Genealogical Magazine* 5 (1904): 57.

26. John Irving, *A Day on the Cooper River* (1842), enlarged and edited by Louisa Cheves Stoney (Charleston, S.C.: A. E. Miller, 1932), 143.

27. Ibid., 141–43.

28. For examples of equivalent works done by local amateurs, see the following: *Tranquil Hill, seat of Mrs. Ann Waring, near Dorchester* at the Gibbes Museum of Art, and *Quinbey Plantation* by J. P. Hall, both reproduced in Edward Ball, *Slaves in the Family* (New York: Random House, 1998), following 122 and 250; *The Elms, Goose Creek* (1809) by Thomas Middleton, reproduced in Lane, *Architecture of the Old South: South Carolina*, 107; and *Jericho Plantation* and *Cedar Grove Plantation*, both by William M. Hutson (ca. 1860), reproduced in Todd and Hutson, *Prince William's Parish and Plantations*, 214 and 232.

29. Mark Roskill, *The Languages of Landscape* (University Park: Pennsylvania State University Press, 1997), 23–25; Edward J. Nygren, *Views and Visions: American Landscape Before 1830* (Washington, D.C.: Corcoran Gallery of Art, 1986), 18–21.

30. Severens and Wyrick, *Charles Fraser of Charleston*, 78.

31. William Gilpin, *Observations on Several Parts of Cambridge, Norfolk, Suffolk, and Essex, also on several parts of N. Wales* (1769; reprint, London: T. Cadell and W. Davies, 1809), 119–21.

32. William Gilpin, *Observations on the Western Parts of En-*

gland (1798; reprint, London: T. Cadell and W. Davies, 1809), 328, emphasis in original; 328–29.

33. David Doar, *Rice and Rice Planting in the South Carolina Low Country* (Charleston, S.C.: Charleston Museum, 1936), 8.

34. William Gilpin, *Observations on Several Parts of England Particularly the Mountains and Lakes of Cumberland and Westmoreland* (London: R. Balmire, 1786), xxviii–xxix.

35. Charles Joyner, *Down By the Riverside: A South Carolina Slave Community* (Champaign: University of Illinois Press, 1984), 61–63.

36. Barbara Novak, *Nature and Culture: American Landscape and Painting, 1825–1875*, rev. ed. (New York, Oxford University Press, 1995), 149–50.

37. Joyner, *Down By the Riverside*, 42.

38. Ball, *Slaves in the Family*, 393.

39. Charles Fraser, *A Charleston Sketchbook, 1796–1806* (1940; reprint, Charleston, S.C.: Carolina Art Association, 1971), v. This image of Runnymeade plantation was apparently given to John Pringle, Fraser's mentor in the law.

CHAPTER FOUR

1. *Encyclopaedia of New Orleans Artists, 1718–1918* (New Orleans: Historic New Orleans Collection, 1987), 300.

2. H. Parrott Bacot, "Persac Family History," in H. Parrott Bacot, Barbara SoRelle Bacot, Sally Kittredge Reeves, John Magill, and John H. Lawrence, *Marie Adrien Persac: Louisiana Artist* (Baton Rouge: Louisiana State University, 2000), 1–3.

3. Quoted in Roger Price, *The French Second Republic: A Social History* (Ithaca: Cornell University Press, 1972), 125, 243, 265.

4. Barbara SoRelle Bacot, "Marie Adrien Persac, Architect, Artist, and Engineer," *Antiques* 140 (1991): 808.

5. *Daily Crescent* (New Orleans), February 16, 1857.

6. Quoted in B. S. Bacot, "Marie Adrien Persac," 808.

7. From the files of the Louisiana State Museum, New Orleans, courtesy of Timothy Lupin.

8. Albert Grace, *The Heart of the Sugar Bowl: The Story of Iberville* (Plaquemine, La.: n.p., 1946), 75; William Edwards Clement, *Plantation Life on the Mississippi* (New Orleans: Pelican, 1952), 184; Harnet T. Kane, *Plantation Parade* (New York: William Morrow, 1945), 238–43.

9. Jesse Poesch and Barbara SoRelle Bacot, eds., *Louisiana Buildings, 1720–1940: The Historic American Buildings Survey* (Baton Rouge: Louisiana State University Press, 1997), 120.

10. See the advertisement for the sale of Belle Grove by John Andrews in 1867, which describes "twenty superior framed double cabins," in ibid., 121.

11. Milton B. Newton Jr., *Atlas of Louisiana* (Baton Rouge: School of Geoscience, Louisiana State University, 1972), 46.

12. See Fred B. Kniffen, "Louisiana House Types," *Annals of the Association of American Geographers* 26 (1936): 183–84; Jay D. Edwards, *Louisiana's Remarkable French Vernacular Architecture* (Baton Rouge: Department of Geography and Anthropology, Louisiana State University, 1988), 27–28.

13. Alfred Daspit, *Louisiana Architecture, 1714–1830* (Lafayette: Center for Louisiana Studies, 1996), 105, recounts that Hickey did hold the position of colonel during the War of 1812, when he was an officer in the state militia. On *Norman's Chart*, Persac lists Hickey as "Cl. P. Hickey."

14. Bernard Lemann, *The Lemann Family of Louisiana* (Donaldsonville, La.: B. Lemann & Bros., 1965), 37.

15. Ibid., 109, compares Persac's painting of Palo Alto with a photograph of the former slave quarters taken in 1895.

16. Miriam G. Reeves, *The Governors of Louisiana* (Gretna, La.: Pelican, 1972), 45–46; Joseph G. Dawson III, ed., *The Louisiana Governors* (Baton Rouge: Louisiana State University Press, 1990), 96.

17. Robert C. West, *An Atlas of Louisiana Surnames of French and Spanish Origin* (Baton Rouge: Geoscience Publications, Louisiana State University, 1986), 140.

18. In 1857 Bannon Thibodaux commissioned Persac to paint his own plantation estate, called Balzamine, which was located slightly downstream from St. Bridgette. This image presents a cottage-scaled house set in a luxuriant garden filled with exotic plants. Other than the presence of a few stalks of sugar cane, there are almost no indications that this was one of the larger plantations in the parish. See H. P. Bacot et al., *Marie Adrien Persac*, 26–27, for a reproduction of this painting.

19. See ibid., 72–73, for a reproduction of this painting.

20. "Terrebonne Parish, Louisiana," *De Bow's Commercial Review of the South and West* 6 (1850): 147–48.

21. Sally Kittredge Reeves, "The Notarial Archives Drawings of Adrien Persac," in H. P. Bacot et al., *Marie Adrien Persac*, 86.

22. Maurine Bergerie, *They Tasted Bayou Water: A Brief History of Iberia Parish* (Ann Arbor, Mich.: Edwards Bros., 1962), 17.

23. Glen R. Conrad, ed., *New Iberia: Essays on the Town and Its People* (Lafayette, La.: Center for Louisiana Studies, 1979), 64.

24. B. S. Bacot, "Marie Adrien Persac," 810.

25. Conrad, *New Iberia*, 45.

26. Morris Raphael, *Weeks Hall, The Master of the Shadows* (Detroit: Harlow, 1981), 20; Kane, *Plantation Parade*, 250–51.

27. Paul E. Stahls, *Plantation Homes of the Teche Country* (Gretna, La.: Pelican, 1979), 35.

28. See H. P. Bacot et al., *Marie Adrien Persac*, 24–25, for a reproduction of this painting.

29. See ibid., 52–53, for a reproduction of this painting.

30. For a detailed description of the Lady of the Lake house, see Daspit, *Louisiana Architecture*, 47–49; and Barbara SoRelle Bacot, "Lady of the Lake," in H. P. Bacot et al., *Marie Adrien Persac*, 52.

31. John B. Rehder, "Diagnostic Traits of Sugar Plantations in Southern Louisiana," in *Man and Environment in the Lower Mississippi Valley*, Geoscience and Man Series Vol. 19, ed. Sam B. Hilliard (Baton Rouge: School of Geoscience, Louisiana State University, 1978), 135.

32. Poesch and Bacot note that some sugarhouses were ornamented with Greek Revival facades or Gothic Revival spires. Poesch and Bacot, *Louisiana Architecture*, 168.

33. Writer's Program, *Louisiana: A Guide to the State* (New York: Hastings House, 1945), 623.

34. Newton, *Atlas of Louisiana*, 179.

35. "Sugar and the Sugar Region of Louisiana," *Harper's New Monthly Magazine* 7 (1853): 753.

36. See H. P. Bacot et al., *Marie Adrien Persac*, 50–51, for a reproduction of this painting.

37. Dawson, *Louisiana Governors*, 122.

38. Jacqueline P. Vals-Denuziere, *The Homes of the Planters* (Baton Rouge, La.: Claitors, 1984), 100–101.

39. The federal census of 1860 listed Ile Copal as having twenty-five slave houses.

40. See H. P. Bacot et al., *Marie Adrien Persac*, 70–71, for a reproduction of this painting.

41. Cited in J. Carlyle Sitterson, *Sugar Country: The Cane Sugar Industry in the South, 1753–1950* (Lexington: University Press of Kentucky, 1952), 135.

42. By creating an impressive image of a technological marvel, Persac may have been attempting to reassert his credentials as a civil engineer. In an advertisement in the *New Orleans Bee* in 1869, he identified himself as capable of providing "dessin d'architecture et des machines" [designs for buildings and machines]. In his image of the Riverlake sugarhouse, the refining machinery is the paramount element. See Barbara SoRelle Bacot, "Marie Adrien Persac—Artist of the American Landscape" in H. P. Bacot et al., *Marie Adrien Persac*, 12.

43. Cited in B. A. Botkin, *Lay My Burden Down: A Folk History of Slavery* (Chicago: University of Chicago Press, 1945), 127.

44. Another of Persac's paintings that focuses prominently on an industrial operation is his watercolor of Magnolia plantation in Lafayette Parish. In it, he renders a view of a small steam-powered sawmill that is not only centermost but also stands well forward of the planter's house and his sugar mill. This unusual focus suggests that the plantation owner, Rousseau Mouton, was particularly proud of his lumbering operation. See H. P. Bacot et al., *Marie Adrien Persac*, 66–67.

45. Botkin, *Lay My Burden Down*, 120.

46. Ronnie W. Clayton, *Mother Wit: The Ex-Slave Narratives of the Louisiana Writer's Project* (New York: Peter Lang, 1990), 162.

47. Narrative of Anne Clark, in *The American Slave: A Composite Autobiography*, 19 vols., ed. George P. Rawick, (Westport, Conn.: Greenwood, 1972), Vol. 4, pt. 1, p. 224.

48. Gilbert Osofsky, ed., *Puttin' On Ole Massa: The Slave Narratives of Henry Bibb, William Wells Brown, and Solomon Northup* (New York: Harper & Row, 1969), 338.

49. For an example, see Samuel Wilson Jr. and Bernard Lemann, *New Orleans Architecture*, Vol. 1: *The Lower Garden District* (Gretna, La.: Pelican, 1971), 36. Some thirty-one of these "elevation" drawings are on file in the New Or-

leans Notarial Archives. See also Reeves, "Notarial Archives Drawings," in H. P. Bacot et al., *Marie Adrien Persac*, 85–99.

50. Cited in the Historic American Engineering Record report for Laurel Valley Plantation, La Fourche Parish, Louisiana (1978), on file in the Prints and Photographs Division, Library of Congress.

51. This information on Persac's later career comes from the files of the Louisiana State Museum, New Orleans, courtesy of Timothy Lupin.

CHAPTER FIVE

1. Quoted in Bryan Le Beau, "'Colored Engravings for the People': The World According to Currier and Ives," *American Studies* 35 (1994): 131.

2. Walton Rawls, *The Great Book of Currier & Ives' America* (New York: Abbeville, 1979), 58.

3. Roy King and Burke Davis, *The World of Currier and Ives* (New York: Bonanza, 1987), 12.

4. Ewell L. Newman, *Currier & Ives: Nineteenth-Century Printmakers to the American People* (Sandwich, Mass.: Heritage Plantation of Sandwich, 1973), 10.

5. Charlotte Streifer Rubinstein, "The Early Career of Frances Flora Bond Palmer," *American Art Journal* 17 (1985): fig. 2, p. 72.

6. Stephen Daniels, *Fields of Vision: Landscape Imagery and National Identity in England and the United States* (Princeton: Princeton University Press, 1993), 177.

7. Ibid., 179.

8. Rubinstein, "Early Career of Frances Flora Bond Palmer," 87.

9. Rawls, *Great Book of Currier & Ives' America*, 47–48, 289.

10. Compare Palmer's riverboat prints with Mark Twain's descriptions in "The House Beautiful," chap. 38 of *Life on the Mississippi* (New York: Harper & Brothers, 1883), 277, 282–83.

11. John Francis McDermott, *George Caleb Bingham: River Portraitist* (Norman: University of Oklahoma Press, 1959), 58–59, notes that in 1847 over 18,000 prints of *The Jolly Flatboatmen* were issued, making it one of the most accessible images of the American frontier.

12. *Harper's New Monthly Magazine* 12 (1855–56): 25–44; the

illustrations appear on 27, at the top and bottom of the page.

13. Daniels, *Fields of Vision*, 188–89. Palmer's *Across the Continent* offered a vernacular response to Emanuel Leutze's *Westward the Course of Empire Takes Its Way* (1862) which today hangs in the rotunda of the United States Capitol. Palmer's image was apparently influenced by A. R. Waud's print *Building the Union Pacific Railroad in Nebraska*, which appeared in Albert D. Richardson's 1867 gazetteer *Beyond the Mississippi*.

14. On the complexities of reconstruction politics, see Eric Foner, *Reconstruction: America's Unfinished Revolution, 1863–1877* (New York: Harper & Row, 1989), esp. chap. 6, "The Making of Radical Reconstruction."

15. Rawls, *Great Book of Currier & Ives' America*, 43.

16. Estill Curtis Pennington, *Look Away: Reality and Sentiment in Southern Art* (Spartanburg, S.C.: Saraland, 1989), 101.

17. See Roger G. Kennedy, *Greek Revival America* (New York: Stewart, Tabori and Chang, 1989), 350; and Talbot Hamlin, *Greek Revival Architecture in America* (New York: Oxford University Press, 1944), 137–40.

18. Since Ithiel Town died in 1844, the same year that Palmer arrived in New York from England, she would not have had any direct contact with him. She did, however, do several commissions for his partner Alexander J. Davis, and thus, via this connection, she would have learned about Town and his more celebrated works, such as the Samuel Russell house. In fact, not only was Davis the delineator for the engraved view of the Russell house, but the print was published by the London firm of I. T. Hinton & Simpkin & Marshall, and thus Palmer may have known of the Russell house even before she set foot in America.

19. William H. Ranlett, *The Architect*, Vol. 1 (1849) and Vol. 2 (1851) (reprint, New York: Da Capo, 1976). The Italian Bracketed Villa appears in Vol. 2 as Design XXVI, plate 7. The house appears again in the background of another Currier and Ives print, *A Home on the Mississippi* (1871).

20. See John Michael Vlach, *Back of the Big House: The Architecture of Plantation Slavery* (Chapel Hill: University of North Carolina Press, 1993), 153–82.

21. A. J. Downing, *The Architecture of Country Houses* (1850; reprint, New York: Dover, 1969), 73–78 and fig. 5, facing 73. According to Rubinstein, "Early Career of Frances

Flora Bond Palmer," 85, Palmer was very familiar with Davis's works, having produced a print of one of his designs for a suburban villa in 1846.

22. Mary Bartlett Cowdrey, "Fanny Palmer, an American Lithographer," in *Prints*, ed. Carl Zigrasser (New York: Holt, Rinehart, Winston, 1962), 225.

23. See Charles White, *White's New Book of Plantation Melodies* (Philadelphia: T. B. Peterson, 1845), 20, 36, 57.

24. For examples, see the proslavery print *Slavery As It Is*, published in 1850 by J. Haven of Boston, or *The Breakdown*, one of a series of "American Home Scenes" that were published in *Harper's Weekly* (April 13, 1861).

25. See Robert C. Toll, *Blacking Up: The Minstrel Show in Nineteenth-Century America* (New York: Oxford University Press, 1974), 25–57; and Hans Nathan, *Dan Emmett and the Rise of Early Negro Minstrelsy* (Norman: University of Oklahoma Press, 1962).

26. The unknown artist who created this vignette apparently combined the slave house from Currier & Ives's *The Old Plantation Home* with another of their prints of a flatboat scene, entitled *Floating Down to Market*, which was also published in 1870. Muller & Company modified these appropriated images only slightly while remaining faithful to the Currier & Ives originals.

27. W. E. B. Du Bois, *The Souls of Black Folk: Essays and Sketches* (1903; reprint, Greenwich, Conn.: Fawcett, 1961), 106–7.

28. On the varieties of racist tactics employed in the South, see C. Vann Woodward, *The Strange Career of Jim Crow* (New York: Oxford University Press, 1966).

CHAPTER SIX

1. August P. Trovaioli and Roulhac B. Toledano, *William Aiken Walker: Southern Genre Painter* (Baton Rouge: Louisiana State University Press, 1972), 129–31.

2. Ibid., 62, 14.

3. James C. Kelly, "William Aiken Walker," in *The South on Paper: Line, Color and Light* (Spartanburg, S.C.: Robert M. Hicklin, Jr., Inc., 1985), 66.

4. Cynthia Seibels, *The Sunny South: The Life and Art of William Aiken Walker* (Spartanburg, S.C.: Saraland, 1995), 87–88.

5. Ibid., 90 and 72.

6. There is some resemblance between the trees seen in background of *The Rice Harvest* and those found in an undated painting by Walker entitled *Rice Field with Bald Cypress in Louisiana*; see Trovaioli and Toledano, *William Aiken Walker*, 115, plate 19. Further, in *The Rice Harvest* the stalks of rice are delivered from the fields to the mill on wagons, while in South Carolina, the other state where rice was a major plantation commodity, sheaves of rice were usually transported on barges, via a network of canals. See the images by Alice Ravenel Huger Smith in Chapter 7, esp. Fig. 7.14.

7. See Trovaioli and Toledano, *William Aiken Walker*, 115 and 117, plates 18 and 22, for reproductions of these two paintings.

8. Walker's formula may have been set by John Antrobus, who lived in New Orleans from 1850 to 1861. Antrobus embarked on a project to paint twelve large pictures representing southern life and nature. The first of these pictures was a plantation scene, now lost, that he exhibited in 1859. A New Orleans newspaper reported of it: "The picture, which is of a large size, was painted from a real life scene on the plantation of Col. Watts, of Bayou Macon, in this State, and represents the negroes engaged in picking and carrying cotton to the gin-house. . . . Far in the background are seen the banks of the bayou and objects beyond; in the middle ground the gin-house, the overseer upon his horse, and other plantation aspects; while in the foreground is the grouping of the negroes at their work in various attitudes, carrying baskets highpiled with the fleecy staple." While one cannot be certain that Walker ever saw this painting, there are obvious compositional parallels. For more on Antrobus, see Hugh Honour, *The Image of the Black in Western Art*, Vol. 4: *From the American Revolution to World War I* (Cambridge: Harvard University Press, 1989), 214–15.

9. Trovaioli and Toledano, *William Aiken Walker*, 63.

10. Guy McElroy, *Facing History: The Black Image in American Art, 1710–1940* (Washington, D.C.: Corcoran Gallery of Art, 1990), xviii.

11. Estill Curtis Pennington, *Downriver: Currents of Style in Louisiana Painting, 1800–1950* (Gretna, La.: Pelican, 1991), 115. A copy of this poster is currently in the collection of the Sewall family of Vidalia, La.

12. John B. Lillard, *Guide to the World's Industrial and Cotton Centennial Exposition* (Louisville, Ky.: Courier-Journal Job Printing Co., 1884), 16–17.

13. Seibels, *Sunny South*, 110–12.

14. John B. Boles, *The South through Time: A History of an American Region* (Englewood Cliffs, N.J.: Prentice-Hall, 1995), 380–81.

15. Henry W. Grady, *The New South* (New York: Robert Bonners Sons, 1890), 268.

16. For an example of a mule-powered cotton gin, see John Michael Vlach, *Back of the Big House: The Architecture of Plantation Slavery* (Chapel Hill: University of North Carolina Press, 1993), 130–31.

17. See Charles S. Aiken, "The Evolution of Cotton Ginning in the Southeastern United States," *Geographical Review* 63 (1973): 202; and Pete Daniel, *Standing at the Crossroads: Southern Life in the Twentieth Century* (New York: Hill and Wang, 1986), 5–6.

18. Daniel Augustus Tompkins, *Cotton and Cotton Oil* (Charlotte, N.C.: by the author, 1901), fig. 26.

19. Pennington, *Downriver*, chap. 3, "Light in Louisiana Landscape Art."

20. Seibels, *Sunny South*, 121.

21. Cited in ibid., 90, 92.

22. Quoted in ibid., 92.

23. Merle Prunty Jr., "The Renaissance of the Southern Plantation," *Geographical Review* 45 (1955): 466–71.

24. James C. Cobb, *The Most Southern Place on Earth: The Mississippi Delta and the Roots of Regional Identity* (New York: Oxford University Press, 1992), 69; William Cohen, *At Freedom's Edge: Black Mobility and the Southern White Quest for Racial Control, 1861–1915* (Baton Rouge: Louisiana State University, 1991), 259–60, 264. Between 1865 and 1880 approximately 6,250 blacks left Mississippi for Kansas, most of them from the Delta region. Cohen, *At Freedom's Edge*, 303.

25. Cobb, *Most Southern Place on Earth*, 70–71.

26. Edward L. Ayers, *The Promise of the New South* (New York: Oxford University Press, 1992), 135.

27. Cobb, *Most Southern Place on Earth*, 76.

28. Cited in Michael Wayne, *The Reshaping of Plantation Society* (Baton Rouge: Louisiana State University Press, 1983), 80–81.

29. David L. Cohn, *The Life and Times of King Cotton* (New York: Oxford University Press, 1956), 168.

30. James L. Watkins, *King Cotton: A Historical and Statistical Review, 1790 to 1908* (1908; reprint, New York: Negro Universities Press, 1969), 22–23.

31. Quoted in Trovaioli and Toledano, *William Aiken Walker*, 70.

32. Ibid., 119–20.

33. Ibid., 87–88.

34. Seibels, *Sunny South*, 146, 151.

35. Pennington, "Below the Line: Design and Identity in Southern Art," in Kelly, *The South on Paper*, 2.

36. Pennington, *Downriver*, 114.

37. Quoted in Seibels, *Sunny South*, 92.

38. Ibid., 153.

39. Pete Daniel, "The Metamorphosis of Slavery," *Journal of American History* 66 (1979): 99.

CHAPTER SEVEN

1. Alice Ravenel Huger Smith, "Reminiscences," in Martha R. Severens, *Alice Ravenel Huger Smith: An Artist, a Place, and a Time* (Charleston, S.C.: Carolina Art Association, 1993), 84.

2. Severens, *Alice Ravenel Huger Smith*, 2–3.

3. Smith, "Reminiscences," 90–92.

4. Quoted in Severens, *Alice Ravenel Huger Smith*, 45.

5. Henry S. Canby, "Review of *A Carolina Rice Plantation of the Fifties*," *Saturday Review* (December 5, 1936), cited in *Alice Ravenel Huger Smith of Charleston, South Carolina* (Charleston, S.C.: privately published, 1956), 21.

6. Alice Ravenel Huger Smith, *A Carolina Rice Plantation of the Fifties* (New York: William Morrow, 1936), xi.

7. Severens, *Alice Ravenel Huger Smith*, 57, 59.

8. Smith, *Carolina Rice Plantation*, xi.

9. Smith, "Reminiscences," 71.

10. Alice Ravenel Huger Smith and Daniel Elliott Huger Smith, *Twenty Drawings of the Pringle House on King Street, Charleston, S.C.* (Charleston, S.C.: Lanneau's Art Store, 1914).

11. For a detailed study of Susan Pringle Frost, a pioneer in Charleston's preservation movement and the owner and

resident of the Brewton house at the time when Smith was creating her portfolio, see Sidney R. Bland, *Preserving Charleston's Past, Shaping Its Future: The Life and Times of Susan Pringle Frost* (Westport, Conn.: Greenwood, 1994).

12. Alice R. Huger Smith and D. E. Huger Smith, *The Dwelling Houses of Charleston, South Carolina* (Philadelphia: J. B. Lippincott, 1917).

13. Alice R. Huger Smith and D. E. Huger Smith, *Charles Fraser* (New York: Frederick Fairchild Sherman, 1924).

14. Smith would eventually publish a Fraser sketchbook in a facsimile edition: Charles Fraser, *A Charleston Sketchbook, 1796–1806* (Charleston, S.C.: Carolina Art Association, 1940).

15. D. E. Huger Smith, "A Plantation Boyhood," in Smith, *Carolina Rice Plantation*, 60.

16. Ibid., 62.

17. Ibid., 63.

18. Smith, *Carolina Rice Plantation*, xi.

19. For a historical description of Smithfield, see Suzanne Cameron Linder, *Historical Atlas of the Rice Plantations of the ACE River Basin—1860* (Columbia: South Carolina Department of Archives and History, 1995), 563–72.

20. Smith, "Reminiscences," 98. On Strawberry Chapel, see Samuel Gaillard Stoney, *Plantations of the Carolina Lowcountry* (Charleston, S.C.: Carolina Art Association, 1938), 52, 112.

21. Severens, *Alice Ravenel Huger Smith*, 50.

22. See Cornelius O. Cathey's introduction to Pringle, *A Woman Rice Planter* (1914; reprint, Cambridge: Belknap Press of Harvard University Press, 1961), xxix.

23. See Pringle, *A Woman Rice Planter*, frontispiece and 4, 107, 272, 331.

24. Marietta Neff, "A Painter of the Carolina Lowlands," *American Magazine of Art* 17 (1926): 407.

25. Stephanie Yuhl, "High Culture in the Low Country: Arts, Identity, and Tourism in Charleston, South Carolina, 1920–1940," doctoral dissertation, Duke University (1998), 107.

26. Martha R. Severens, *The Charleston Renaissance* (Spartanburg, S.C.: Saraland, 1998), 100.

27. For examples of Smith's images of black subjects that capture personality rather than a generic type, see the following illustrations from *A Woman Rice Planter*: "A request from Wishy's mother, Annette, for something to stop bleeding" (17); "My little brown maid Patty is a new acquisition and a great comfort, for she is very bright" (53); "Pa dey een 'e baid" (102); "His wife was very stirring" (136); "Old Florinda, the plantation nurse" (144); "Patty came in" (210); "I met Dab on the road" (249); "Chloe began: 'W'en I bin a small gal'" (288).

28. D. E. Huger Smith, *A Charlestonian's Recollections, 1846–1913* (Charleston, S.C.: Carolina Art Association, 1950), 162.

29. Neff, "Painter of the Carolina Low Country," 407. Smith said that when she painted her sketches of black vendors and flower sellers, she did "seven on Monday, six on Tuesday, five on Wednesday—hardly enough energy to do one on Saturday."

30. Smith, "Reminiscences," 78–79.

31. Ibid., 120.

32. Ibid., 97; emphasis in original.

33. Herbert Ravenel Sass, "The Rice Coast: Its Story and Its Meaning," in Smith, *Carolina Rice Plantation*, 39.

34. Smith, "Reminiscences," 99.

35. "Art in Charleston," *The State* (1931), cited in Severens, *Alice Ravenel Huger Smith*, 45.

36. Smith, "Reminiscences," 97.

37. David Doar, *Rice and Rice Planting in the South Carolina Low Country* (Charleston, S.C.: Charleston Museum, 1936), 8.

38. See D. E. Huger Smith, "A Plantation Boyhood," 64–65.

39. In this image Smith anachronistically outfitted the planter in the attire of a twentieth-century gentleman.

40. At the Pringle House Smith did four views of the laundry and kitchen buildings and their adjacent work yards. In *The Dwelling Houses of Charleston* she provided renderings for slave quarters and back buildings at the Jacob Motte house (53), the Nathaniel Heyward house (289), and the Jefferson Bennett house (333). Although her visit to Chicora Wood took place well after Emancipation, she nevertheless did several sketches that include black houses; see Pringle, *A Woman Rice Planter*, 171, 187, 236, 262, 375.

41. See Bertram Wyatt-Brown, *Southern Honor: Ethics and Behavior in the Old South* (New York: Oxford University Press, 1982), esp. chap. 2, for a discussion of the origins

and consequences of the southern custom of familial loyalty.

42. Smith, "Reminiscences," 71.

43. D. E. Huger Smith, *A Charlestonian's Recollections, 1846–1913* (Charleston, S.C.: Carolina Art Association, 1950); and Alice Ravenel Huger Smith and D. E. Huger Smith, eds., *Mason Smith Family Letters, 1860–1868* (Columbia: University of South Carolina, 1950).

44. U. B. Phillips, *American Negro Slavery* (New York: D. Appleton, 1918), 343.

45. Sass, "The Rice Coast," 42.

46. Cited in Charles Joyner, "Julia Mood Peterkin," in *Encyclopedia of Southern Culture*, ed. Charles Reagan Wilson and William Ferris (Chapel Hill: University of North Carolina Press, 1989), 1586.

47. George P. Rawick, *The American Slave: A Composite Autobiography*, 19 vols. (Westport, Conn.: Greenwood, 1972), vol. 2, pt. 1, pp. 110, 145; vol. 2, pt. 2, p. 306.

48. James C. Kelly, *The South on Paper: Line, Color and Light* (Spartanburg, S.C.: Robert M. Hicklin, Jr., Inc., 1985), 11.

49. *Alice Ravenel Huger Smith of Charleston*, 28.

50. Smith, "Reminiscences," 105.

51. Cited in Kelly, *The South on Paper*, 14.

52. See *Alice Ravenel Huger Smith of Charleston*, 39–58, for a complete listing of 619 artworks.

CHAPTER EIGHT

1. Quoted in Peter Wood, *Black Majority: Negroes in Colonial South Carolina from 1670 through the Stono Rebellion* (New York: W. W. Norton, 1974), 132.

2. James Clifton, "Rice," in *Dictionary of Afro-American Slavery*, ed. Randall M. Miller and John David Smith (New York: Greenwood, 1988), 645.

3. George P. Rawick, ed., *The American Slave: A Composite Autobiography*, 19 vols. (Westport, Conn.: Greenwood, 1972), vol. 3, pt. 4, p. 177; vol. 15, pt. 2, p. 364.

4. Mechal Sobel, *The World They Made Together: Black and White Values in Eighteenth-Century Virginia* (Princeton: Princeton University Press, 1987) describes this critical interaction between blacks and whites during the colonial period.

5. Letitia M. Burwell, *A Girl's Life in Virginia Before the War* (New York: Frederick A. Stokes, 1895), 8.

6. See Larry E. Tise, *Proslavery: A History of the Defense of Slavery in America, 1701–1840* (Athens: University of Georgia Press, 1987); Eugene D. Genovese, *The World the Slaveholders Made: Two Essays in Interpretation* (New York: Pantheon, 1969); and Drew Gilpin Faust, *A Sacred Circle: The Dilemma of the Intellectual in the Old South, 1840–1860* (Baltimore: Johns Hopkins University Press, 1977).

7. For further instances of how blacks were marginalized as subjects in works of art, see Albert Boime, *The Art of Exclusion: Representing Blacks in the Nineteenth Century* (Washington, D.C.: Smithsonian Institution Press, 1990).

8. Edith Rossiter Bevan, "Perry Hall: Country Seat of the Gough and Carroll Families," *Maryland Historical Magazine* 45 (1950): 35.

9. Francis Gaines Pendleton, *The Southern Plantation: A Study in the Development and the Accuracy of a Tradition* (New York: Columbia University Press, 1924), 5.

10. Isaac E. Holmes, *Recreations of George Taletell, F.Y.C* (Charleston, S.C.: Duke & Brown, 1822), 33–34.

11. Ibid., 58–61.

12. David R. Coffin, *The English Garden: Meditation and Memorial* (Princeton: Princeton University Press, 1994), 87–127, 119.

13. For examples, see Jack P. Greene, ed., *The Diary of Colonel Landon Carter of Sabine Hall, 1752–1778* (Charlottesville: University Press of Virginia, 1965); and Karl Lehmann, *Thomas Jefferson: American Humanist* (New York: Macmillan, 1947), esp. 179–81.

14. George Tucker, *The Valley of the Shenandoah or Memoirs of the Graysons* (New York: C. Wiley, 1824), 25.

15. J. E. Heath, *Edge-Hill, or, The Family of the Fitzroyals* (Richmond, Va.: T. W. White, 1828), 6.

16. James Hall, *The Harpe's Head; a Legend of Kentucky* (Philadelphia: Key & Biddle, 1833), 18.

17. William Gilmore Simms, *Mellichampe; A Legend of the Santee* (New York: J. S. Redfield, 1854), 63.

18. John Pendleton Kennedy, *Swallow Barn; or, A Sojourn in the Old Dominion* (1853; reprint, Baton Rouge: Louisiana State University Press, 1968), 27.

19. Ibid., 29.

20. Guy A. Cardwell, "The Plantation House: An Analogical Image," *Southern Literary Journal* 2 (1969): 16.

21. Mary Boykin Miller Chesnut, *Mary Chesnut's Civil War*, ed. C. Vann Woodward (New Haven, Conn.: Yale University Press, 1981), 488.

22. Orville Vernon Burton, *In My Father's House Are Many Mansions: Family and Community in Edgefield, South Carolina* (Chapel Hill: University of North Carolina Press, 1985), 160.

23. James Henry Hammond, "'Mud-Sill' Speech" (1858), in *Slavery Defended: The Views of the Old South*, ed. Eric L. McKitrick (Englewood Cliffs, N.J.: Prentice-Hall, 1963), 122–23.

24. William J. Grayson, "The Hireling and the Slave," in McKitrick, *Slavery Defended*, 64.

25. Richard H. Colfax, *Evidence Against the Views of the Abolitionists* (1833), cited in George M. Fredrickson, *The Black Image in the White Mind: The Debate on Afro-American Character and Destiny, 1817–1914* (New York: Harper & Row, 1971), 50.

26. Kennedy, *Swallow Barn*, 453.

27. George Fitzhugh, *Cannibals All! or Slaves Without Masters*, ed. C. Vann Woodward (Cambridge: Harvard University Press, 1960), 18.

28. Thomas Nelson Page, "Two Colonial Places," cited in Cardwell, "The Plantation House," 11.

29. Thomas Nelson Page, *In Ole Virginia, or Marse Chan and Other Stories* (Nashville, Tenn.: J. S. Sanders & Co., 1991), 10. For an interesting comparison of Page's plantation imagery with that of nineteenth-century African American writer Charles Chesnutt, see Keith Byerman, "Black Voices, White Stories: An Intertextual Analysis of Thomas Nelson Page and Charles Waddell Chesnutt," *North Carolina Literary Review* 8 (1999): 98–105.

30. Joel Chandler Harris, *Uncle Remus: His Songs and His Sayings* (1880; reprint, New York: Penguin, 1982), 185.

31. Cited in Fredrickson, *Black Image in the White Mind*, 207 (Grady), 209 (Field).

32. See Edward D. C. Campbell Jr., *The Celluloid South: Hollywood and the Southern Myth* (Knoxville: University of Tennessee Press, 1981).

33. James Mitchner, "The Company of Giants," introduction to the fiftieth anniversary edition of *Gone with the Wind* (1976), reprinted in *Recasting: "Gone with the Wind" in American Culture*, ed. Darden Asbury Pyron (Miami: University Presses of Florida, 1983), 72.

34. Richard H. King, *A Southern Renaissance: The Cultural Awakening of the American South, 1930–1955* (New York: Oxford University Press, 1980), chap. 2; Richard H. King, "The 'Simple Story's' Ideology: *Gone with the Wind* and the New South Creed," in Pyron, *Recasting*, 173.

35. Fredrickson, *Black Image in the White Mind*, 324–25.

INDEX

Note: Italic page numbers indicate illustrations; plate numbers refer to color plates.

DATE DUE

GAYLORD PRINTED IN U.S.A.